SALVADOR DALÍ

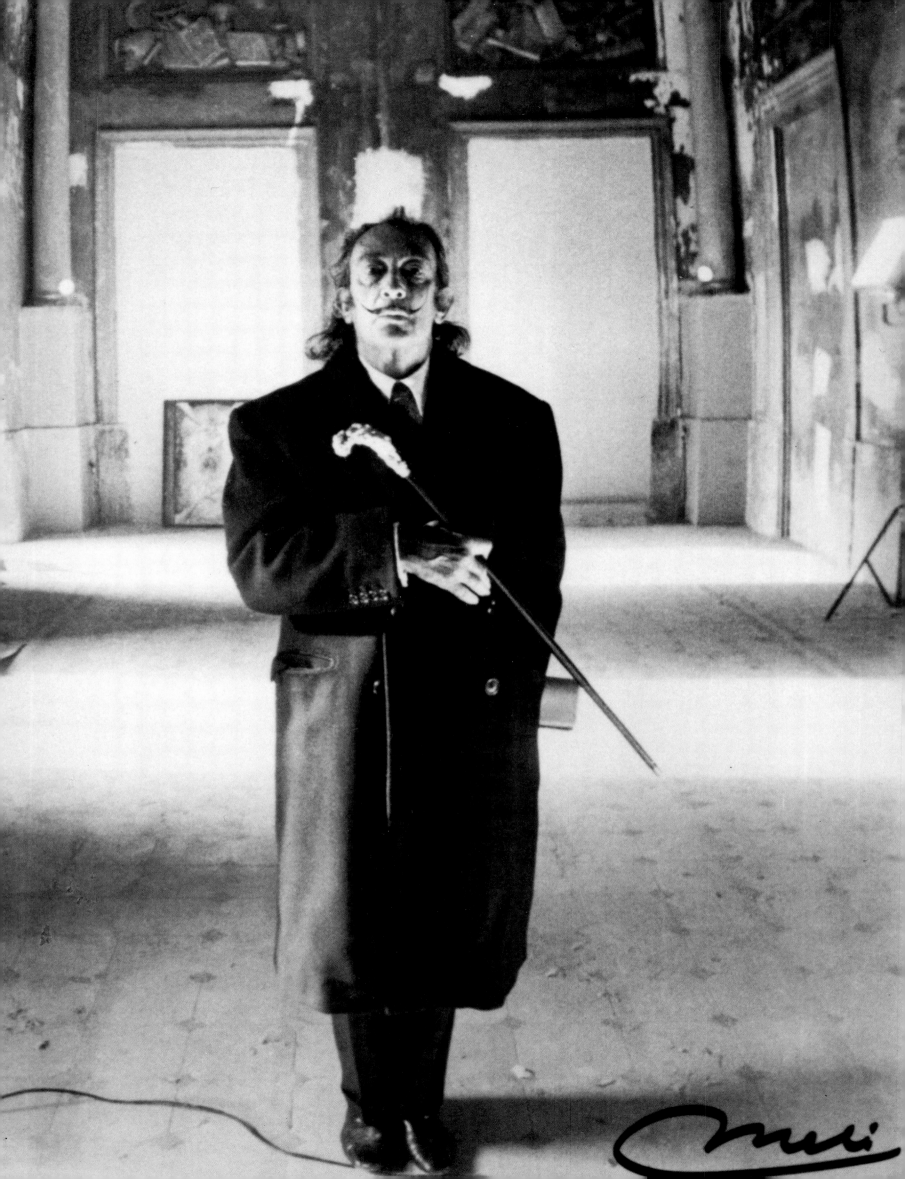

SALVADOR DALÍ

MASTERPIECES FROM THE

COLLECTION OF THE

SALVADOR DALÍ MUSEUM

KENNETH WACH

HARRY N. ABRAMS, INC., PUBLISHERS

IN ASSOCIATION WITH THE

SALVADOR DALÍ MUSEUM

ST. PETERSBURG, FLORIDA

TO THE MEMORY OF HELENA WACH

Project Manager: Eric Himmel
Editor: James Leggio
Designer: Robert McKee

Library of Congress Cataloging-in-Publication Data
Wach, Kenneth.
 Salvador Dalí: masterpieces from the collection of the Salvador Dalí Museum / Kenneth Wach.
 p. cm.
 Includes bibliographical references and index.
 ISBN 0-8109-3235-0 (hardcover) / ISBN 0-8109-2693-8 (Mus. pbk.)
 1. Dalí, Salvador, 1904–1989—Catalogs. 2. Surrealism—Spain—Catalogs. 3. Salvador Dalí
 Museum—Catalogs. I. Salvador Dalí Museum. II. Title.
N7113.D3A4 1996
709' .2—dc20 —dc20
[741.94'074'43] 96-3544

Text copyright © 1996 Kenneth Wach
Illustrations copyright © 1996 The Salvador Dalí Museum, Inc.

Printed and bound in Spain

FRONTISPIECE: Salvador Dalí in 1970 in the foyer of the theater in Figueres, Spain,
that was soon to be reconstructed as the Teatro-Museo Dalí

All works of art reproduced in this volume are from the collection of the Salvador Dalí Museum,
St. Petersburg, Florida. All photographs reproduced were provided by the Museum. For certain photographs,
the following additional credits are due: Rudolph Burkhardt, pages 13, 27 bottom, 28, 29; Meliton Casals,
frontispiece and pages 118, 119 top; Edward Meneeley, page 18; Charles Reynolds, page 17.

CONTENTS

Preface and Acknowledgments

The present Salvador Dalí Museum formally opened on March 7, 1982, in St. Petersburg, Florida. The Museum's permanent collection is devoted solely to the work of Dalí. At present, the collection comprises ninety-five oil paintings, over one hundred watercolors and drawings, and nearly thirteen hundred prints, together with a substantial selection of sculptures, objets d'art, works of jewelry, ceramics, coins, glass, limited-edition publications, and photographs. Chronologically, the Museum's holdings span virtually Dalí's entire active career, offering a peerless panorama of his stylistic evolution over a period of sixty-seven years. The core collection of artworks is complemented by an extensive archive of primary documents, rare books, scholarly publications, films, photographs, and other research materials related to Dalí's life and work.

The collection represents the philanthropic gift of A. Reynolds Morse and Eleanor R. Morse, who assembled these works over the course of half a century. Most of the objects were acquired directly from the artist, or with his advice, during the many years of the Morses' friendship with him between 1943, when they first acquired one of his paintings, and Dalí's death in 1989. The collection continues to develop, however, and the Museum's most recent major acquisition was made in 1995. Taken as a whole, in its quality and scope the collection bears witness to a history of informed patronage that is remarkable in its consistency and focus.

Beyond the works acquired from the artist or under his supervision, objects also came into the collection from the private holdings of the following patrons and collectors: John E. Abbott, J. W. Alsdorf, Garriga Bachs, Domingo Carles, Antonio Carreras, Margit Chanin, Jean Cocteau, Valerie Cooper, Joseph Cornell, Jorge de Piedrablanca de Guana (the Marquis Georges de Cuevas), Ana María Dalí, Lise Deharme, Gabriel Dereppe, Mrs. R. N. Ducas, Paul Eluard, Joseph Forêt, Thomas A. Fransioli Jr., Juan Subias Galter, Delius Giese, Alfonso González, A. Conger Goodyear, George F. Goodyear, Julian Green, Cécile Grindel, Felipe José M. Gudiol, J. W. Hambuechen, Rebekah Harkness, Huntington Hartford, Claude Hersent, Georges Hugnet, Juan Agustí Juncá, Georges Keller, Comte Alain de Lêché, Julien Levy, Simon Linares, Mrs. Peter Lloyd, Wright Ludington, Man Ray, Prince Leone Massimo, Pierre Matisse, Enric Morera, Javier Rosa Salleras de Naveira, Alonzo Net, Mrs. J. J. O'Donohue, Pedro Peré, André Petit, Albert Puig, Charles E. Roseman, Jr., Helena Rubinstein, James Thrall Soby, Tony Spinazzola, Ladislas Szecsi, Justin K. Thannhauser, Domènech Vilanova, Edward Wasserman, André Weil, Joseph Winterbotham, and Mrs. Michael M. Zatorski.

Although the Salvador Dalí Museum has been at its present location only since 1982, the Museum's history actually began four decades earlier, in Cleveland, in 1942. At that time, Reynolds and Eleanor Morse first saw a substantial group of Dalí's works, in a large traveling exhibition organized by the Museum of Modern Art, New York; it was a decisive experience that led, soon after, to their first purchase of a work by Dalí, from the Bignou Gallery, New York. As their interest developed, the Morses not only won the friendship of the artist and his wife, Gala, but set out on the five decades of collecting that produced the most comprehensive collection of Dalí's art in existence.

At first, the couple exhibited the burgeoning collection in a wing of their business buildings in Cleveland, but subsequently opened the original Salvador Dalí Museum, in March 1971, in nearby Beachwood, Ohio. Dalí attended the Museum's inaugural ceremonies in recognition of the collection's importance. The Salvador Dalí Museum continued at that location until the late 1970s, when the Morses began to seek a permanent home more suited to what had become by then a remarkably extensive collection. One of their principal criteria was that the collection remain intact, as a uniquely comprehensive overview of one of this century's major artistic figures.

Ultimately, the city of St. Petersburg was selected as the site of the new Salvador Dalí Museum. Since its opening in 1982, the Museum has drawn increasing numbers of visitors and is now one of the most heavily attended art museums in the state. The Salvador Dalí Museum maintains active relationships with the Fundació Gala-Salvador Dalí in Figueres, Spain, the Fundació García Lorca in Madrid, and the Museo Nacional Centro de Arte Reina Sofía in Madrid. It remains firmly committed to the preservation and exhibition of its unique collection, and to providing a rich resource for artistic enjoyment and aesthetic education, one of the goals of the present volume.

◆ ◆ ◆

My work on this book was facilitated by the Australian Research Council, through a research grant awarded by the University of Melbourne. Valuable support was also provided by the School of Visual and Performing Arts Education, University of Melbourne, through its dean, Graham Reade, and by the School of Studies in Creative Arts, Victorian College of the Arts, University of Melbourne, through its dean, Angela O'Brien.

I wish also to thank Joan Almeida and Leanne Howard of the Education Resource Centre, University of Melbourne, for their help with bibliographical material. The staffs of the libraries of the Museum of Modern Art and Columbia University in New York were most helpful in providing access to their research collections. Vanessa Meckes was the very able research assistant for this project, and I am most grateful for her skill in locating rare documentary sources.

The members of the staff of the Salvador Dalí Museum were enormously helpful throughout the preparation of this volume, and I owe a debt of gratitude to the Museum's Director, T. Marshall Rousseau, for making the institution's resources readily available. I wish to thank him also for the consideration that he showed during my stay in St. Petersburg and for his initiatives on behalf of this project. The Board of Trustees of the Museum deserves special mention for its encouragement of this endeavor. Joan Kropf, Curator of the Salvador Dalí Museum, was a much valued source of guidance and professional advice. Peter Tush, Assistant Curator, provided informed access to the Museum's archives and was generous in offering his own time.

Among scholars and museum professionals outside the Salvador Dalí Museum, I am especially grateful to Dawn Ades of the University of Essex, in England, for recommending my participation in this project. The support and advice of Robert Descharnes, Michael Stout, and of Michael Lloyd, Deputy Director of the National Gallery of Australia, Richard Haese of LaTrobe University, and Erica Davies, Director of the Freud Museum, are also most gratefully acknowledged. James Leggio and Eric Himmel at Harry N. Abrams, Inc., deserve my sincere thanks.

A. Reynolds Morse and Eleanor R. Morse very graciously made themselves available for the interviews essential to the preparation of this volume. Their hospitality and generosity during my visit to St. Petersburg were memorable, and this project would not have been possible without their exemplary support.

K.W.

Salvador Dalí: An Introduction

In many respects, art critics and commentators are right when they express reservations about aspects of the work of Salvador Dalí. Some of Dalí's copious output is indeed uneven in quality or sustained originality; some of it is tainted by overt commercialization; and some of it is undoubtedly bound up with the artist's loquacious self-aggrandizement. These occasional lapses have loomed large for many past commentators, who have tended to relegate his work to the margins of serious art history. However, several important recent publications and a plethora of large international exhibitions have set aside the cult of personality and prompted revaluations of Dalí's contribution to the history of art. As a result, Dalí's place within the Surrealist movement has now been more firmly established, and new scholarship has underscored his originality, technical brilliance, and intellectual vision.

The breadth and quantity of Dalí's lifework evince an assiduous approach to artistic endeavor as well as a sustained creativity. It is worth remembering that in addition to his painting, Dalí was involved with many other kinds of projects, from prints and sculptures to objets d'art, jewelry, and fashion items, from designs for furniture, ceramics, coins, and glass to advertisements. His published works include sixty illustrated books, two diaries, one novel, scores of interviews, many of them recorded, and over a hundred articles and expository texts. In the realm of the performing arts, Dalí made one film and collaborated on eight others as well as completing work on seven ballets, two operas, and three theatrical productions. This diverse artistic and intellectual activity spans a full sixty-seven years of consistent creative effort and amounts to a body of work remarkable in its force and scope. When we examine his oeuvre in all its richness and complexity, the overall impression is of a rare and dedicated artistic application. This brief text cannot do justice to the sweeping range of this life's work, but it can offer a concise overview of the artist's principal accomplishments.

Salvador Dalí (Salvador Felipe Jacinto Dalí i Domènech) was born to Salvador Dalí Cusí and Felipa Domènech Ferrés on May 11, 1904, at the family home in Figueres, Spain. Despite Dalí's later claim to have been named after an elder brother, who had died at the age of twenty-two months in 1903, the fact is that Dalí was given the name Salvador after his father and great-grandfather, while the name Felipe is the male equivalent of his mother's name, and the name Jacinto came from his uncle. Dalí's later ruminations over his name say more about his falling out with his father than about any original intention on the part of his parents. Dalí's father was a local governmental notary, one of five in the area, and was a well-known and respected member of the legal profession; his mother was the daughter of a Barcelona haberdasher. The two met during a holiday in the small town of Cabrils in Spain and were married shortly afterward in Barcelona, on December 29, 1900. They led a comfortable life in Figueres and later in Cadaqués; the young Dalí was cosseted by his nurse Lucia Moncanut and the women of the family, and his talent was recognized and encouraged at an early age.

Figueres is a small, rural town; at the time of Dalí's birth in 1904, its population numbered about thirteen thousand. Located inland within the principality of Catalonia, in the windswept foothills of the Pyrenees, sixteen miles south of the Spanish-French border, the town lies in an area, fed by the Tech and Ter rivers, that is generally known as the Ampordá. The region's history is marked by successive waves of Phoenician, Greek, Roman, and Arab settlers, and it remains infused with Arthurian, Carolingian, and Saracenic legend. This local area, etched into Dalí's mind, is part of the background of his mature works.

Dalí attended the Christian Brothers' Immaculate Conception primary school in Figueres and was taught by Señor Esteban Trayter for four years. As Dalí's diary of 1942 reveals, he was indifferent to these early studies, and, perhaps in compensation, he developed a strong imaginative facility together with, if his later diary is accurate, a remarkable power of visual memory.

Sigmund Freud's *The Interpretation of Dreams* had been published in 1900, and it should come as no surprise that Dalí later would take such an interest in Freudian theory and respond to a climate of opinion and a school of thought that was both timely and of his time. Yet even at this early point, it is useful to note that Dalí's later explorations in psychology were preconditioned by his precocious reading of Voltaire, Nietzsche, Kant, Spinoza, and Descartes. The works of these philosophers, with their interest in the problem of perception and the nature of reality, instilled in the young Dalí an abiding sense of purpose that was never to leave him.

This seemed to be recognized early on, from about the time that Dalí attended secondary school for the six-year state baccalaureate course, in 1916–21, at the Figueres Institute and the Academy of the Marist Order in Figueres. Through his father's social connections, the twelve-year-old Dalí began

to supplement his education by spending his summer holidays with the artistic family of Ramón Pichot at its residence, El Molí de la Torre, on the road to Rosas just outside of Figueres. The Pichot family lived in Barcelona but had property at Figueres and also a summer house at Punt dels Sortel at Cadaqués. Ramón Pichot, a cultivated man and a well-known artist, maintained friendships with Pablo Picasso and André Derain. Pichot was probably the young Dalí's first sustained contact with professional artistic practice. Additionally, Pichot's children were all artistically inclined: Ricard was a cellist and a favored pupil of Pablo Casals's; Luis was a noted concert violinist; María was a famous opera singer; and Mercedes was married to the writer Eduardo Marquina. At Dalí's father's urging, the eldest son, José, became Dalí's much admired preceptor and guide. Added to this, Dalí's uncle Anselmo Domènech, a bibliophile who owned the famous Llibreria Vergaguer bookshop in Barcelona, supplemented the eager young Dalí's growing knowledge with letters, suggested reading, and ready supplies of books.

It was in this expansive, talented company that the young and impressionable Dalí first began to develop the wide reading, diverse cultural pursuits, and broad artistic interests that mark his maturity. His earliest surviving paintings date from this period, and he studied drawing and printmaking with the well-known artist and engraver Juan Nuñez at the Municipal School of Drawing in Figueres. Nuñez was a fine teacher who had attended both the Academy of San Fernando in Madrid and the Spanish Academy in Rome. Under his expert tutelage and encouragement, the thirteen-year-old Dalí soon began to display exceptional talent and was awarded a prize certificate by the Municipal School of Drawing. Some of this youthful talent may be discerned in the sophistication of the early oil painting *View of Cadaqués with Shadow of Mount Pani* of 1917 (page 33). It was probably executed with the set of oils that he received as a gift from the holidaying German artist Siegfrid Burmann, who must have recognized the budding talent of the young boy. Dalí's avid scrutiny of the fifty-two-volume set of the Gowan's series of art books kept in the family home shows through in the accomplished composition. Moreover, this painting is an important harbinger of his later artistic development (see page 32).

His proud father subsequently publicly exhibited Dalí's drawings and juvenilia at the family home in Figueres. In this climate of encouraging attention, Dalí began to write stories and journal entries, probably in response to the inspira-

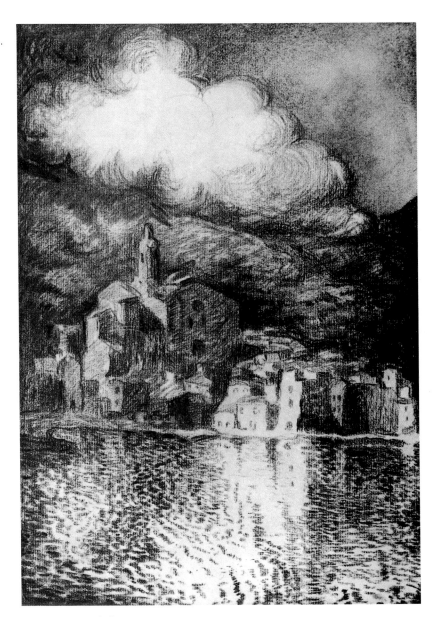

Cadaqués. 1918. Charcoal, 13⅝ x 9" (34.5 x 22.7 cm)

tion of Gabriel Alomar, one of his teachers at the Figueres Institute, who later became a noted writer, politician, and diplomat. Dalí showed two oil paintings in a local art exhibition at Figueres in 1918, and he submitted a drawing for publication in the Catalan magazine *Patufet* the same year. By now, he was taking a greater interest in the art of Cubism, and in 1919 participated in a group exhibition of the Sociedad de Conciertos in Figueres. At this time, the fifteen-year-old Dalí sold two paintings, his first recorded sale of works, to the family friend Joaquim Cusí and received praise in his first critical review, in the local newspaper *Empordià Federal:* "Dalí Domènech, a man who can feel the light . . . is already one of those artists who will cause a great sensation . . . one of those who will produce great pictures. . . . We welcome this new artist and express our belief that at some point in the future our humble words will prove to be prophetic."

Dalí's earlier literary interests manifested themselves actively in 1919, and he collaborated on the student magazine *Studium,* publishing there his first liter-

ary works: a poem, a prose piece, and a number of articles on his most admired artists—Goya, El Greco, Dürer, Leonardo, Michelangelo, and Velázquez. At the age of sixteen, he started a novel entitled *Summer Evenings,* which was never published; two years later, he began another one, *The Tower of Babel,* but it too remained unpublished.

In 1919, he also began to keep a diary, *Impressions and Private Memories,* in which he wrote, "I'll be a genius, and the world will admire me." This surprising claim from a fifteen-year-old tells of early ambition. His confident assertion may be read as indicative of the approach he took to his artistic pursuits: his many works of this time all display technical bravura and restless energy. His small *Port of Cadaqués (Night)* of 1918–19, for example (page 35), brims with

Barracks—Cadaqués. 1923. Pencil, 12¾ x 9" (32.3 x 22.7 cm)

eagerness to experiment with paint; its freely applied surface, found in all the works of this time, shows a grasp of impasto techniques not seen earlier. His many works during this period expertly deploy a variety of views, styles, approaches, techniques, and coloristic effects, which together indicate persistent diligence and a precociously developed seriousness of artistic purpose.

This seriousness of purpose was given a considerable fillip when Dalí was accepted as a student at the Academy of San Fernando, the famous art school in Madrid, where he stayed until 1922. He lived at the Residentia de Estudiantes and it was there that he met such other exceptional students as Federico García Lorca, Luis Buñuel, Pedro Garfias, Eugenio Montes, Rafael Barradas, Maruja Mallo, Moreno Villa, and José Bello. The Residentia de Estudiantes was widely known and respected for its dedicated promotion of the arts: its many guest lecturers included international figures as eminent as Hilaire Belloc, Marie Curie, H. G. Wells, John Maynard Keynes, Albert Einstein, Paul Claudel, Louis Aragon, and José Ortega y Gasset. It was probably at this institution that Dalí first became acquainted with the theories of Sigmund Freud and with some of the writings of the French Surrealists, in translation—especially those of Louis Aragon, Jacques Baron, André Breton, Paul Eluard, Robert Desnos, Benjamin Péret, and Philippe Soupault, all of whom had their works published in Spanish magazines. While a student, Dalí became closely acquainted with the collection of the Prado Museum in Madrid, and through his wide reading and study he became more fully aware of the Cubist works of Picasso, Georges Braque, Juan Gris, and the Metaphysical School paintings of the Italian artists Carlo Carrà, Gino Severini, Giorgio Morandi, and Giorgio de Chirico.

The heady atmosphere of these studies was dissipated for a time by the death of Dalí's mother, from cancer, on February 6, 1921. Dalí later said of his mother, "She adored me with a love so whole and so proud that she could not be wrong," and, as might be expected, her death was difficult for him to accept. He wrote in a diary of 1942: "My mother's death struck me as an affront of destiny—a thing like this could not happen to me—either to her or to me!" In part to "avenge" this personally felt affront, and echoing his earlier private motivations, he avowed a desire to make his name "glorious."

Soon after, much to Dalí's chagrin, his father married Catalina Domènech Ferrés, the sister of his first wife. This perceived impropriety must have rankled, since Dalí never saw fit to mention the marriage in his writings and many inter-

Cubist Study of Figures on a Beach. 1923–25. Ink, 7¾ x 10" (19.7 x 25.3 cm)

views, and always referred to his stepmother as his aunt. It is likely that Dalí's ambivalence toward his father arose at this point.

The emotional tension of this period may be sensed in *Self-Portrait (Figueres)* (page 37)—one of Dalí's earliest and most revealing self-portraits—painted the year of his mother's death. This portrait's frontality and brooding haughtiness convey a direct and unflinching resolve, making an individualistic show of the outward confidence that must have sustained his nervous constitution during this stressful period. Dalí's adoption at this time of an aristocratic manner and elegant dress may, when viewed sympathetically, be seen as similar outward displays, hiding a febrile and tormented soul. Considered this way, Dalí's later exhibitionism and baroque extravagances of manner and action may be seen as attempts to keep at bay an unsympathetic and cruel reality. Little wonder then that Dalí's work changed so dramatically from this point onward.

Fired by a spirit of rebellion, Dalí embarked on a long, personal adventure that was avowedly self-referential. His friend the Spanish poet Rafael Alberti recalled attributes displayed in 1921 that give an indication of Dalí's new energy and ambition:

> Dalí seemed to me in those days timid and taciturn. I was told that he worked all day, sometimes forgetting to eat or arriving in the Refectory when the meal was over. When I went into his room . . . I didn't know where to put my feet: the floor was covered with draw-

ings. Dalí had a formidable vocation, and at that time, in spite of his youth, he was an astonishing draftsman. He drew as he wished, from nature or from his imagination. His line was classical and pure. His perfect stroke . . . already heralded the great Surrealist Dalí, of the first Paris years. With a serious air characteristically Catalan, but hiding a rare humor, which not a feature of his face betrayed, Dalí never failed to explain what was happening in each picture, revealing his incontestable literary talent.

Encouraged by the attention of his peers and by contact with Lorca, Dalí, pursuing his private ambitions, started to paint personally generated works outside the restrictions and requirements of the art-school curriculum. The content of these early works arose from lived experience and reflected familial ties, private urges, and the local environment. At the same time, Dalí was becoming disenchanted with the curriculum of the Academy of San Fernando; it seemed in his mind to pale by comparison with the comprehensive yet personalized tuition that he had received during his formative time with the Pichot family at Figueres, and it seemed at odds with his newfound sense of artistic urgency. And in 1923, Dalí was temporarily suspended by the disciplinary council of the Academy of San Fernando for his part in a student group protest—against the hiring of a purportedly unqualified lecturer in place of the eminent Spanish artist Daniel Vázquez Díaz. Undeterred while on suspension, Dalí continued to paint

Femme Couchée (Nu Allongé). 1926. Pencil, 5 x 5¾" (13 x 14.5 cm)

and attended drawing classes given by Julio Moisés at the Free Academy in Madrid. After this, Dalí returned home to Figueres, met his former teacher Juan Nuñez, and began making some of his earliest prints on the press bought as a gift by his father.

Freud's famous study *The Interpretation of Dreams,* originally published in 1900, was translated into Spanish in 1923; in it, Dalí found a new direction. Until recently, there remained some residual uncertainty among scholars about just how much of Freud's work Dalí had actually read, but he is now definitely known to have read this key text, as his personal annotated copy still exists in a private collection in his hometown of Cadaqués. In Freud's theoretical writings, Dalí found a liberating conceptual framework just at the time when the Surrealist movement was developing in Paris. When one realizes that psychological theory came to Dalí when he was at his most susceptible, it is easy to appreciate why he clutched it so fervently. He immersed himself in it and forever after thought of Freud as the one person to whom he was most indebted—a debt he personally expressed to Freud when he met him in London in 1938. There is little doubt that Freudian concepts—such as free association, dream narration, dream symbolism, condensation, displacement, and sublimation—found fruitful parallels in Dalí's paintings.

The impact of this baptism into theory may be gauged in some of Dalí's later writings. Dalí's two published diaries are almost clinical in their analytical attention to subjective states and personal associations. His first and more remarkable diary, *The Secret Life of Salvador Dalí* of 1942, with its telling title, offers vividly detailed recollections of his childhood. The Freudian overtones of this impassioned text are unmistakable, in the brutal confessional honesty of its treatment of Dalí's youth. The rich vein of thought and the adjectival flow of the writing certainly owe much to the word-association techniques of Freud, and even the actual terms occasionally used—such as "wish fulfillment," "dream symbolism," "representation," "paranoia," and "delirium"—betray an obvious Freudian origin. To this is added a curious overabundance of hyperbole that makes its presence felt in almost every turn of phrase. This exaggerated, even baroque, characteristic was strongly influenced by the effusive writings of the Spanish Gongorists, a literary school, known for its high-flown verbosity, that was familiar to Dalí, as reading these works aloud was a common practice during his evenings at the Pichot family home. Dalí's spirited emulation of their

Rabelaisian style produced writing that mixes a confessional tone with insouciant aristocratic extravagance. Dalí's writings provide insight into his contemporary paintings and bear witness to their parallel sources in ways that are most uncommon and revealing. Painting and writing form a complementary partnership of the imagination and together indicate how Freudian theory conditioned his personal memory—how the rich lode of his recollected childhood experiences was excavated, refined, and artistically transformed.

Dalí had his first solo exhibition, with fifteen paintings, at the age of twenty-one at the Dalmau Gallery in Barcelona in 1925. The famous Spanish poet Josep Vicens Foix wrote an article about it; Picasso visited the exhibition and later publicly praised the work.

Returning to study at the Academy of San Fernando in Madrid after his temporary suspension, Dalí showed ten paintings in a group exhibition at the Salón de la Sociedad de Artistas Ibéricos in Madrid. His studies there came to an abrupt end when Dalí was officially and permanently expelled from the Academy for refusing to be examined in Fine Art Theory. The expulsion was signed by the King of Spain—a not-uncommon formal requirement—and was announced in *La Gaceto* on October 20, 1926. Dismayed but undeterred, Dalí returned to Figueres and worked on more paintings, personally encouraged by the support of Joan Anton Maragall y Noble, the influential Director of the Sala Parés in Barcelona.

Later in 1926, traveling with his stepmother and sister, Dalí visited Brussels and Paris for the first time. In Paris, he was introduced to Picasso by Manuel Angeles Ortiz and showed him two of his recent paintings. He also visited Joan Miró and Luis Buñuel, and Buñuel went on to accompany him to various artistic

attractions, such as the Café de la Rotonde, Jean-François Millet's studio, the Grévin Museum, the Palace of Versailles, and the Louvre.

After his return to Figueres and during the next year, Dalí took his work in several different directions, as though he wished to test the various options open to him. His famous *Basket of Bread* of 1926 (page 43), a meticulous and justly admired painting, is very different from the Cubist structure and composition of his *Femme Couchée* of the same year (page 45). The compass of style demonstrated by these two works in a single eventful year indicates the range of Dalí's experimentation as he attempted to find a style that could serve as a distinguishing hallmark. Melding pictorial Cubism with academic tradition would be a herculean task for any artist, no matter how gifted; for the twenty-two-year-old Dalí, this self-imposed goal, though unachieved, enabled him to test himself against tradition and to silence his many critics with displays of enviable artistic skill.

As Dalí's work progressed, his burgeoning notoriety guaranteed that he would be noticed—which was what he wanted above all. Subsequent works, such as *Apparatus and Hand* of 1927 (page 47), with its uncensored autobiographical references, soon brought him the opportunity to make his name "glorious." His response to the influence of Miró in such works did not go unnoticed, and it was this artist and countryman who, more than anyone, was responsible for Dalí's eventual foray into the art world of Paris. In 1928, Dalí again traveled to Paris, this time to sign his first contract with the Parisian art dealer Camille Goemans. His later works of 1928, such as *The Bather* and *Beigneuse* [*sic*] (pages 49, 51), show an unabashed embrace of Surrealist conventions and compositions. These paintings confirmed the emergence of a major new talent; the way they resonate with relived sensations and images galvanized the interest of the Surrealists in Paris. Suddenly, all of his diverse youthful enthusiasms cohered, and during this important period his subjects and formal concerns

The Bather. 1927. Ink, 9½ x 12½" (24 x 31.5 cm)

were visually reconstituted in ways that presage his later works and signal a continued interest in autobiography and the potential of introspective reverie.

Dalí was soon offered his first solo exhibition in Paris, at the prestigious Goemans gallery in 1929. André Breton, the leader of the Surrealist group, wrote a glowing introduction for the exhibition catalogue and Dalí's fame was assured. Energized by the success of this important exhibition and by his new-found artistic direction, Dalí at the age of twenty-five began a long period of furious, highly productive activity, managing to hold twenty major solo exhibitions in the next sixteen years: nine in New York, seven in Paris, two in London, one in Hollywood, and one in Barcelona. His international reputation grew quickly following this unprecedented year of 1929, a year during which he wrote three publications, worked with Buñuel on the Surrealist film *Un Chien Andalou (An Andalusian Dog),* and was accepted as a member of the Surrealist group in Paris.

Surrealism as a movement in art and literature had been formally constituted and conceptually defined in 1924 by Breton. Soon after, Surrealism, with Breton as its leader, became an energetic activity that, despite its literary origins, promoted a wide-ranging, extraliterary investigation of creative thought and artistic practice. From about 1925 onward, Surrealism supplied many artists of a more courageous, or recalcitrant, bent, such as Salvador Dalí, with a liberating conceptual framework and a creative focus.

The Surrealist movement quickly prospered in Paris and over the next thirty years it developed into a truly international movement. The Surrealists' major journal, *La Révolution Surréaliste (The Surrealist Revolution),* was first published in Paris in 1924, and continued through twelve issues until 1929. Surrealism, and its Freudian-based theory, rapidly insinuated itself into the consciousness of many artists as an intellectual and artistic movement blithely unconcerned with conventional behavior, morality, or old habits of thought. According to Breton, what was needed was an unshackling of thought, a liberation into the possibilities of a Freudian age.

What Surrealism called for, in art as in life, was new, cohesive interaction between the phenomena of the objective, external world and the interior workings of the individual psyche. It denied the authority of the camera's documentary realism as well as the narrative traditions of art and literature. Emboldened by the theories of Freud and the rhetoric of Breton, Surrealists, like Dalí, sought

to upset the comfortable certitudes of bourgeois life, tipping the artistic balance toward the depiction of life as lived in the mind. This poetic emphasis on the internal formed much of the Surrealist program. Recording the unconscious, dreams, trance states, poetic thoughts, memories, evocations, and psychological or psychopathological associations, Surrealism rooted itself firmly in paradox and contradiction rather than in the tradition of mimesis. Surrealism as an international phenomenon in art and literature emerged historically as a foster child of French Symbolism and late Romanticism, and, given the climate of Freudianism in the 1920s and 1930s, it is not surprising that it developed both a popular and an intellectual reputation so quickly. What is surprising, however, is how eagerly Dalí adopted, and adapted, it. Dalí met all the Surrealists and through them, especially René Crevel, was introduced to such future friends and supporters as Coco Chanel, Elsa Schiaparelli, Misia Sert, Princesse Marie-Blanche de Polignac, Comte Etienne de Beaumont, Arturo López-Wilshaw, Prince Mdivani, the Maharajah of Kapurthala, Vicomte de Noailles, and Prince Jean-Louis Faucigny-Lucinge. Dalí relished these prestigious contacts and soon began opportunistically to play to this Parisian high-society group, much to the later growing annoyance of the other Surrealists.

It was also at this time that Dalí met Gala Eluard. Although he had noticed her earlier, Dalí's first encounter with Gala occurred in 1929, when she visited Cadaqués with her husband, the Surrealist poet Paul Eluard, and their daughter Cécile Grindel, together with René Magritte, Georgette Magritte, Buñuel, Goemans, and Yvonne Bernard. Gala Eluard now made a fateful impression on Dalí, and their fifty-three-year relationship commenced. The Russian-born Gala became Dalí's partner, guide, mentor, preceptor, goad, business manager, and impresario. Gala's relationship with Dalí was paradoxical and emotionally problematic; recent scholarship has cast it in an unflattering light and made much of her supposed rapacity and manipulativeness. Nevertheless, the fact remains that Dalí was utterly devoted to her, to the point of adding her name to his signatures from 1931 onward, a very unusual thing in itself, and her sudden death in 1982 certainly accelerated his own decline in health.

In 1930, Dalí wrote and illustrated *La Femme Visible (The Visible Woman)* and dedicated it to Gala. This early text introduced the original outline of his pivotal, and later celebrated, "paranoiac-critical method." This much discussed, but little defined, methodological approach was indebted to the Surrealist con-

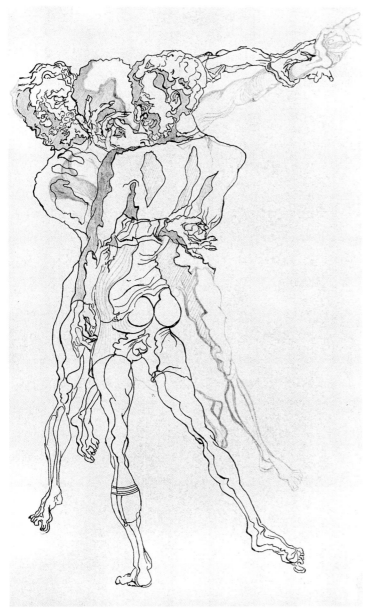

Figures after William Tell. 1932. Red and black ink,
10 x 5¾" (25.2 x 14.5 cm)

cept of "pure psychic automatism" as propounded and developed in Breton's
Manifesto of Surrealism in 1924. In that important document, Breton gave his
famous all-encompassing definition of Surrealism:

> SURREALISM, noun, masculine. Psychic automatism in its pure state, by
> which one proposes to express—verbally, by means of the written word,
> or in any other manner—the actual functioning of thought. Dictated by
> thought, in the absence of any control by reason, exempt from any aes-
> thetic or moral concern. ENCYCLOPEDIA, *Philosophy:* Surrealism is based
> upon the belief in the superior reality of certain forms of previously
> neglected associations, in the omnipotence of dream, in the disinterest-
> ed play of thought. It tends to ruin, once and for all, all other psychic
> mechanisms and to substitute itself for them in solving all the principal
> problems of life.

With its grandiloquently expressed conflation of influences, aims, injunc-
tions, and antecedents, Surrealism seemed well suited to Dalí's natural talents
and freewheeling imagination. Before we can place the works of Dalí in relation
to this new school of artistic thought, we must appreciate the instrumental
force of the theory of automatism, among the most important theoretical con-
structs in twentieth-century art. Automatism as a Surrealist concept encom-
passed a cluster of literary and pictorial techniques involving aspects of
spiritism, word association, hypnotism, automatic writing, chance, reverie, and
dream analysis—all intended to record directly the free flow of thought. Its pro-
ponents sought to make creative use of the work of the psychologists Jean
Charcot, Pierre Janet, and Freud.

Automatism promised, through what Breton called "a vertiginous descent
into ourselves," an insight into the dark world of the Freudian unconscious—a
world of the unknown within. It provided access to a universe of unrecognized
and liberating possibilities that lay beyond the grasp of reason. The Surrealists,
Dalí prominent among them, turned to automatism in order to articulate subjec-
tive experiences that could not be fully expressed in preexisting modes of pic-
torial generation. It led to the discovery of new forms and new imagery, and it
helped artists to free themselves from the perceived restrictions of established
aesthetic tradition.

In addition, automatism was employed by various individual artists to
induce a sort of *furor poeticus,* a visionary fever, releasing a level of the uncon-
scious that had not yet been articulated. Generally, however, Surrealist experi-
mentations with automatism may also be described in more conventional terms
as serious attempts to resolve the many paradoxical conflicts implicit in the mak-
ing of art, such as the conflict between form and content, between freedom
and control, between rationality and irrationality, and between appearance and
reality. Straddling those oppositions, the Surrealist artist dared to pursue as the
ultimate aim of art the resolution of opposites into a unified identity. Disdainful
of public opinion, Surrealist art was born of the private image conceived in the
mind, a mental image arising out of Breton's "pure psychic automatism." Broadly,
Surrealism was an attempt to stabilize, to hold and artistically fix, the inherent
flux of this psychological process. It was an art that sought to establish reality
as well as portray it—an art produced not as symptom but as revelation.

Study for Conic Anamorphosis. 1933. Pencil, 9½ x 7" (24 x 17.7 cm)

For Dalí, such spontaneous mental images provided "guideposts to the mind," disclosing a region "wherein its desires are made manifest." To him the external world was "a forest of signs," in Breton's phrase, a world where disparate objects and ideas form a network of significance in the mind of the viewer as they do in dreams, and where every image, as Freud maintained, was potentially meaningful. The artist was therefore, Max Ernst later explained, "a mere spectator at the birth of his work," and "just as the poet has to write down what is being thought—voiced—inside him, so the painter has to limn and give objective form to what is visible inside him."

Dalí found these ideas galvanizing. Encouraged by them, he developed what he described as "a spontaneous method of irrational associations based upon the critical-interpretative association of delirious phenomena." This method, furthered by his readings of the psychologists Emil Kraepelin and Eugen Bleuler, introduced a more active alternative to the passive techniques of the early Surrealists, with their reliance upon reverie, chance, and "pure psychic automatism." Instead, Dalí stressed the process of willed, sometimes willful, searching: the artist was to comb the external world for magical coincidences that held personal meaning.

His method thus participated in the Surrealist quest for images that were as revelatory as they were unsuspected—for sparks of insight that would throw light back onto the perceiver even as they subverted the operation of logic. The artist or poet sought the kind of startling juxtaposition seen in the Comte de Lautréamont's famous comparison, "As beautiful as the chance encounter between a sewing machine and an umbrella upon a dissecting table." "Let us not mince words," Breton said in the *Manifesto of Surrealism;* "the marvelous is always beautiful; in fact, only the marvelous is beautiful." The quality of the "marvelous," Dalí averred, must be discovered in the everyday, the discarded, the coincidental, and the unnoticed.

All this Dalí managed to combine in his "paranoiac-critical method," a way of working that made use of personal associations that were almost hallucinatory in character. These nonrational associations were often based on childhood memories spontaneously rising up or on seemingly mundane objects or events that suddenly provoked a psychological discovery. Such associations were subjected to a scrutiny that was both "paranoiac" and "critical"—essentially a process of interrogating the artist's obsessions and elaborating on them in works of art.

In this scheme of correspondences, the external world was a complex web of significances—Breton's "forest of signs"—which, seen through the eye of Dalí's fervid imagination, generated a discontinuous and illogical narrative. The experimental nature of all this, and Dalí's prudent addition of the word *critical* to his definition of the method, save both him and it from charges of mere insanity. In fact, his artistic activity was, so to speak, only *semi*-paranoiac; it was selective and conscious, rather than unconscious. Thus considered, Dalí's famous statement, "The only difference between myself and a madman is that I am not mad," seems not only witty but perfectly sane.

Therefore, paintings such as *The Average Bureaucrat, Shades of Night Descending, Au Bord de la Mer,* and *Memory of the Child-Woman* of the early 1930s (pages 61, 63, 65, and 67) should be seen as presenting psychological insights drawn from the artist's emotional life in ways that would have been inconceivable before the development of Surrealism. Firmly based on Freudian method, they are impelled by Dalí's new enthusiasm for the Surrealist message. These particular paintings stand as pictorial metaphors for Dalí's own complex, emotionally ambivalent state at the time; the role played by Gala Eluard is promi-

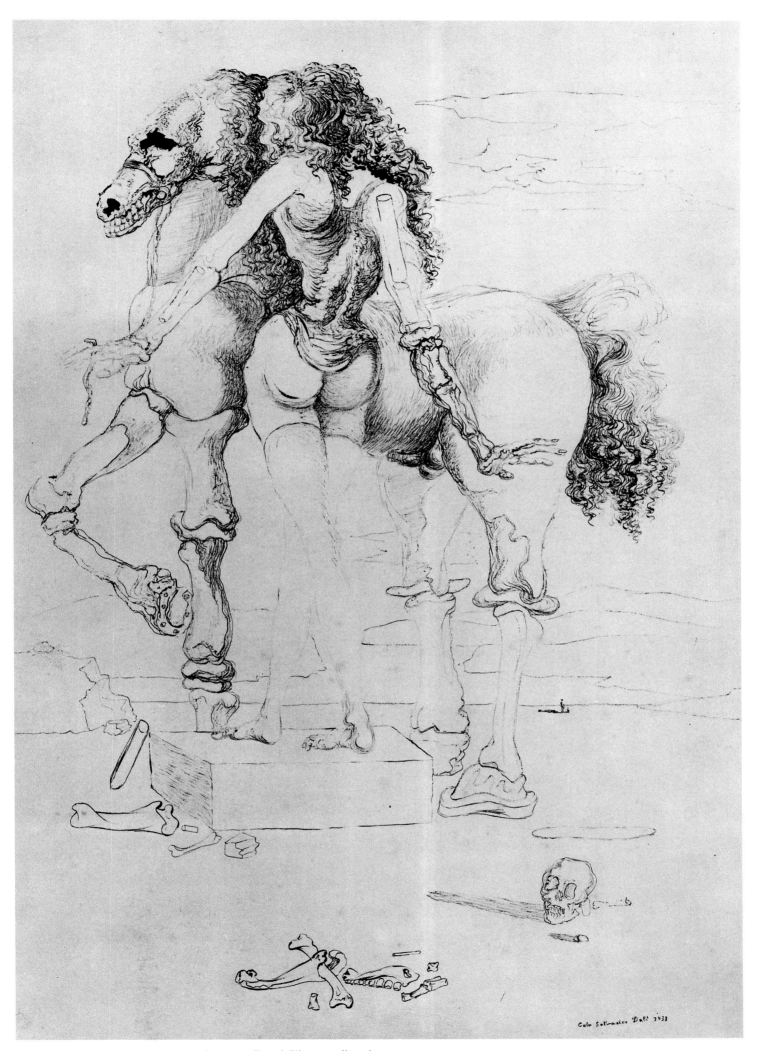

Femme—Cheval (Woman—Horse). 1933. Ink, 20¾ x 14⅝" (52.5 x 37 cm)

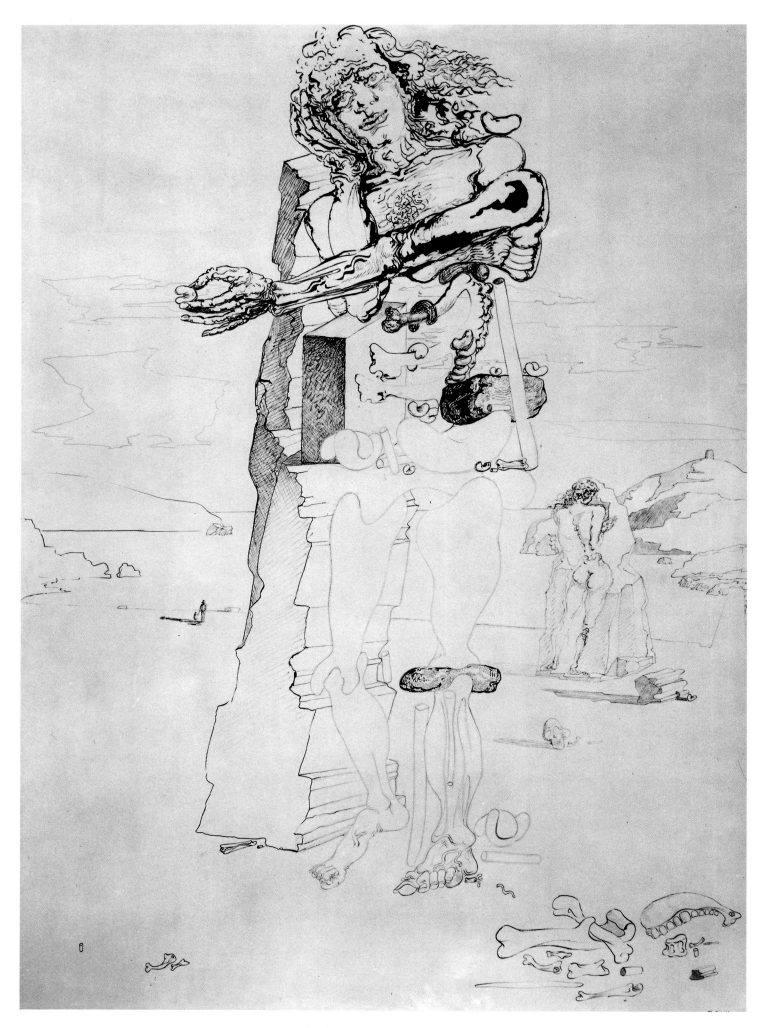

Surrealist Figure in Landscape of Port Lligat.
1933. Ink, 42 x 30" (106.5 x 76 cm)

nent, and his tense relationship with his father weaves its way through the paintings like an ominous Oedipal thread. These works, painted at a time when Gala Eluard was seriously ill and underwent surgery, are invested with Dalí's psychological anxieties in an especially urgent way. Heavy shadows, recalling the paintings of Giorgio de Chirico, lend an air of solemnity to these brooding, uneasy scenes.

Much of this heavy atmosphere lifted in 1933 with the formation of the Zodiac group, at the suggestion of Gala Eluard and with the assistance of Prince Jean-Louis de Faucigny-Lucinge. In this group of twelve patrons, each was allowed one month per year, chosen by lottery, in which to pick out Dalí works—one large painting and one small one—for their own collections. Later modified, the group originally consisted of Caresse Crosby, Emilio Terry, Anne Green, Julian Green, Marquise Cuevas de Vera, André Durst, Countess Pecci-Blunt, René Laporte, Prince Faucigny-Lucinge, Félix Rolo, Robert de Saint-Jean, and Vicomte de Noailles. This fortunate patronage arrangement, which continued until the outbreak of World War II in 1939, did much to promote Dalí's art and alleviate his financial difficulties. His relief may be sensed in *Sugar Sphinx* and *Portrait of Gala* of 1933 (pages 69, 71), intimate tributes to Gala Eluard, whom he would marry in a civil ceremony in Paris early in 1934.

During that year, Dalí visited America for the first time, traveling to New York at the instigation of Caresse Crosby, his earliest American patron, with the assistance of Picasso, who donated part of the travel cost. He managed to hold five solo exhibitions during this momentous year—two in Paris, two in New York, one in London—and as a result of his increasing notoriety was featured in the Hall of Fame section of the American magazine *Vanity Fair.* But the same year witnessed his formal expulsion from the Surrealist group in Paris, mainly for political reasons, reflecting residual resentments going back to 1930 as well as controversies over his recent paintings.

Perhaps inured to expulsions after his art-school experiences, Dalí worked on unperturbed and won the support and patronage of the wealthy English collector Edward James, entering into an important contractual arrangement to produce artworks for him, which continued until the war. In 1935, Dalí published his book *The Conquest of the Irrational,* where he gave a fuller account of his theories and methods. The "paranoiac-critical method" enunciated there and in various lectures gave rise to a new group of works at this time. Most typical of these is his painting *Archaeological Reminiscence of Millet's "Angelus,"* completed in 1935 (page 79). In this canvas, Dalí pursued his long fascination with *The Angelus,* the painting by the French artist Jean-François Millet. That popular nineteenth-century painting became for him a metaphor of the battle of the sexes, here stated in entomological terms: the central figures were now understood to be posed in the stances of praying mantises—one of the insect species whose mating ends with the destruction of the male. Dalí's way of dealing with his fear of female sexuality through the medium of this painting is the epitome of his "paranoia-critical method." This whole fascinating drama engendered by the painting is given full scope in Dalí's book *The Tragic Myth of Millet's "Angelus": Paranoiac-Critical Interpretation and the Myth of William Tell,* which was originally written about 1933, lost during World War II, and not published until 1963.

In 1936, Dalí participated in the International Surrealist Exhibition in London and at the opening ceremony gave a notorious lecture, entitled "Paranoia, the Pre-Raphaelites, Harpo Marx, and Phantoms," which he delivered in a deep-sea diving suit. He met the exhibition organizer, the collector Sir Roland Penrose, and was introduced to the English Surrealists as well as to Sir Herbert Read, Cecil Beaton, Lord Berners, and Peter Watson.

Shortly after their return to Spain, Dalí and Gala were forced by the outbreak of the Spanish Civil War to leave for Paris. After their departure, Dalí's family home in Cadaqués was bombed and damaged, and his own home at Port Lligat was ransacked and destroyed. The human toll was even greater: Federico García Lorca, Dalí's friend of fifteen years, was captured by the fascists and executed; Dalí's sister Ana María was imprisoned and tortured, events that left her traumatized for many years. In 1937, fearing the worst, Dalí and Gala left Paris and visited Italy for an extended period. Avoiding the obvious dangers, they went to various locations in Italy to stay with Edward James, Lord Berners, and Coco Chanel. Dalí seemed to suffer some form of delayed nervous exhaustion, which necessitated a period of rest at the Tre Croci in Cortina. After he recuperated, he began to take a new interest in the art of the Italian Renaissance and the Baroque together with the architecture of Andrea Palladio and Donato Bramante. He also began to collaborate with the Marx Brothers on the scenario of a film, *Giraffes on Horseback Salad,* which was never produced. For the magazines *Vogue, Harper's Bazaar, Town and Country,* and *Flair,* he produced

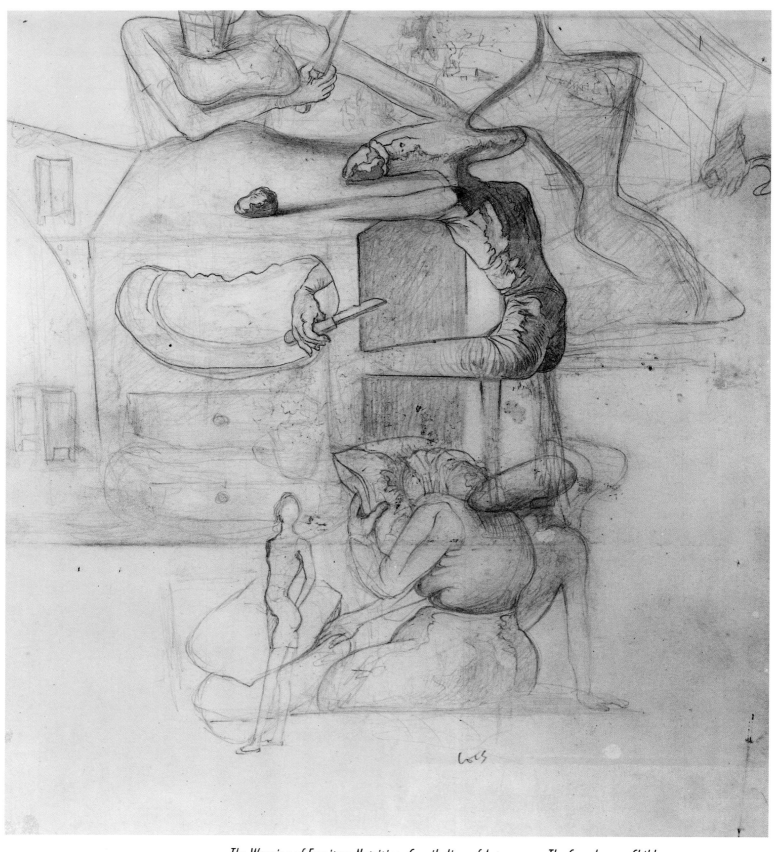

Studies for **The Weaning of Furniture Nutrition, Cannibalism of Autumn,** *and* **The Grasshopper Child.**
1933. Pencil, 9 x 8" (22.7 x 20.2 cm)

Study for the Figure of the Nurse in
The Weaning of Furniture Nutrition.
1933. Pencil, 9 x 8" (22.7 x 20.2 cm)

designs, illustrations, and advertisements as popularized extensions of his more serious Surrealist works, and he designed various fashion items for Schiaparelli.

Accompanied by Gala, Stefan Zweig, and Edward James, on July 19, 1938, Dalí met Sigmund Freud, who had recently emigrated from Vienna and was living in Hampstead, a suburb of London. In writing to Freud to confirm the arrangements for this meeting, Zweig confided:

> You know how carefully I have always refrained from introducing people to you. Tomorrow, however, there will be an exception. Salvador Dalí, in my opinion (strange as many of his works may appear), is the only painter of genius of our epoch, and the only one who will survive, a fanatic of his conviction, and the most faithful and most grateful disciple of your ideas among the artists. For years it has been the desire of this real genius to meet you. He says that he owes more in his art to you than to anyone else. And so we are coming tomorrow to see you, he and his wife.

Dalí was elated by the meeting, but Freud remained relatively indifferent to his art and theories, and very little has been written about this event. In part this may be because Freud, who had suffered from cancer of the jaw for the previous seventeen years, died only a year later. It is also worth noting that Freud had met with Breton in Vienna in 1921, at the instigation of his friend Théodore Fraenkel, and from the tone of Breton's later remarks in his correspondence, it seems that there was little personal warmth between them. It may be that at the time of his meeting with Dalí, Freud still had deep reservations, dating from his encounter with Breton, about the artists who so ardently adopted him as their patron saint.

Dalí visited New York in 1939. After designing a window display for the Bonwit Teller store, Dalí aroused controversy when, discovering that the store's management had altered the display without consulting him, he went into the

Homage to the "Angelus" of Millet.
1934. Ink, 7¼ x 4¼" (18.3 x 10.7 cm)

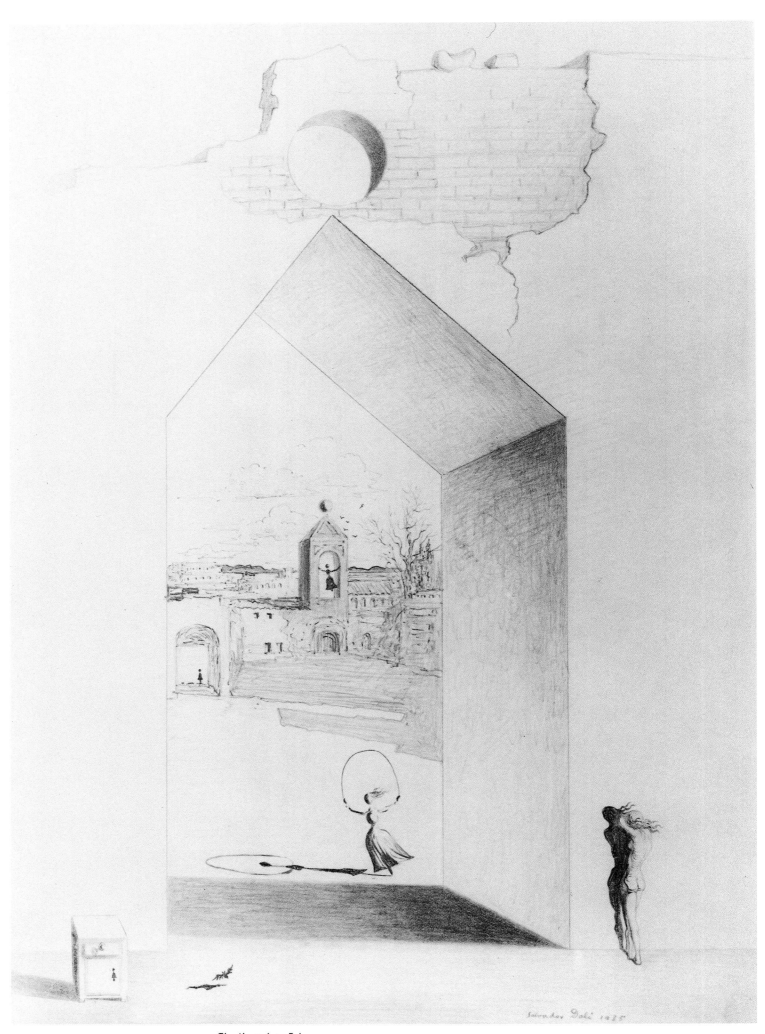

The Nostalgic Echo (frontispiece for Paul Eluard's Nuits Partagées).
1935. Pencil, 11½ x 8¼" (29 x 21 cm)

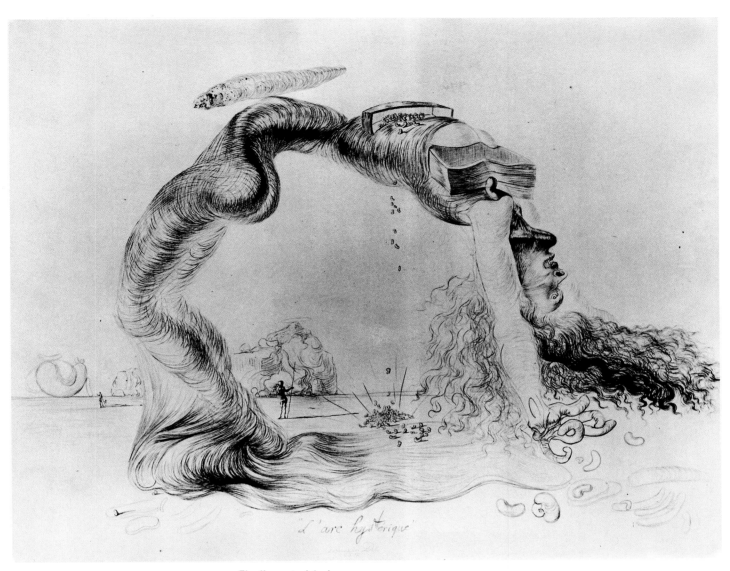

The Hysterical Arch. 1937. Ink, 22 x 30" (55.7 x 76 cm)

display to take it down and broke the glass; he was arrested and made an appearance in court. He also worked on *Dream of Venus,* his "panorama of the unconscious" proposed for the New York World's Fair, and considerable contention ensued over his contract. In defense, Dalí wrote his "Declaration of the Independence of the Imagination and the Rights of Man to His Own Madness," which asserted artists' freedom of imagination.

Dalí and Gala returned to France and stayed in the Grand Hôtel at Font Romeu before continuing on to Paris. When World War II broke out and living in Paris became hazardous, they returned to Font Romeu and then moved to the Villa Flamberge at Arcachon, north of Bordeaux. There they were joined by other artist refugees, such as Marcel Duchamp, Leonor Fini, and the fashion designer Coco Chanel. Dalí and Gala, among many others, were soon forced to flee the area because of the Nazi invasion of France; though they were lucky enough to escape, much of Dalí's recent work was lost or destroyed. A new, dark intensity came to pervade his paintings at about this time, as can be seen in *Telephone in a Dish with Three Grilled Sardines at the End of September* of 1939 (page 87) and in *Daddy Longlegs of the Evening—Hope!* and *Old Age, Adolescence,*

Infancy (The Three Ages) of 1940 (pages 91, 93). These works, primarily suggested by external events—the war and its attendant disasters—evoke an atmosphere of tragedy and psychological confusion; they are perhaps Dalí's most grave and melancholic images.

In 1940, Dalí left France for Madrid to arrange a travel visa while Gala went to Lisbon to buy ship passage to the United States with money donated by their friends, Picasso among them. In Madrid, Dalí sought out his friends Eugenio Montes, Eugenio d'Ors, Dyonisio Ruidejo, and Raphael Sanchez Moros. During this trip, Dalí also visited his family home in Cadaqués, saw his father and sister, and went to his own now devastated home at Port Lligat, where he was shocked by the aftermath of the Spanish Civil War. Eager to meet Gala, Dalí, who had a confirmed fear of flying, took his first plane trip, in the company of Montes, from Madrid to Lisbon. Dalí and Gala then sailed from Lisbon to New York, beginning an extended stay of eight years.

At the age of thirty-seven, in 1941, Dalí was given his first museum retrospective, by the Museum of Modern Art in New York, which included fifty paintings, seventeen drawings, and six items of jewelry. This large and popular

exhibition traveled to eight cities in America. During the year, Dalí was featured in *Life* magazine, and his successes and notoriety continued to irk the Surrealists; Breton was moved to publish his criticism in "Artistic Genesis and Perspective of Surrealism" in Paris and to devise an anagram for Salvador Dalí: Avida Dollars ("Eager for Dollars"). It was also at this time that Dalí met Jorge de Piedrablanca de Guana, the Marquis Georges de Cuevas, the Spanish patron and collector, in New York, and completed his only published novel, *Hidden Faces,* at the collector's home in New Hampshire. The publication of this novel brought Dalí to the attention of a number of respected writers: George Orwell published an essay, "The Benefit of Clergy: Some Notes on Salvador Dalí," on Dalí's art and writings; the English essayist Cyril Connolly wrote on Dalí and film in *The Unquiet Grave;* and the American literary critic Edmund Wilson published his critique "Salvador Dalí as a Novelist."

Study for
The Madonna of Port Lligat.
1950. Ink with sanguine wash,
18⅞ x 12⅜" (48.3 x 13.3 cm)

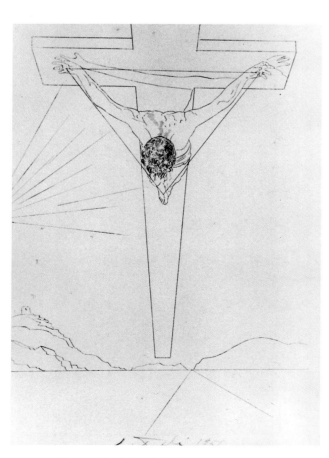

Christ of St. John of the Cross. *1950. Etching,*
7¾ x 5¾" (19.5 x 14.5 cm)

During a period spent in California, Dalí became interested in the theories of proportion of the fifteenth-century monk Luca Pacioli, the work of the Renaissance writer Cennino Cennini, and the contemporary research of the Romanian mathematician Matila Ghyka, then Professor of Aesthetics at the University of Southern California; some of these interests would continue to inform his work from this time on. He also became fascinated by the development of nuclear science after the explosion of the atomic bomb in 1945. He nonetheless still found time to work on popular American movies, most notably Alfred Hitchcock's *Spellbound,* Walt Disney's *Destino* (abandoned), and Vincente Minnelli's *Father of the Bride.*

Flushed with international fame and recent financial success in America, Dalí and Gala returned to Spain and their home at Port Lligat in 1948. A truce was effected with Dalí's father and with his sister Ana María. Shortly thereafter, Dalí published *Fifty Secrets of Magic Craftsmanship.* He then traveled to Rome to work with Luchino Visconti on a production of Shakespeare's *As You Like It.* His theater work continued in Madrid, where he designed the sets and costumes for the play *Don Juan Tenorio* by José Zorilla, and in London, at the Royal Opera House, Covent Garden, with designs for Peter Brook's production of Richard Strauss's *Salome.*

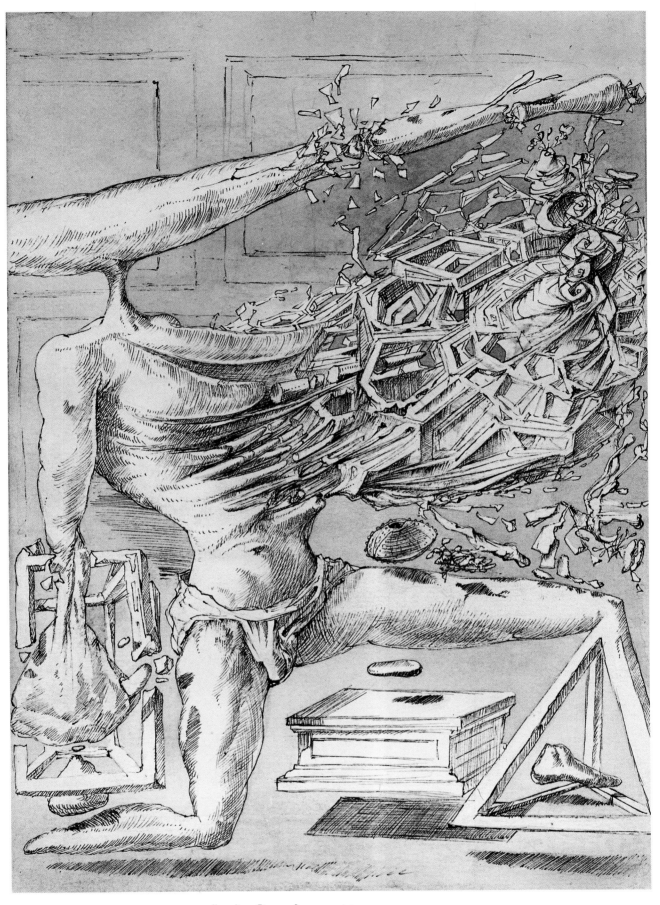

Kneeling Figure: Decomposition. 1951. Ink with wash.
$9\frac{1}{2} \times 6\frac{3}{4}"$ *(24 x 17 cm)*

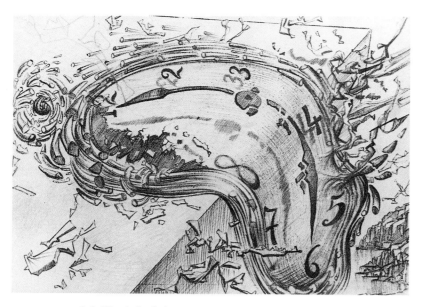

Soft Watch Exploding. 1954. Ink, 5½ x 7½" (14 x 19 cm)

In 1949, Dalí obtained the first of his two audiences with Pope Pius XII in Rome, and during this period he began to make greater use of religious iconography. The reasons for this dramatic turn are not fully clear, but the death of his father in September 1950 and Dalí's admiration of the popular, though controversial, writings of the Jesuit theologian Pierre Teilhard de Chardin may have been factors. Whatever the cause, his mind turned to cosmic matters, and from this time on, most of his works were tinged with a new spirit. It was a spirit which enabled him to return to his earlier interest in the art of Velázquez, Vermeer, and Zurbarán and to demonstrate his undeniable technical skills, including his draftsmanship. Dalí's masterly drawing *Christ in Perspective* of 1950 (page 99), related to his famous *Christ of St. John of the Cross* of 1951 (St. Mungo Museum of Religious Life, Glasgow), shows an aspect of his ability not fully explored since 1926 in his small masterpiece *The Basket of Bread* (page 43). During the same period, Dalí further developed his interest in atomic science and wrote articles on what he called "nuclear mysticism," which may be characterized as attempts to fuse recent scientific findings with a pantheistic cosmology. In articles such as "Mystical Manifesto" of 1951, "Anti-Matter Manifesto" of 1958, and "Ten Recipes for Immortality" of 1973 the theories of Freud were eclipsed by those of the physicist Werner Heisenberg. Technologically motivated paintings like *Nature Morte Vivante (Still Life—Fast Moving)* of 1956 (page 103) and *Galacidalacidesoxiribunucleicacid [sic] (Homage to Crick and Watson)* of 1962–63 (page 109), with their amalgamations of spiritual insight and scientific theory, propelled his work beyond the more personal and introspective modes of the past. Such paintings divined a new alchemy in natural laws and the composition of matter. Yet these works avoided the apocalyptic imagery often found with his contemporaries, proposing instead a more socially and politically removed and optimistic iconography. Dalí imagined the world as being held together by a mysterious order, a ubiquitous symmetry, that only scientific thought and, by implication, his "paranoiac-critical method"

could convey. His earlier interest in the theories of proportion of Luca Pacioli and the aesthetic ideas of Matila Ghyka also inform the compositional structure of the works from this period. The discovery of the DNA double helix by Francis Crick and James Watson in 1953 confirmed his intuition of a hidden order, encouraging his belief in the transformational power of "nuclear mysticism"—that is, in what he called "the vision of matter constantly in the process of dematerialization, of disintegration, thus showing the spirituality of all substance."

As if to encompass these grand thoughts, Dalí now embarked on a series of paintings that were epic in scale and operatic in ambition. These large paintings seemed to be motivated by a desire to match such admired historical antecedents as the Spanish artists Murillo, Velázquez, and Zurbarán and thereby to secure his place in the art of the century. Consequently, they show Dalí at his most encyclopedic and impressive. A bold return to traditional, even academic modes of depiction, these paintings, with their personal elaboration of philosophical and theological insights, accompany the new halcyon period that was inaugurated by the remarriage of Dalí and Gala in a religious ceremony at La Capella de la Mare de Deu dels Angels, near Gerona, Spain, on August 8, 1958. The most prominent of these new works, made over the next twenty years, are *The Discovery of America by Christopher Columbus* of 1958, *The Ecumenical Council* of 1960, *Galacidalacidesoxiribunucleicacid [sic] (Homage to Crick and Watson)* of 1962–63, and *The Hallucinogenic Toreador* of 1969–70 (pages 105, 107, 109, and 111).

A large commissioned painting, *The Discovery of America by Christopher Columbus* ostensibly centers on the historical discovery of America but contains as well elements of patriotic pride and oblique references to creative endeavor, to European culture, and to Gala as a personal Mediatrix. The whole painting, patterned after Velázquez, reflects Dalí's reading of the historian Luis Ulloa and is infused with aspects of Catalonian tradition. Some of this may also be sensed in *The Ecumenical Council,* with its Baroque effulgence, inspired by the ecumenical hopes associated with the important meeting between Pope John XXIII and Geoffrey F. Fisher, Archbishop of Canterbury, in 1960—the first such encounter in 426 years—and with the planning for the Second Vatican Council of 1962. In like manner, *Galacidalacidesoxiribunucleicacid [sic] (Homage to Crick and Watson)* was prompted by contemporary events; in this case floods in

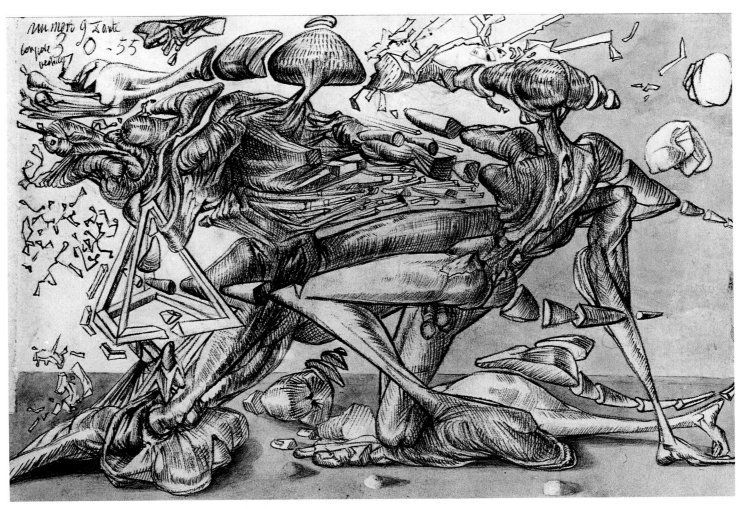

Combat. 1955. Ink with wash. 6³⁄₈ x 9³⁄₄" (16.2 x 24.8 cm)

Barcelona, civil unrest in the Middle East, and the discovery in 1953 of the molecular structure of DNA. These three disparate occurrences prompted a pictorial meditation on biological, theological, and natural phenomena that was much influenced by Teilhard de Chardin. The last of these four epic paintings, *The Hallucinogenic Toreador,* lacks direct theological implications, and may be viewed as a visual compendium of Dalí's work to date. The painting's content arose from Dalí's response to a reproduction of the Venus de Milo, which evoked his own "remembrance of things past." The resultant pictorial autobiography tabulates associations and sensations in a way that is almost Mannerist in its whirling suggestions.

From about 1975, Dalí slowly began to show signs of ill health. The symptoms of Parkinson's disease increasingly interfered with his work, and in 1978 he entered Dr. Antonio Puigvert's clinic in Barcelona for prostate surgery. By 1979, he was seriously ill, and his condition was exacerbated by a viral infection contracted in New York; upon his return to Spain, his health suffered a steep decline. Shortly after he was placed in the care of Dr. Puigvert, Dr. Joan Obiols, and Dr. Manuel Subirana, Dalí's health improved for a time, and he went to his home in Port Lligat and was visited there in 1981 by His Majesty King Juan Carlos, and Her Majesty Queen Sofía of Spain. This respite was brief, and Dalí was soon forced to travel to Paris for treatment of Parkinson's disease. From his hospital bed, Dalí issued a press statement to clear the air of rumors about his

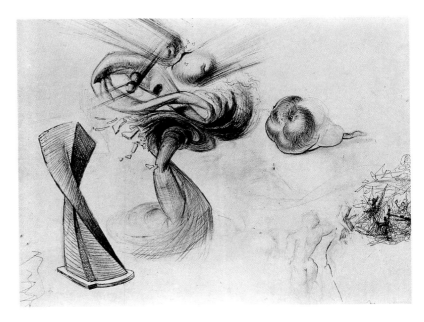

Compote and Fruit (Study for Nature Morte Vivante*). 1956.
Pencil.* 16¹⁄₄ x 21¹⁄₂" (41 x 53.2 cm)

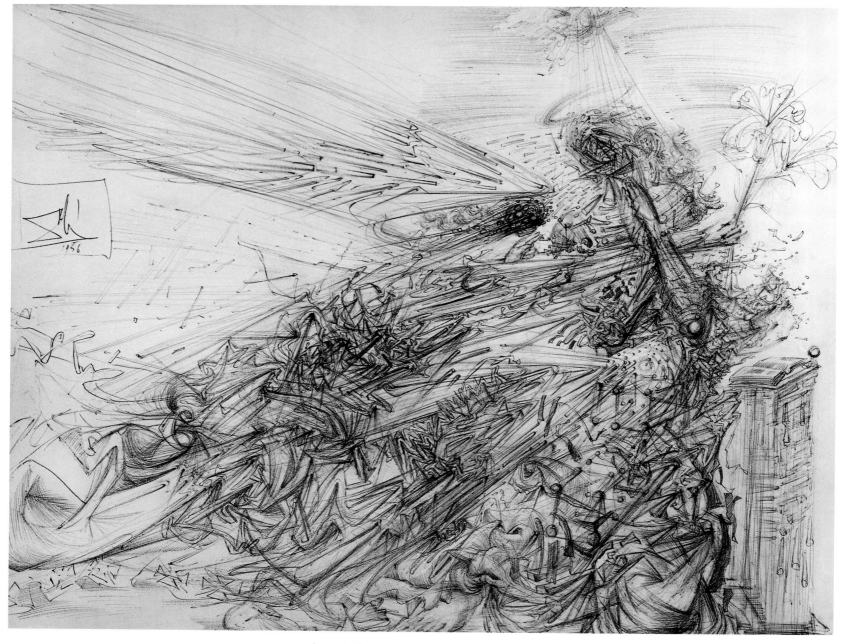

Annunciation. 1956. Ink. 17 x 22" (43 x 55.7 cm)

well-being; in it he also publicly expressed disappointment at the forgery and misuse of his work, saying, "I declare that for several years, and above all since my sickness, my confidence has been abused in many ways and my wishes have not been respected."

In 1982, Gala died suddenly and unexpectedly at Port Lligat and was buried at Pubol Castle, near Gerona. Devastated by the loss of his partner of fifty-three years, Dalí became inconsolable and went into self-imposed exile in Pubol Castle—the castle that he had presented to his wife thirteen years earlier as a gift. He began to shun friends and visitors and redrafted his last will and testament. After suffering serious burns in an accidental fire at the castle, he was hospitalized and, at the age of eighty, underwent a number of delicate skin-graft operations. Dalí appeared on television in 1985 to announce his donation of a substantial body of his works to the Teatro-Museo Dalí in Figueres, Spain. One year later, he consented to the implantation of a pacemaker to correct cardiac

problems. Helmut Newton's photographs taken during his convalescence show him proudly wearing the Grand Cross of Isabella the Catholic and still displaying some gleam of the resoluteness seen in his youthful self-portrait of 1921. With the further deterioration in his health in 1988, Dalí moved into a private room in the Torre Galatea, next to the Teatro-Museo Dalí. He died on January 23, 1989, at the age of eighty-five. His body lay in state for one week at the Teatro-Museo Dalí, and the town of Figueres, by decision of its Council, observed three days of public mourning. He was buried at the Teatro-Museo Dalí.

Dalí's will left his "goods, rights and artistic creations to the Spanish state, with the fervent assignment to conserve, popularize and protect his works of art." Jorge Semprún, Minister for Culture, announced in 1990 that Dalí's collection of one hundred ninety paintings was to be divided, with fifty-six works going to the Museo Nacional Centro de Arte Reina Sofía in Madrid and one hundred thirty-four to the Teatro-Museo Dalí in Figueres.

◆ ◆ ◆

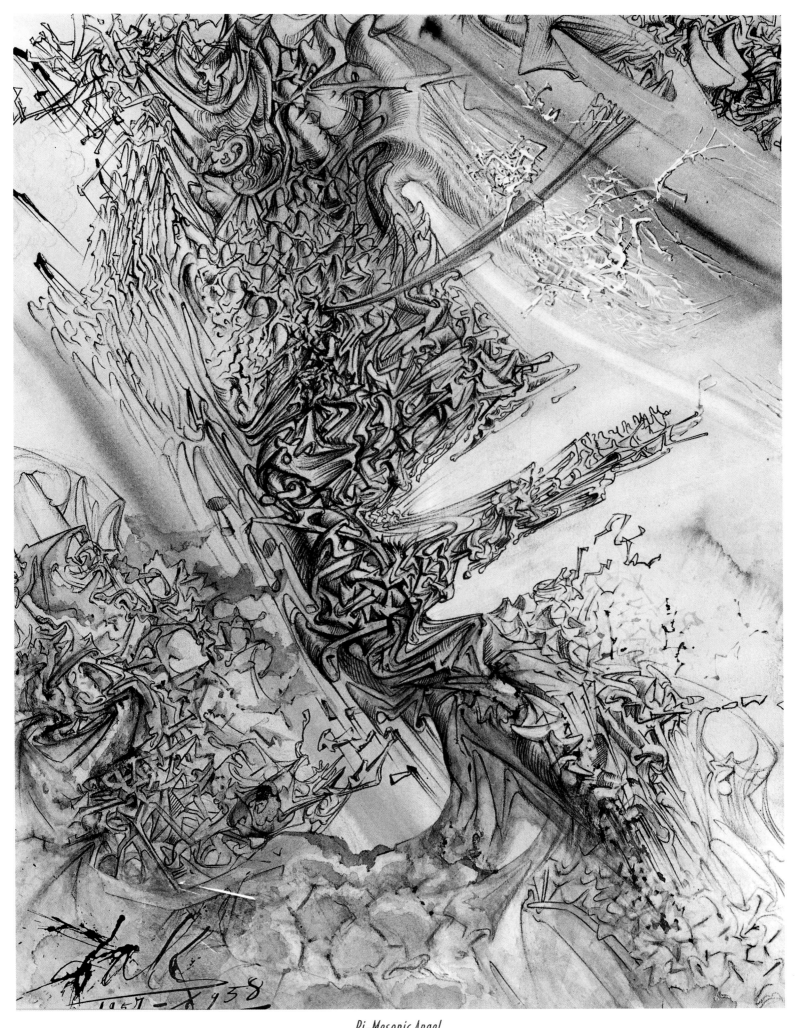

Pi-Mesonic Angel.

1958. Ink and pencil with gouache, 16 x 12" (40.5 x 30.4 cm)

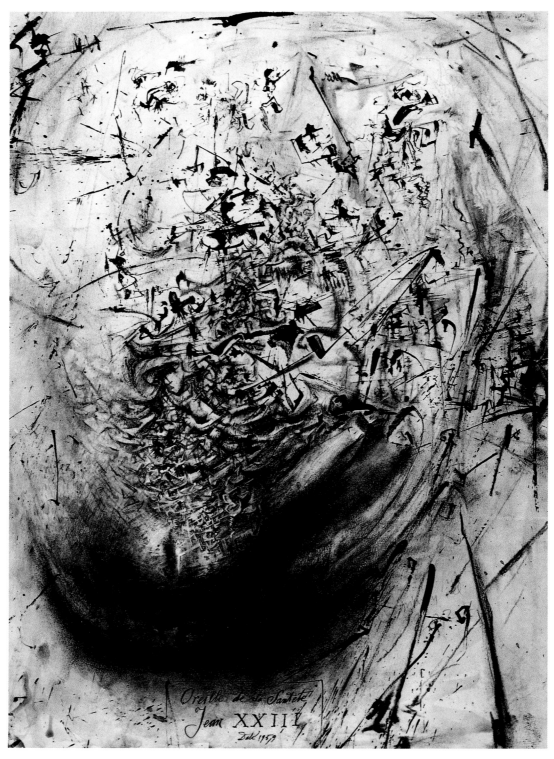

The Ear of His Holiness Pope John XXIII.
1959. Ink with pencil and gouache, 21⅛ x 14¾" (53.5 x 37.3 cm)

From this brief outline of Dalí's eventful life and perplexing thought, it is clear that the personal adventure he ardently pursued all his mature life was consistently predicated on Surrealist ideas. Through activities both remarkable and exemplary, he created a unique self out of the obdurate matter of existence.

To the popular mind, Dalí epitomizes Surrealism, no mean feat in itself; to the scholar, he exemplifies an aesthetic reach that is historically rare. Both of these perceptions may be partly explained by the fact that Dalí's paintings, with their "realistic" images and paradoxical content, seem to mimic the strange process of dreaming, where bright details mix with elusive yet portentous meaning. Since we all dream, we are all drawn to share vicariously in the intrigue of Dalí's works and their oblique meanings. The Surrealists always sought to uncover the "marvelous" in the external world. In the many works of Dalí, this quality of the marvelous reminds us of the wonder of things, the mysteries of being, and of how complex are the mental threads that make up human identity.

Colorplates

View of Cadaqués with Shadow of Mount Pani

1917. Oil on burlap, 15½ x 19" (39.3 x 48.2 cm). Signed and dated lower left: "S. Dalí / 1917"

This painting by the young Dalí shows a sophistication remarkable in a child of thirteen. Photographs of this actual view reveal that the painting is not merely a copy of the scene, as might have been expected with a juvenile effort; instead, Dalí produced a work that is more a rendition than a record. Since it is unlikely that he was aware, at this age, of the concept of artistic license, the work's imaginative freedom may therefore be seen as the result of precocious talent. Perhaps it was this sense of focused ability that Dalí's father had in mind when he later observed, with a slightly exasperated tone, that his son "has a gift for painting, and only for painting."

It was in order to foster this talent that during these years he arranged for his son to spend summer holidays with the cultivated family of Ramón Pichot, a renowned artist in his own right. The route to the Pichot family home, El Molí de la Torre, on the road to Rosas, went past the view afforded by this early painting. Pichot, who counted Pablo Picasso and André Derain among his friends, probably gave the young Dalí' his first sustained contact with the world of professional artists. Moreover, Pichot's children all had considerable artistic talents and interests: Ricard was a cellist and a pupil of Pablo Casals's; Luis was a violinist; María (Maria Gaye) was an opera singer; Mercedes was married to the poet Eduardo Marquina. At the request of Dalí's father, the eldest son, José (also called Pepito), became Dalí's preceptor. It was in this expansive circle of talented friends that the young and impressionable Dalí was introduced to the wide reading and broad cultural interests that would remain with him the rest of his life. Here, his talent was recognized and given timely and nurturing encouragement, eight years before his first exhibition in Barcelona, and twelve years before his solo exhibition in Paris.

The salutary company of the Pichots provided a context for the obvious sophistication of this very early painting. Deft touches of shadow in the umbrella pines to the right judiciously balance the pink tones of the setting sun and heighten the effect of the glowing atmosphere in the distance. The composition of the work, with its diagonally balanced triangles of vista and trees, shows a natural instinct for pictorial structure, organizing the complementary color areas. A sprig of leaves in the upper left corner adds a bordering constraint that is compositionally astute. The descending shadow of Mount Pani, later a common image, spreads across the bay of Cadaqués in a way that presages the soft, dark qualities of Dalí's mature work. Some of the hallmarks of the mature Dalí are already present in embryo in the elements of this work—the shadows, vistas, and sunsets that occur throughout his later paintings. Their simple appearance here underscores the importance of this formative early period, a time and a place that remained alive in Dalí's mind as a permanent resource of his later imagination. As he himself put it, twenty-two years later, "With each passing day I feel myself, and it is high time to say it, virtually nailed to my geology."

Port of Cadaqués (Night)

1918–19. Oil on canvas, 7³/₈ x 9¹/₂" (18 x 23 cm). No visible signature

This freely painted early work was most probably set as a student exercise for the fourteen-year-old Dalí. The previous year he had commenced classes under the well-known Spanish artist and engraver Juan Nuñez at the Municipal School of Drawing in Figueres. Nuñez was a fine teacher who had studied both at the School of Fine Arts in Madrid and the Spanish Academy in Rome, where he had lived, worked, and exhibited for several years. The many works that Dalí undertook under the guidance of this impressive and inspiring teacher reflect a variety of styles, approaches, techniques, and coloristic effects. Although their range of subjects is restricted to areas within walking distance of his family's summer home on the bay of Cadaqués and their format is usually small, all of these works display a bravura that belies the artist's age and indicates his growing confidence, his quick grasp of aesthetic principles, and his eager response to tutored guidance.

The encouragement of Nuñez and the Pichot family can be seen not only in the volume of Dalí's output at this time, but also in the seriousness of purpose that radiates from this small and revealing work. It was this seriousness that prompted his participation in his first group exhibition during the production of this work, showing two oil paintings in Figueres, and he also submitted a drawing for publication in the Catalan magazine *Patufet*.

Night scenes such as this are notoriously difficult to paint; tonal ranges are close, colors are muted, and forms are made indistinct by falling shadows. The young Dalí has managed to meet these challenges, particularly in his rendition of the glow of the night colors, the light on board the moored boat, and the undulating reflections in the water. The wavy patterns of light and the blue-green shimmer of the colors capture the quiet warmth of a Mediterranean evening.

An intriguing and overlooked feature of this painting is the fact that it is almost exactly replicated in another work of the same time, having the same subject and the same title. Contemporary witnesses recounted seeing the young Dalí painting two canvases at once—one with his left hand and one with his right. If that is what happened in this case, then this early painting is the first surviving instance of his experimentation with two-handed painting, and one of the first hints at his later interest in double images and in stereoscopic vision.

Self-Portrait (Figueres)

1921. Oil on jute canvas floated on velvet, 14½ x 16½" (37 x 43 cm). No visible signature

This bold painting is one of Dalí's earliest self-portraits. The dark, brooding background hints at the new role that he had adopted: the early days of technical exercise have passed, and the seventeen-year-old aspirant now sees himself as an artist. The face of the artist emerges from the shadows of the background into an individualistic prominence, and the gaze is arresting in its directness. The painting suggests artistic and intellectual seriousness and at the same time a newfound, almost haughty, confidence that permitted him to play the dandy. It was a confidence that was shown in the elegant and often eccentric dress that Dalí adopted, in the aristocratic way he acted, in the novel he started to write, and, above all, in the way he applied himself to his vocation—a sense of certainty about his chosen path that never left him. The hardening of his resolve may have been in part a reaction to the death of his mother in the year that this work was painted. Her death from cancer was a traumatic event that cemented this resolution; Dalí became gripped by a demiurgic passion to avenge this "affront of destiny" by making his name "glorious." Seen in that context, this assured work, with its staring eye—near the center of the canvas, fixing the viewer—seems to throw out a proud challenge to fate; the clearly painted eye now gleams with new determination. His sense of purpose was given a further impetus, in the year he made this portrait, when Dalí was accepted as a student at the Academy of San Fernando in Madrid.

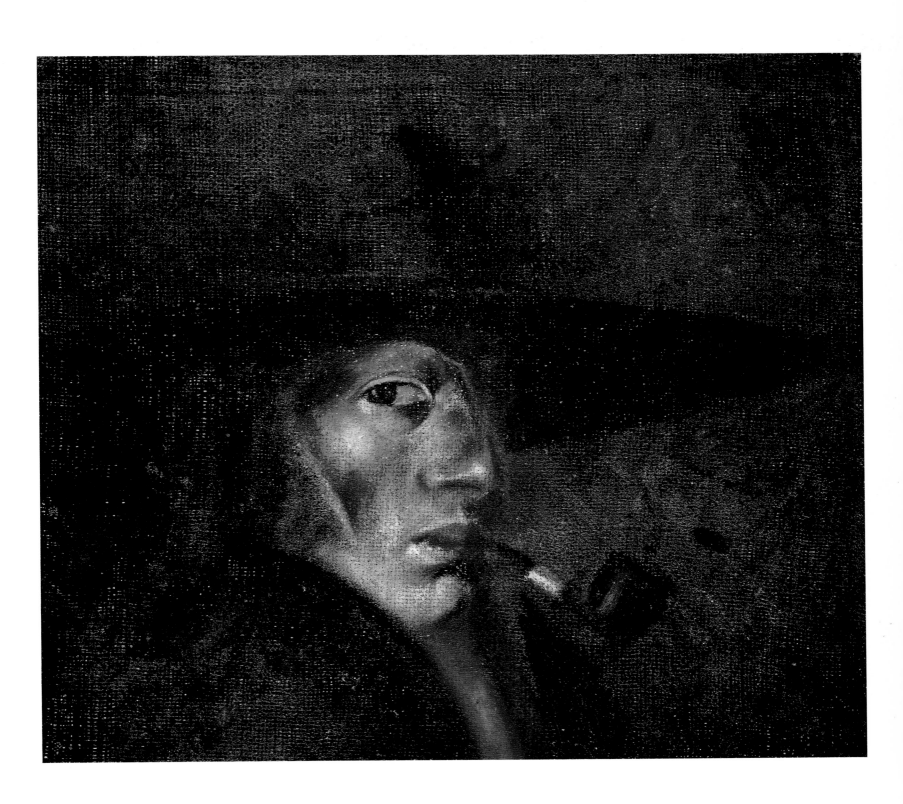

Still Life: Pulpo y Scorpa

1922. Oil on canvas, 21³⁄₈ x 22¹⁄₂" (54.2 x 57 cm). No visible signature; dated upper right: "1922"

This still life, set in his mother's kitchen at home, displays Dalí's developing grasp of painting technique. The raw quality of his earlier work is replaced by an assured though still freely scumbled surface that creates a lively visual texture without the heavy impasto of the recent past. The background ocher color is modulated in a way that flows into the red of the tablecloth, while the shadows on the wall and around the objects continue the tonal suggestions of depth evident in Dalí's earlier works. These features of painterly interest are joined by a new desire for realism and clarity, which can be seen in the way that the rim of the white dish reveals its terra-cotta colors through chips in its glazed surface, in the shine on the knife blade, and in the careful rendering of the lemon and its peelings. It is a realism of depiction that is later to be more acutely, even obsessively, demonstrated. Additionally, the composition of this work introduces what will become Dalí's characteristic use of a tablelike ground plane. In later works, these flat surfaces—a beach, a plateau, or a table—present an arrangement of objects, often with dishes such as this, that arise from imaginative associations; in this work, the objects are still grounded in the everyday and are decidedly domestic—a dish, a tablecloth, a jug, a knife, an octopus, three portions of a lemon, and a scorpa, a local fish. Certainly this early work may have been prompted by a desire to emulate Spanish still-life paintings, a traditional genre where painterly concerns predominate, but its hidden formal structures resonate through Dalí's mature works. Even the central element of this work, the fish-on-a-dish theme, with its palpable links to Giorgio de Chirico's *The Sacred Fish* of 1919, is repeated in many later paintings.

At this time in his development, Dalí was becoming disenchanted with the teaching at the Academy of San Fernando in Madrid; it seemed to pale by comparison with the individualized tuition that he had received during his formative time with the Pichot family in Figueres. He continued to paint works outside the restrictions and requirements of the school curriculum; like this one, they were invariably done at home and were thus more revealing of his true inclinations. Strongly imbued with familial ties and with the local environment, these seemingly mundane works therefore held great significance for Dalí. This can be sensed in his touching admission to A. Reynolds Morse that he once was able to detect a fake "Dalí" because it contained a fish not found in his native region, and also because, he explained, "I remember every object in my mother's kitchen." Sentiments such as those underlie the perceptual force and clarity of his works at this time, works that gained him his first favorable critical review.

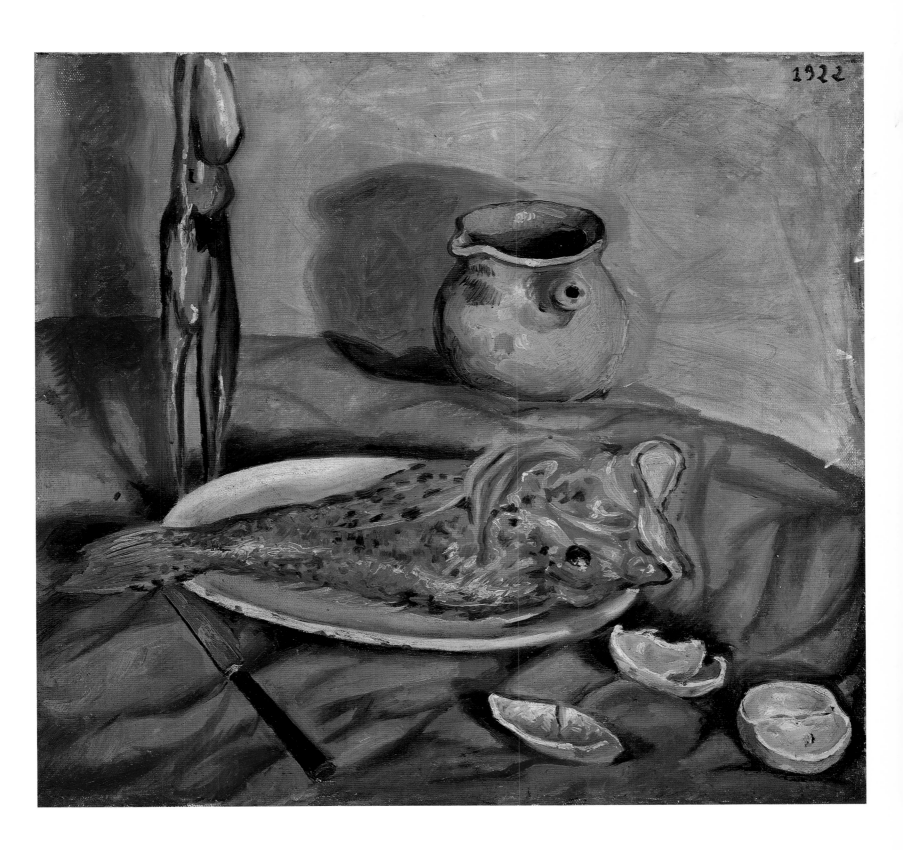

1922

Still Life: Sandia

1924. Oil on canvas, 19½ x 19½" (49.5 x 49.5 cm). Signed and dated upper left: "Dalí / 1924"

This painting was completed the year that Surrealism was formally defined in André Breton's *Manifesto of Surrealism.* The painting, however, betrays no hint of any Surrealist intention; indeed, it serves to show by that very fact how quickly Dalí's work developed with his adoption of Surrealist conceptualization five years later. In this painting, he was concerned with the more formal relationships of shapes that characterize the art of Cubism, rather than with the personalized imaginative license of Surrealism.

The painting, curiously, is almost split in two: the left side harks back to the works of Dalí's student days, with its more naturalistic rendition of a table and its arrangement of a tiled floor and a fruit dish containing a pear and a lemon; the right side displays a more geometric arrangement of forms, less easily recognized, and shows the extent of his debt to Cubism. On the right side, the black outline of the fruit-dish shape serves to tilt the composition upward into a more vertical position, which, in a typically Cubist way, emphasizes the flatness of the composition—a flatness not replicated in the left side of the work, with its more diagonal and angular recession. Yet the visual disjunction between the two halves of the painting is softened by the large piece of watermelon, which, with its curved form and more strident color, optically links the two sides of the canvas. The upper register of the work further links the two sides with impastoed triangular forms and with the inclusion of a textured wall on the left. With the obvious exception of the watermelon, the work's color range is subdued and tonally restricted in the Cubist manner, and in total the work displays a competent assimilation of the influence of Picasso.

The visual split of this canvas should not be read as indicating any ambivalence in Dalí's artistic direction; rather it records an important moment of transition in his aesthetic advance. The dashed-off quality of this canvas and the overworking of its right side, attributes rarely present in the more disciplined works of Cubism proper, may indicate that this moment occurred in the midst of executing the painting. Read from left to right, the painting tabulates a progression from the adolescent experimentation of the previous five years to the mature reflection that will characterize his next two years—a dynamic change that may be detected exactly midway across this instructive canvas.

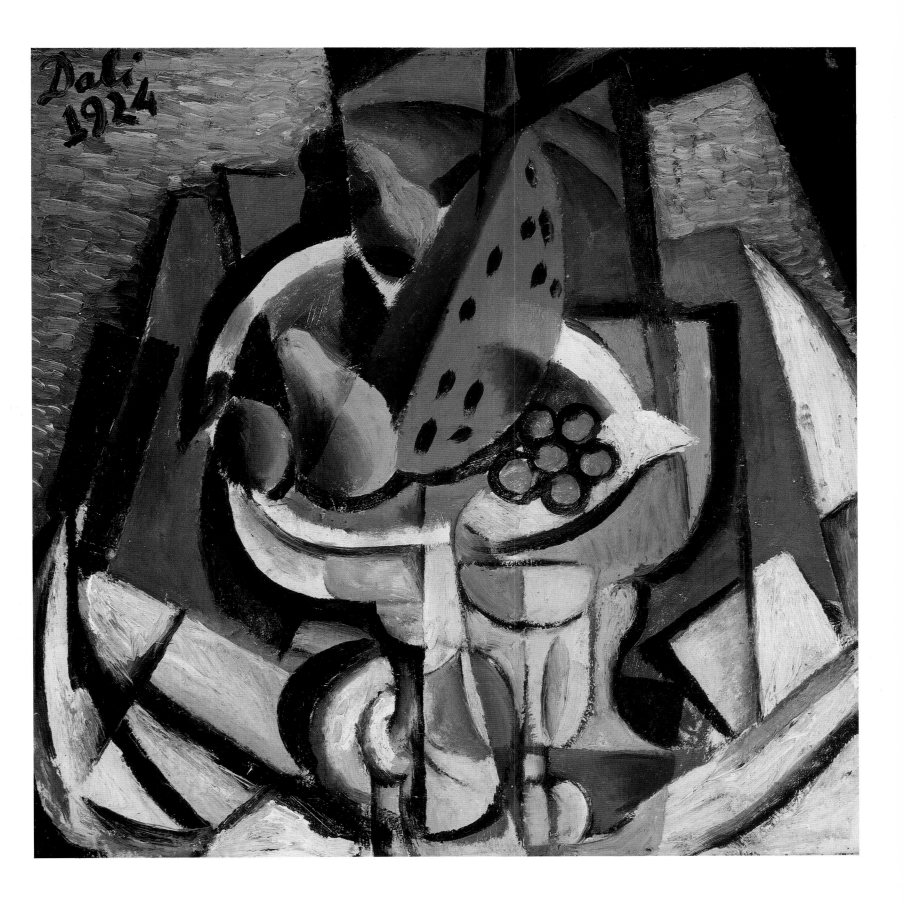

The Basket of Bread

1926. Oil on cradled wood panel, 12½ x 12½" (32 x 32 cm). Signed and dated lower left: "Salvador Dalí / 1926"

*T*he Basket of Bread, with its visual precision and rigor, was painted during the same year as freer and more experimental works. By comparing this finely painted image to *Girl with Curls* (also in the Salvador Dalí Museum) and *Femme Couchée* (page 45), both from 1926, we can begin to appreciate the full extent of Dalí's technical virtuosity and adaptability. It could almost be imagined that the works were painted by different artists, so marked are their differences. These works served to demonstrate Dalí's ability to turn his dexterous hand to virtually any style—like a musical prodigy playing different compositions. It is as though his aim, in this eventful year, was precisely to incorporate a number of diverse styles, hoping somehow to blend these disparate approaches into a single idiosyncratic manner that would be uniquely his own. This was an ambition made more urgent by his expulsion from the Academy of San Fernando in the same year. The fact is that Dalí did not succeed in fully blending these differing approaches; they remained distinguishable for the rest of his life, thereby endowing many of his later compositions with a formal richness and a complexity of structure rarely evident in a more homogeneous style. He did, however, succeed fully in silencing his detractors by demonstrating his undeniable technical mastery. (Dalí would return to the theme and style of *The Basket of Bread* in 1945, as if to reconfirm his singular gifts.)

The clarity and optical fidelity of *The Basket of Bread* are mature extensions of the desire for realism first displayed in *Still Life: Pulpo y Scorpa* of 1922 (page 39), where painterly interest was modified by a new desire for objectivity. In both works, domestic objects are placed in a way that seems natural and uncontrived. Yet the light is quite different. The dark background tones of the later painting highlight an indistinct table surface almost covered by a simple white tablecloth. The objects in the painting are lit by an external source, but their soft shadows suggest a luminosity that arises from within the simple scene itself. The lined wicker basket with its four pieces of bread seems to glow with its own light, a radiance heightened by the background contrast.

Just how Dalí achieved this feat is a technical mystery. Certainly this early work may have been prompted by a desire to try his hand against the Old Masters and to emulate Spanish still-life paintings—a traditional genre where virtuoso pyrotechnics predominated. His interest, at the time, in the work of artists such as Jan Vermeer, Diego Velázquez, and Francisco de Zurbarán, for example, led to many studies of their techniques and methods. He investigated esoteric paint ingredients, such as amber, wasp venom, jet, gold and silver oxide, together with methods of surface preparation and traditional pictorial execution. These intensive studies underlie and inform this famous painting—a work of great exactitude that manages to invest a humble staple food, "our daily bread," with an almost sacramental aura.

The painting was shown in Dalí's first exhibition in America, in Pittsburgh in 1928. It was once in the collection of James Thrall Soby, who wrote the first English-language monograph on Dalí, in 1942.

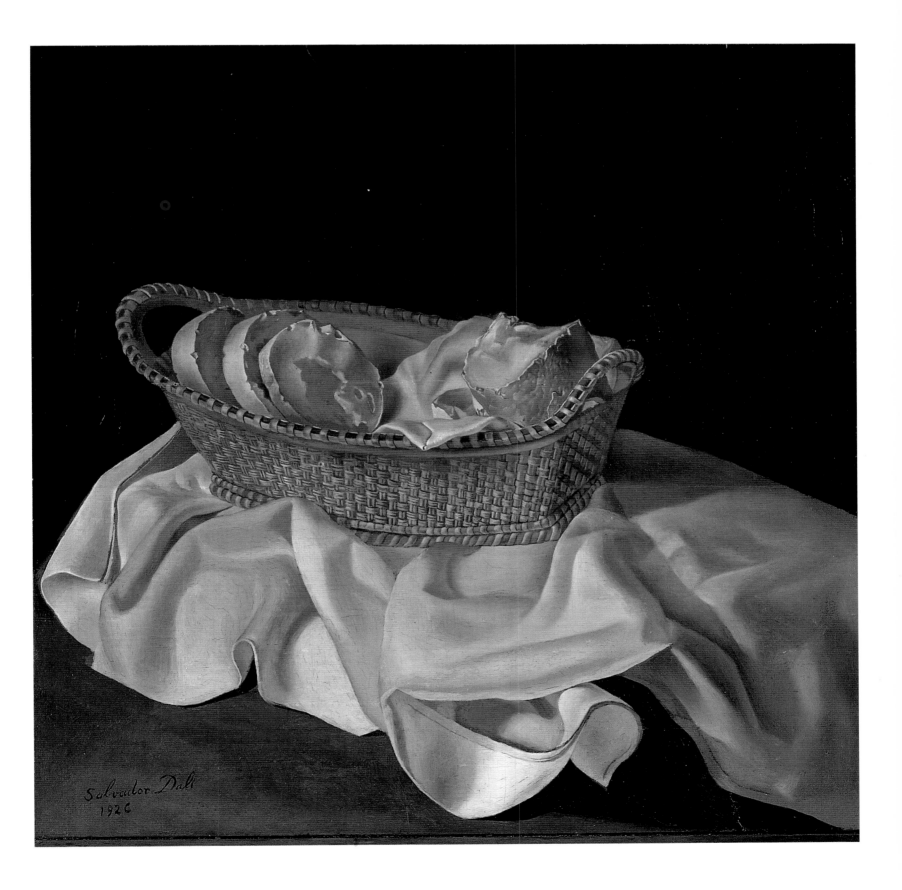

Femme Couchée

1926. Oil on wood panel, 10¾ x 16" (27.5 x 40.5 cm). Signed and dated lower left center: "Salvador Dalí / 1926"

The composition of *Femme Couchée,* or *Reclining Woman,* is strikingly Cubist; it announces Dalí's confident assimilation of the influence of his countrymen Pablo Picasso and Juan Gris. The narrow range of colors in this work allows us to concentrate more easily on its strict geometry: two diagonal axes draw the eye to the precise point of their intersection in the mid-torso of the figure. That central, pivotal point acts as a visual fulcrum for the splayed, cruciform shape of the recumbent female. The geometry of the oversize, supine figure, suggestive of a starfish on a beach, closely associates her with the angular geography of the setting, as though she arises naturally from it; the figure is *of* the landscape rather than merely *in* the landscape, the waterfall flowing from the woman's left hand suggests as much. Although there are only about six extant paintings of this type, the association between the figure of a woman and the landscape is by no means uncommon in Dalí's later art. It appears in many of his subsequent works, most notably in the justly famous *Specter of Sex Appeal* of 1932, as well as in *Woman Sleeping in a Landscape* and *Solitude* of 1931, and its occurrence reflects Dalí's abiding interest in the anthropomorphic, such as the common practice of naming geographical landmarks after the human forms that they suggested. Viewing landscape features as reminiscent of the body is endemic among local fishermen, but the most famous subject of this type of anthropomorphism is the mountain range of Toroella de Montgri, south of Cadaqués, where this work was painted, which is well known in the area for delineating the outline of a recumbent woman—a breast being suggested by a round hill and its nipple by the thirteenth-century Montgri Castle.

This important painting was executed in the year of Dalí's expulsion from the Academy of San Fernando in Madrid, a year during which he visited Paris for the first time and met Picasso. Dalí called this work "neo-Cubist." It illustrates his very competent deployment of Cubist principles, as do his Synthetic Cubist works, which were yet to come. At the same time, it heralds his later anthropomorphizing vision, with its overt sexuality, and his common practice of seeing forms, indeed naming forms, according to their evocative associations.

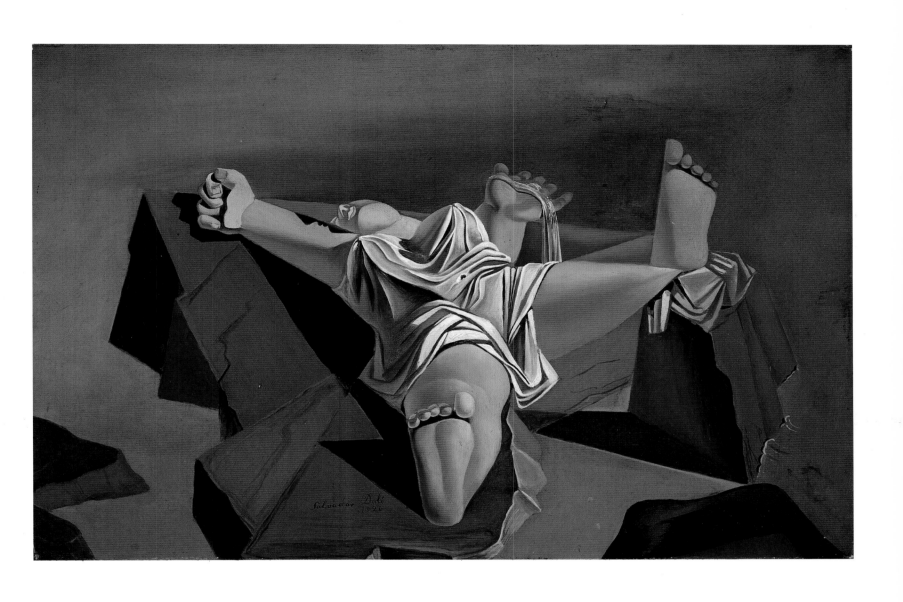

Apparatus and Hand

1927. Oil on cradled wood panel, 28¼ x 20½" (71.5 x 52 cm). Signed and dated lower left: "Salvador Dalí / 1927"

The free swirl of background sky in this painting signals Dalí's lessened restraint in the works of this period. His expulsion from the Academy of San Fernando, though dismaying, was countered by the support of loyal friends and patrons such as Federico García Lorca and Joan Anton Maragall y Noble, and Dalí, heartened by their encouragement, continued to work; he exhibited at the Autumn Salon at the Establiments Maragall in Barcelona and in the exhibition "Modern Catalan Art" in Madrid, and his new paintings began to display a personal intensity well beyond his studied earlier compositions.

Apparatus and Hand is one of the most accomplished works of this period. Gone are the Cubist-derived colors and geometric forms of the recent past; this painting announces a fresh Mediterranean luminosity that was to stay with Dalí, together with a more uninhibited repertoire of images and associations. These new images hover in a free-floating imaginary space, suspended from the sky of his own local environment. This open space, freed of the restrictions of a studio or interior, returns us to the landscape of Dalí's juvenile works, where his comparatively untutored response had been more direct. Now, the landscape is altered by the intrusion of a tablelike plane, which supports emblems and images drawn out of an erotic delirium. The overall impression of this important transitional work is faintly suggestive of the French artist Yves Tanguy but much more reminiscent of Joan Miró, whose wispy, poetic forms are echoed here. However, in Dalí, Miró's soft forms join with the legacy of Lorca's contemporary line sketches. The frankness of the psychological content in this work hints at some of Dalí's later concerns. The large hand, for instance, testifies to his self-confessed onanistic guilt; its throbbing veins and radiating spermatozoa are disturbingly, even distastefully, blunt. The monumental hand flaunts its prominence in Dalí's life and forms a jarring contrast with its probable source: Giorgio de Chirico's famous painting *The Song of Love* of 1914. De Chirico's love song here becomes a coarse ditty. The stylized "apparatus" dominating the center of the work derives from the colloquial Spanish term for the male member. The naked female torso on the left also refers to Dalí's masturbatory imaginings, and the birdlike markings opposite probably tabulate their incidence. The rearing donkey, in a mating position, reaches for a fish, which in other works Dalí often associates with female genitalia. The figure on the right in a bathing suit links this work to the local inspiration of some of his previous paintings; its mannequinlike arrangement hints at his art-school training, while the geometric forms around it, like the shadows in the work, betray the persistent influence of Picasso's Cubism, along with the angular forms of Carlo Carrà, and aspects of de Chirico's early works. This strange and heady concoction of internalized influences illustrates Dalí's bold use of Freudian free association and his early adoption of Surrealist concerns, fully two years before he was formally accepted into the Surrealist group. In this fervid painting, exhibited in Dalí's first Parisian exhibition in 1929, we can sense why Dalí galvanized the Surrealists' interest; the painting's shockingly autobiographical imagery bears precocious witness to the sort of spontaneous, uncensored self-revelation recommended by André Breton and his group. The painting was once in the collection of the Galerie Surréaliste in Paris.

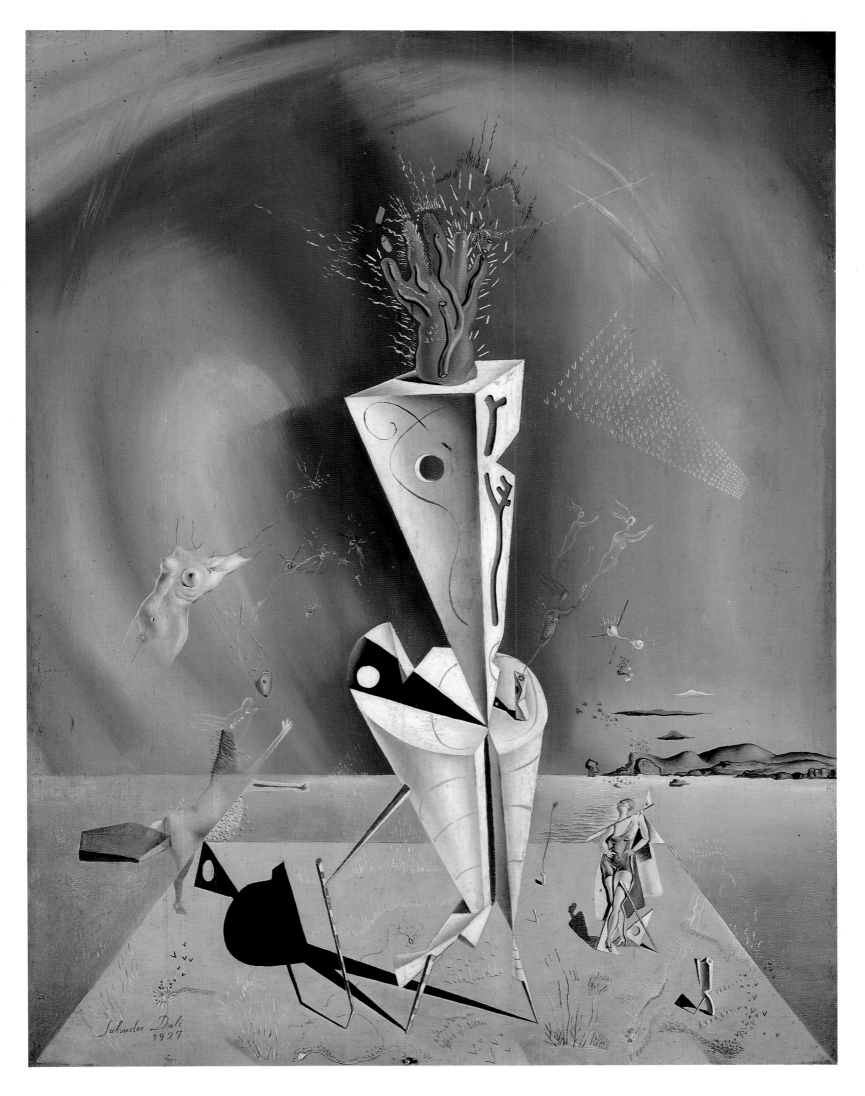

The Bather

1928. Oil, beach sand, and small sea shells on panel, 20½ x 28¼" (52 x 72 cm). Signed right center: "Salvador Dalí"

The central form in this painting was most likely suggested to Dalí by the shape of his own thumb, protruding from his artist's palette while he worked. Dalí's gift for transformation is seen at its most bizarre and abstracted in this formative work. Though indebted to the automatic forms of Joan Miró and to the ocean settings of Yves Tanguy, the painting's ambiguous shapes indicate different aims and ambitions. We are presented with a meditation on this thumblike shape, and its metamorphic possibilities, together with Dalí's thoughts on his own, local sources of artistic inspiration.

The jagged rocks of the nearby Isle of Farnera, a silhouette of facial features, are portrayed with imagined bodily extensions that congregate on the horizon line. In its topography, this work is closely related to the painting *Beigneuse* of the same year (page 51), as are drawings such as the one entitled *The Bather* of 1927. In all of these works, the same amoebic shape is conjoined with the landscape of his home environs. In this painting, however, the obvious linearity of the *Bather* drawing and the sexual overtones of *Beigneuse* are replaced by a more formal interest in the material and textural qualities of the actual painted surfaces and their relationship to the two types of collaged sand in the lower half of the work. The three horizontal sections of the painting—the sky, the water, and the beach—create a compositional order that draws interest to the transition from one surface to another.

This concern, a legacy of Cubism's emphasis on surface texture, is balanced by the soft, fleshy shapes of a recumbent figure, its legs trailing to the right and its face formed by the nail of the thumb—a bloated Venus that seems to have been dredged up from the adjoining sea by the fishermen's nets that cling to its body. The wrapping of nets leads us to an additional, underlying source for the strange protoplasmic shape of this grounded flesh. In his diary of 1942, Dalí noted the memorable childhood scene of a beached whale that appeared on the local shore one morning; the painting recalls the shape and colors of that magical apparition. The whole remembered spectacle is relived in this work in a way characteristic of Dalí's early interest in mental association. Memory and formal elements are visually combined in the twenty-four-year-old artist's mind in a way that presages his later works and signals his continued interest in the potential of introspective reverie. The painting is a valuable indicator of Dalí's individualistic talents, one year before his involvement with the Surrealists and his meeting with Gala Eluard.

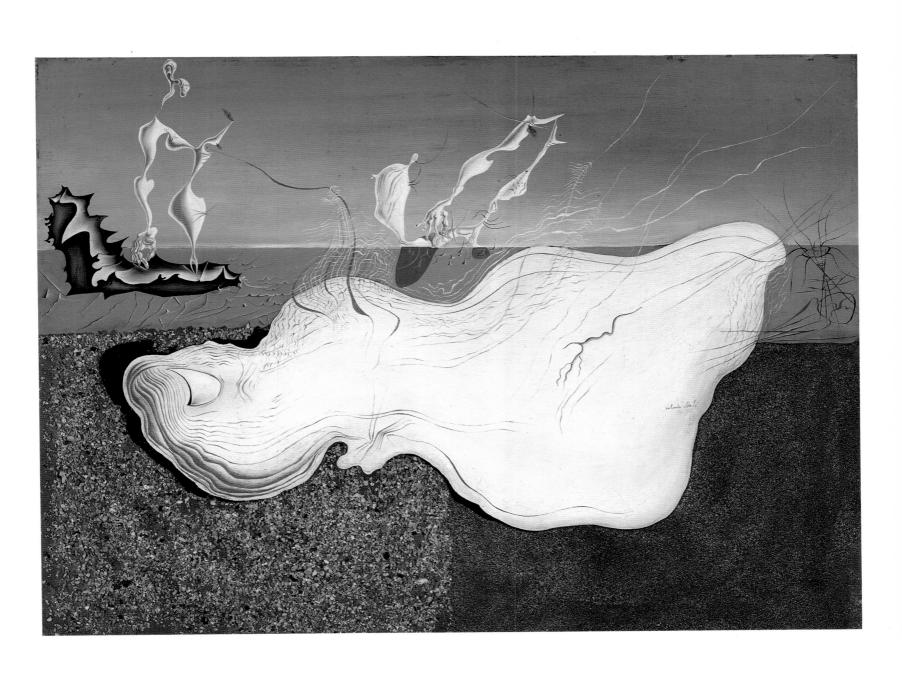

Beigneuse [sic]

1928. Oil and beach sand on fiber panel, 25 x 29½" (63.5 x 75 cm). Signed and dated, right center, at a later time: "Salvador Dalí / 1938"

The deliberately misspelled title of this painting—*Beigneuse* instead of the expected *Baigneuse* ("bather")—puns on the French word *beignet,* for a kind of fried doughnut whose puffed shape may have suggested the peculiarly bloated figure in this work. Its simple origin, however, tells us little about the significance of the figure. The fleshy body of the bather, her pose mimicking that in Pablo Picasso's *Printemps (Spring),* lies uncomfortably against the hard rock of the beach coast around Dalí's home, in the same way that the luminous blue sky presses against the coarse reality of the glued sand at the horizon line to the left and right. As in *Femme Couchée* of 1926 (page 45), the figure of the woman arises from the landscape; this time, however, its biomorphic qualities owe more to the fluidity of Miró than to the angularity of Picasso. Nonetheless, the painting has an aggressive, almost cruel quality that conveys Dalí's anxious, ambivalent response to the challenge of female sexuality. The figure is presented as a corpulent blob of flesh, reddened by the sun, and is almost repulsive. Its minuscule head contains a tiny depiction of an open trap, hinting at dangers posed by this figure. (Later, Dalí would explore the praying-mantis theme, where female sexual power is fearfully represented.) The most conspicuous feature of the figure is its right hand—large, dirty fingernailed, and genitally suggestive—extended in a gesture signifying cuckoldry. Altogether, the female is presented as the agent of a dangerous availability, her allure mixed with discomforting sensations of revulsion.

The painting can be understood as a personalized version of well-known nineteenth-century academic depictions of a siren on the rocks; with Dalí, however, this traditional subject is harshly deromanticized, and its literary or mythological meanings are replaced by symptomatic signs of some of his later psychological themes. Compositionally, this may be discerned in the vague double image of a silhouetted face in the rock above the head, and in the shape of the body and tail of a fish, which arises from the figure's lower left arm, poised over the pudenda. Also, the figure's left leg descends into an amorphous mass, the shape of which foreshadows some of the forms in Dalí's beach-related works of the 1930s, while its right leg shrinks away to insignificance. Moreover, the outline of the whole figure bears the contour of Dalí's own later soft self-portraits, themselves drawn from, and combined with, the evocative outlines of rocks on the local beaches.

The work is related to other important paintings of the period, such as *Dialogue on the Beach,* which was banned from his 1928 exhibition at the third Autumn Salon at the Sala Parés in Barcelona, and it is similar in its elements to *Cenicitas (Little Cinders)* and to *The Bather* of 1928 (page 49). Despite its seemingly innocuous origin, this painting offers a complex review of Dalí's emerging interests at a transitional point in his work.

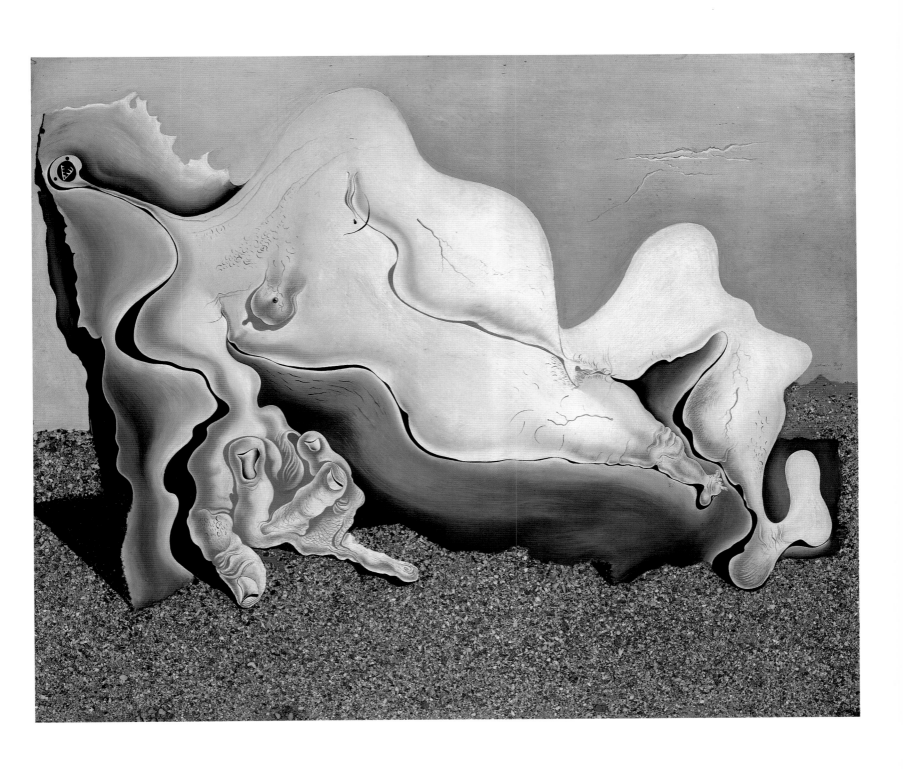

Dit Gros, Platja, Luna i Ocell Podrit
(Big Thumb, Beach, Moon, and Decaying Bird)

1928. Oil and gravel on masonite panel, 19¾ x 24" (50 x 61 cm). Signed and dated bottom center: "S. Dalí / 28"

Dalí published a paper on Joan Miró the same year that he produced this painting (formerly in the Albert Puig collection in Paris). In this work, it can be seen how well Dalí had understood Miró's language of forms as he made use of it in a painting that is, nonetheless, primarily an extension of his own work of the year. For example, the painting has the same dark background evident in *Ocell . . . Peix* (page 55). It displays as well a command of the sand-painting techniques of André Masson, together with a confident placement of compositional elements that is a hallmark of the contemporary work of Jean Arp, whose torn and collaged shapes find their echo here. The muted Cubist tones of the work concentrate attention on formal balance and harmony, without the distractions of color.

There is little doubt that Dalí often experimented with automatic placement of forms, but this work's balanced, harmonious composition indicates that, here at least, he was prompted more by the abstract beauty of the textured shapes themselves. Dalí was attempting a symphonic harmony of parts rather than the elaboration of a theme. Though this painting, like *The Bather* of the same year (page 49), was prompted by the shape of his thumb seen protruding through an artist's palette, there is no hint of the hidden psychological meaning that permeates *The Bather* and related works—even Max Ernst's psychologized bird-motif, culled from Ernst's *La Belle Saison (The Beautiful Season)* of 1925, is here subsumed by the overall compositional concord. In this sense this painting, although considerably more simplified and abstracted, looks to Dalí's earlier Cubist works, with their formal and textural harmonies, as well as to his admiration of Picasso's *La Copa i li Pipa (The Goblet and the Pipe)* of 1925, a work of similar restraint.

Dalí seems at this time to be at an important intermediary stage: though not a true collage, this painting is distinctly informed by the collage aesthetic; though not fully Cubist, it is linked to Picasso and to Dalí's earlier Cubist experimentation; and though not yet fully Surrealist, it shows the influence of three Surrealist artists—Ernst, Masson, and Arp. It thus constitutes a revealing link between his early work and the paintings that would be propelled by Surrealist theories.

This transitional painting, executed like others of the period in the town of Cadaqués, was shown at the third Autumn Salon at the Sala Parés in Barcelona in 1928, the year of its production.

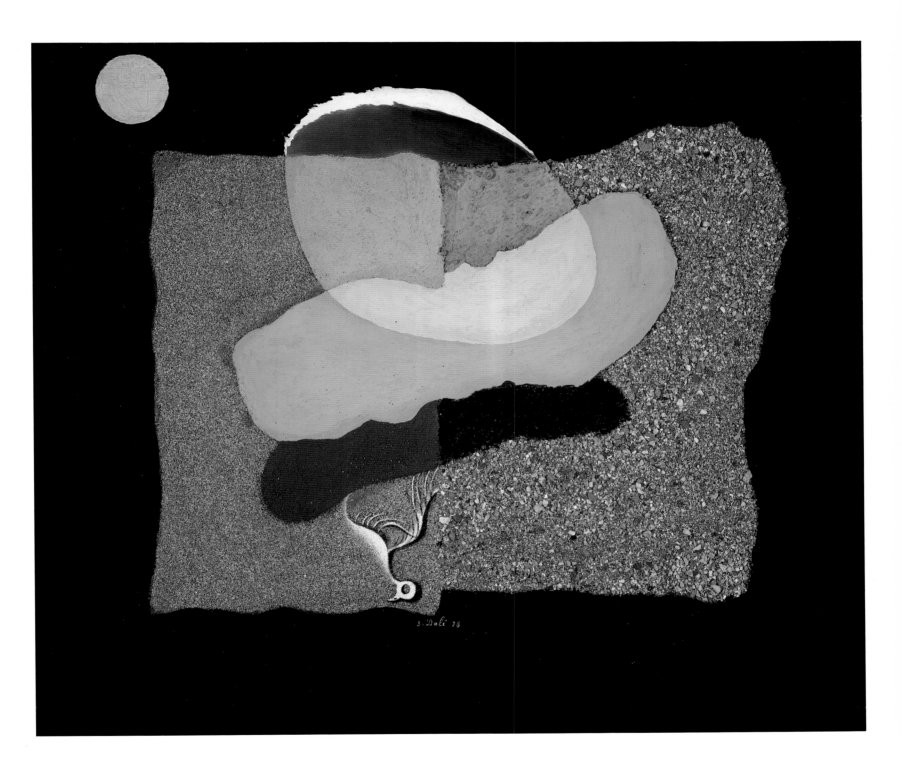

Ocell... Peix

1928. Oil and beach sand on fiber panel, 24 x 19½" (61 x 49.5 cm). Signed lower left: "S. Dalí"

The unusual dark background of this painting serves to emphasize the foreground in a way that will become increasingly common in Dalí's work. The painting's composition, once again, is strongly reminiscent of Joan Miró, particularly in the dotted line nexus between earth and sky and in the lyrical nature of the work's sparse elements, a lyricism that is also suggestive of Jean Arp.

The painting's dark sky betrays its origins in the Surrealists' experimental technique of *grattage*—a method of pictorial generation that relied upon the uncovered images formed by scratching back layers of ink or thin bitumen spread over preexisting work. The effect of this procedure, with Dalí, is enhanced by a pictorial structure indebted to the technique known as Exquisite Corpse, a Surrealist parlor game of the 1920s in which each participant added a section of writing or drawing to a piece of paper that was folded to hide the earlier contributions. The central dotted line in this work is reminiscent of the ever-present paper fold line of these Exquisite Corpse drawings, and it serves to divide the two main images.

Dalí's grasp of these two Surrealist techniques, *grattage* and Exquisite Corpse, and his successful incorporation of the influences of Miró and Arp, produced a painting that marks the midpoint in his Surrealist stylistical development. In it we can see Dalí's natural propensity for the morphological transformation of images: the upper section of the work shows an arm that turns into a fish, while the lower section reveals a bird that arises from a rocky shore, both images emerging from the concealment of the dark background. In addition, Dalí's low horizon line, characteristic of his later work, makes its most obvious early appearance here, although the work maintains a tenuous thematic link to his beach paintings. It also indicates his greater knowledge of Max Ernst, whose work at this time was having a forceful impact on the Surrealist group in Paris. Dalí's boldly inclusive use of these many sources and techniques demonstrates the wide grasp of his imagination, just prior to the onset of heavily Freudian influence.

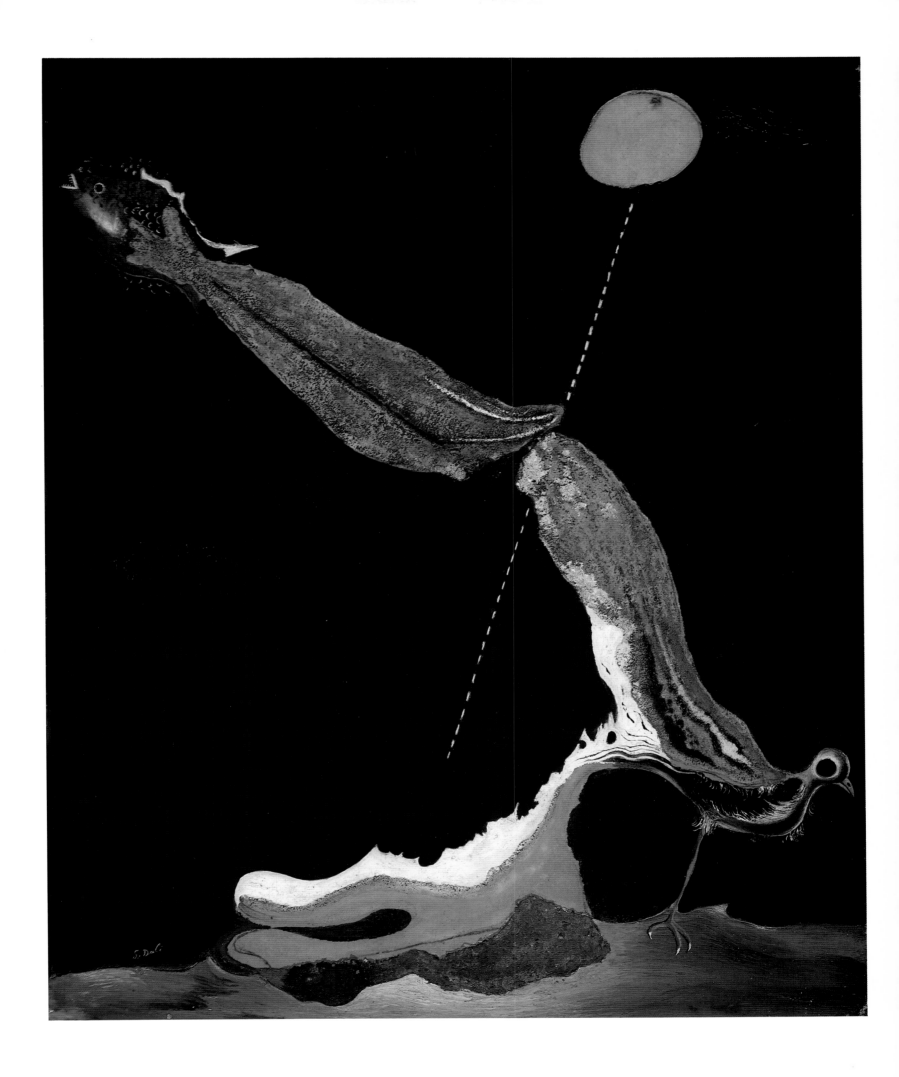

The First Days of Spring

1929. Oil with photo-offset lithograph and photograph on fiber panel, 19¾ x 25⅝ (49 x 65 cm). No visible signature

In the early years of Freudian psychoanalysis, the technique of free association was a prime focus of clinical attention. In this approach, the patient gave unpremeditated responses to various questions or statements, thereby unearthing patterns of association that could be analyzed for the hidden sources of neurosis. Frequently, childhood recollections were evoked. This similarly uncensored painting by Dalí, executed in the year of his adoption by the Surrealists in Paris, is a condensed pictorial equivalent of that sort of free association. The imagery is grouped around a central dividing line, like the axis of a folded Rorschach test, and gives prominence to sexual associations. The work's personal nature is stressed by the central collaged photograph of Dalí himself as a child, and the painting constructs a landscape of symbolic mental images around that emblem of innocence. It is an innocence now compromised and challenged by the incursion of adult desire.

The kaleidoscope on the right hints at such multifarious new complexities. The head of the dreaming Dalí arises from this kaleidoscopic box via a series of bird images, which for Max Ernst constituted an alter ego; here in Dalí they lead to a fantasized female head—with a jug handle for an ear, suggesting the Freudian metaphor of woman as receptacle. The teeth of this head grip Dalí's ear in a frenzy, like the fearful grip of the grasshopper, his established phobia. All the while, his mind is occupied by the image of his *femme-enfant,* the child-woman of his dreams, whose cherubic features contrast sharply with his insistently sexual imaginings.

Above this is a floating cameo view of contrastingly innocent, childhood associations: the coloring pencil, the naive drawing, and the picture-book images capture the charm of childish diversion, within an area reminiscent of the candy-shaped pebbles of the Playa Confitera of happy recall. Below Dalí's childhood photograph stands a bizarre composite form made up of anatomical details of female genitalia recalled from the medical text that his father kept in the bedroom. The lower gourd-like shape is suggestive of a uterus; its blue, tractlike forms suggest fallopian tubes; the inscribed numbers refer to the explanatory captions found in anatomy texts; and the surrounding hair continues the pubic association. The line emerging from the handle of this receptacle points toward the closed eye of Dalí's biomorphic face to indicate that this hybrid icon arises from his mind's eye.

The scene to the left highlights the erotic delirium of the painting. A gagged male, suggesting repressed desire, inclines toward a female form with legs splayed; her breasts are outside her clothing and her face is made up of distended female labia—a shocking displacement of individual identity by sexual function that predates René Magritte's *Rape* and *Philosophy in the Bedroom.* The male figure's hands reach down to a receptacle recalling the genital shapes of *Anthropomorphic Beach* of 1928 (also in the Salvador Dalí Museum). The scene's salacious nature seems magnified by the contrast with the collaged background image of rollerskaters on the deck of a cruise ship.

This painting of free association is flanked on the right by a scene of a young girl offering a bearded man her purse and on the left by a seated man turning his back. In the distance an older man shows a child, probably Dalí himself, this panorama of sexuality. Midway between this and Dalí's photograph is a scene that comments on the painting's sources in psychoanalysis: a man in a bowler hat, probably an analyst, stands over a figure on a couch; his hands are on the figure's head in a pose equally suggestive of exorcism and mesmerism. Thus considered, this painting is a repository of freely generated sexual associations, an uncensored pictorial record of the flow of Dalí's subconscious mind.

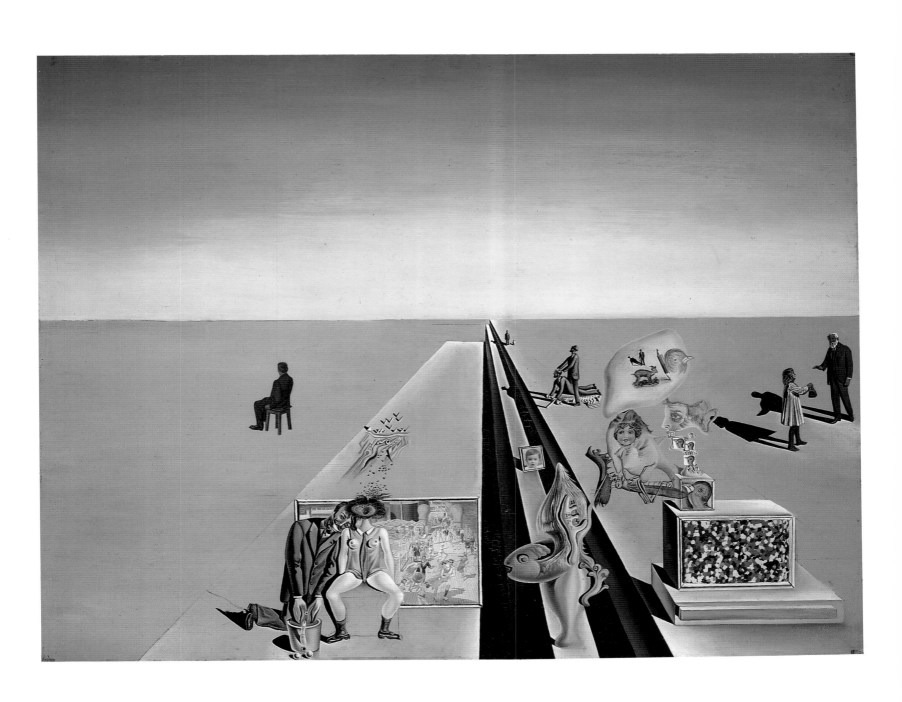

The Profanation of the Host

1929. Oil on canvas, 39⅜ x 28¾" (99 x 72 cm). No visible signature

This painting, at different times in the Cocteau, Levy, and Thannhauser collections, was impounded as obscene by U.S. Customs in 1945, an act that gives some inkling of its mysterious and almost indefinable ability to shock. A massed tide of forms flows from the right side of the painting, carrying with it disturbing associations of guilt and desire.

The lower section of the work, swathed in darkness, outlines dim forms linked to the passions; the older male figure on the left in this section has a gleam in his eye and a grin that hints at his control over the figure with face averted, perhaps Dalí himself, whom he embraces in a version of the return of the Prodigal Son. This father figure looks toward a stylized lion's head, reminiscent of the Lion of Belfort theme of Max Ernst but, more important, also recalling the head of a lion depicted in a lithograph that hung in Dalí's bedroom as a child. The Freudian implications of this lion image are significant here; wild beasts represent untamed passions requiring control by a father, and here, two images, the lion and the leonine-featured father, join forces to dominate the whispering erotic figures who writhe behind the son.

This dark scene is in turn dominated by a large excrescence of fluid forms that combine to make the metamorphic features of Salvador Dalí—shaped to resemble the rock of Cullero on Cape Creus—which are seen in five progressive stages of anatomical disintegration. Reading counterclockwise from the top right, the five are: the head of Dalí about to receive a blood-streaked Communion host from a ciborium; another head with Dalí's resulting fears represented by a grasshopper or locust clinging to its mouth—an insect that held a phobic terror for him; the third head, more deformed than its predecessor, its eye shrunken and bleeding, tormented by a larger grasshopper and a group of ants; immediately below, the fourth stage of the head, now shapeless and defeated by a larger grasshopper, its tenacious grip made more pronounced; and the final stage of disintegration, with the largest grasshopper triumphant over a depleted form whose shape is threatened by an adjacent swarming vortex of nothingness. The whole mass, like some bizarre anemone of the mind, shows a dynamic progression of shame and guilt, accentuated by a slow increase of paint thickness and impasto.

The debilitating fears at work here, preconditioned by the dark confession of secret desires in the lower register, are propelled by the Catholic guilt associated with receiving Holy Communion while in a state of sin—the profanation named in the painting's title. The woman to the left of center in white Art Nouveau robes, who is joined by four stages of Dalí's growth from childhood on, represents an imaginary ideal whose presence would obviate the threatening, abnormal growths that loom over it. But the dark sections at the top and bottom of the canvas compress the central vision in a way that heightens the dramatic force of this Gaudí-like monument. The whole rhythmic structure, designed after the patterns of tidal sand, suggests eddies of abandoned thought. Its visceral qualities evoke a disturbing sense of violation and reflect the consequences of Freudian free association in Dalí's work.

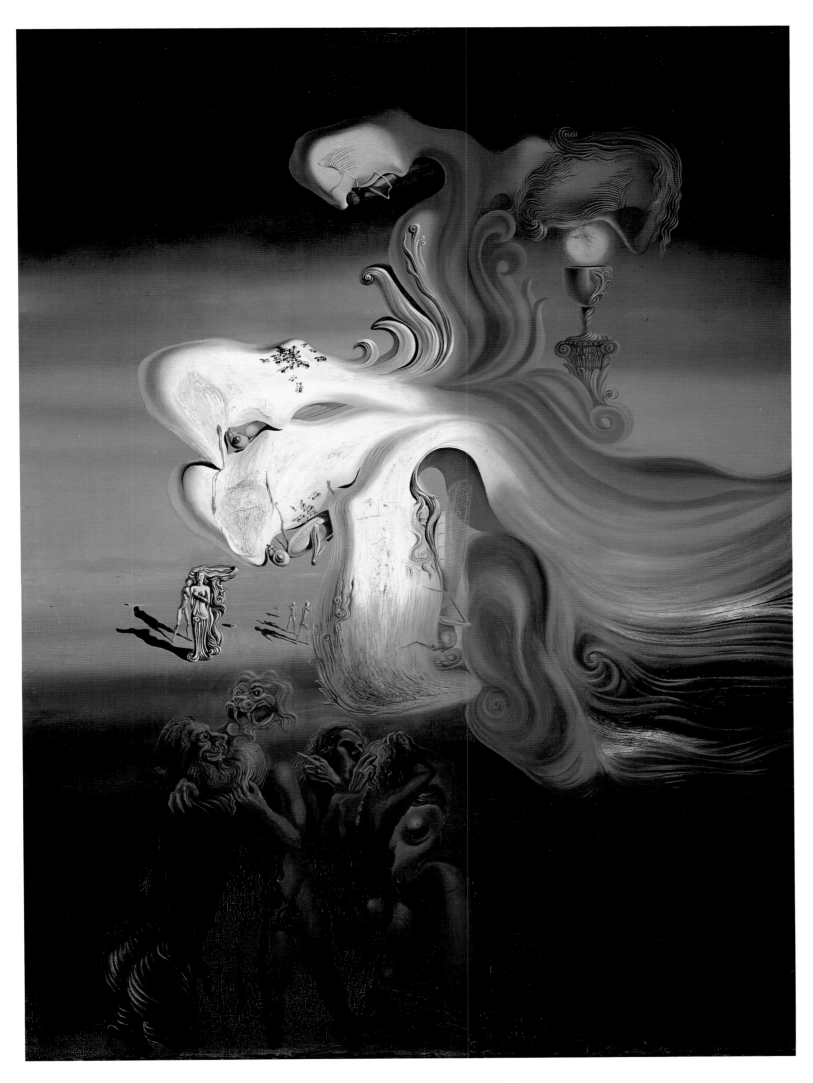

The Average Bureaucrat

1930. Oil on canvas, 31⁷/₈ x 25³/₄" (81 x 65 cm). Signed and dated lower right: "Salvador Dalí / 1930"; lower center: "Gala Salvador Dalí / 1933 Abril"

This elegantly restrained painting, formerly in the collections of Helena Rubinstein and Paul Eluard, is a repository of sublimated emotion. The large figure of the male in the foreground looms over something he presumably holds; this unseen presence adds to the pensive atmosphere. When we realize that this composition was derived from Dalí's 1923 drawing of the Hellenistic sculpture in the Louvre known as *Faun with an Infant,* a work showing a bearded figure with a young child, we are led to believe that the hidden presence, too, is a child. The painting might then form a metaphor of Dalí's complex and ambivalent relationship with his own father and, by extension, with other authority figures; viewed this way, the work would bear a thematic relationship to some of his other paintings and to similar works by Max Ernst and Giorgio de Chirico.

The artist's father, Salvador Dalí Cusí, was a government notary in Figueres and was sixty-seven years of age when this work was painted; the figure's downcast posture may hint at his persistent grief over the loss of his firstborn son, a grief that was a recurrent cause of distress to Dalí himself. The work was painted in a year of intense activity when Dalí's star was very much in the ascendant. His artistic and social success contrasted with the growing domestic tension caused by Dalí's relationship with Gala Eluard, which his father and sister deeply resented. A serious family rupture developed, exacerbated by misunderstandings regarding Dalí's sacrilegious inscription on a reproduction of a religious image. After a serious disagreement with his father, Dalí returned to Paris, and their estrangement continued for eighteen years.

In the painting, to the far left stands a small boy being shown the wider vista by an older man—probably, if contemporary photographs are a guide, the family friend José Pichot, with the young Dalí. The seashells in the foreground figure's head refer to his father's habit of anxiously twirling the hair above his forehead into shell-like shapes, which, as Dalí recalled in his diary of 1942, made him look like Michelangelo's famous sculpture of Moses: "With his furrowed brow and majestic bearing, he became Moses, inspired and imbued with divine authority." His paternal force had precipitated Dalí's fateful choice of personal direction and left them estranged. In this poignant painting, the deep, shroudlike shadow of Mount Pani, near the family home at Cadaqués, glides across the canvas, conveying the sadness of their domestic drama. The father figure, the "average bureaucrat" of the title, looms large over this dark scene—a symbol of Oedipal oppression.

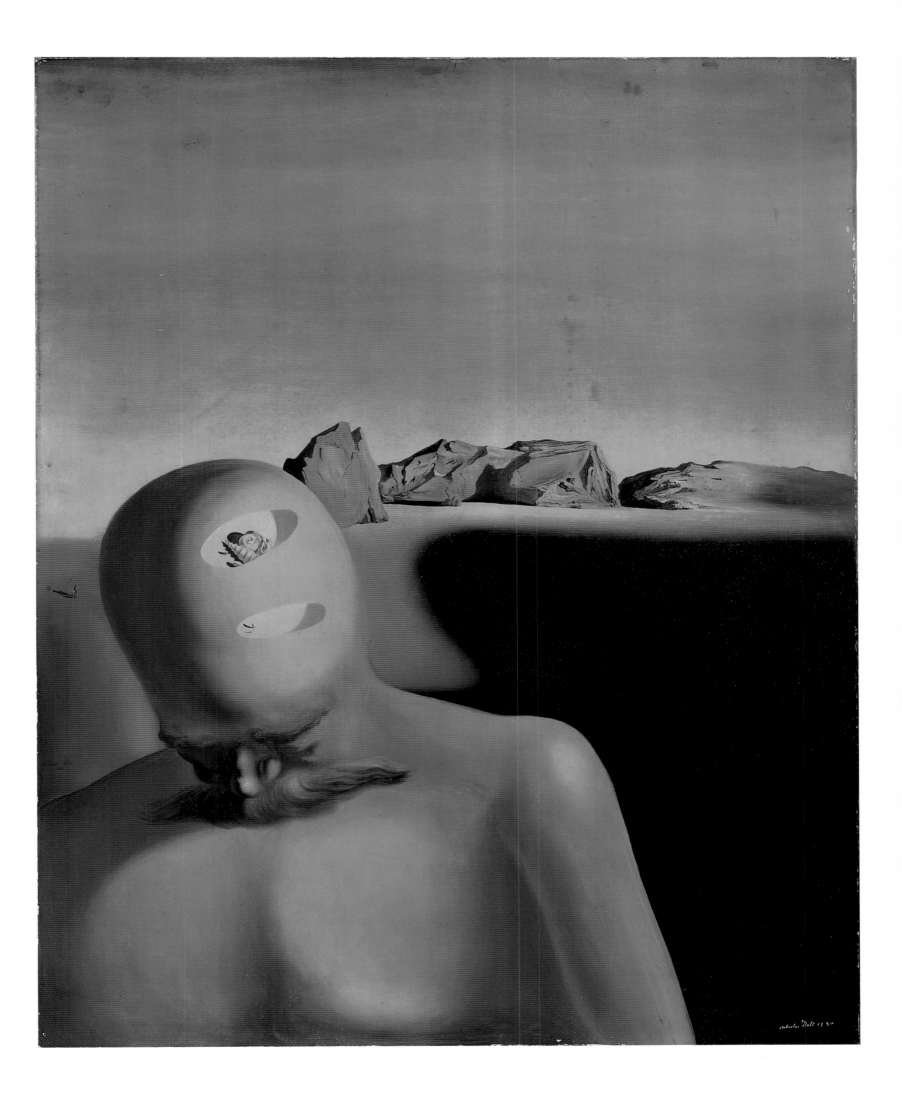

Au Bord de la Mer

1931. Oil on canvas, 13¼ x 10⅜" (33.5 x 27 cm). Signed and dated lower right: "A Gala Salvador Dalí / 1931"

The desolate atmosphere of this sparsely composed beach scene is reminiscent of the works of Giorgio de Chirico. De Chirico was invited to join the Surrealists in their first exhibition in Paris in 1925; earlier, work of his had been acquired directly from the artist by Paul Eluard and his wife Gala, in Rome in 1922, and selected by Tristan Tzara, the leader of the Dada movement, for an exhibition in Zurich in 1917. Dalí knew de Chirico's work well, from his time at the Academy of San Fernando in 1921. His links to the older artist are underscored by the fact that when Filippo Tommaso Marinetti, the leader of the Italian Futurists, spoke of Dalí in 1928, he referred to him as a Metaphysical School painter—the term most often applied to de Chirico. Dalí's deep and long-established admiration of de Chirico was no doubt fed by his relationship, begun in 1929, with Gala Eluard, who had met the artist and owned some of his works.

Close study of de Chirico's paintings may be sensed in this masterly composition, in which mysterious objects cast long shadows and create an aura of solemnity. The beach scene is displayed here with a sense of unease that shows how competently Dalí had assimilated the atmosphere of de Chirico. The large, shrouded shape in the center of the canvas conveys its own dreamlike unreality, though it distantly echoes the form of some of de Chirico's draped white statues waiting forlornly in empty plazas.

The painting's foreground shadow rises before us like a gigantic gray screen, compressing the perspective and reaching toward the familiar bright hills of Dalí's childhood, which are contemplated by the shrouded shape. This oppositional aesthetic of contrasts, seen in other contemporary works, is indicative, in part, of Dalí's mental state—the vagaries of present desires threaten to obscure the certainties of the past. His new life with Gala, with its emotional uncertainties, begins to envelop him, as it does the white form, and he is remote from the comforting background of his origins. The white shape stands at the edge of the sea, like the swathed Ulysses gazing out to the ocean while held captive, as in Arnold Böcklin's influential painting *Ulysses and Calypso,* a composition echoed in de Chirico's *Enigma of the Oracle* and *Enigma of an Autumn Afternoon* of 1910.

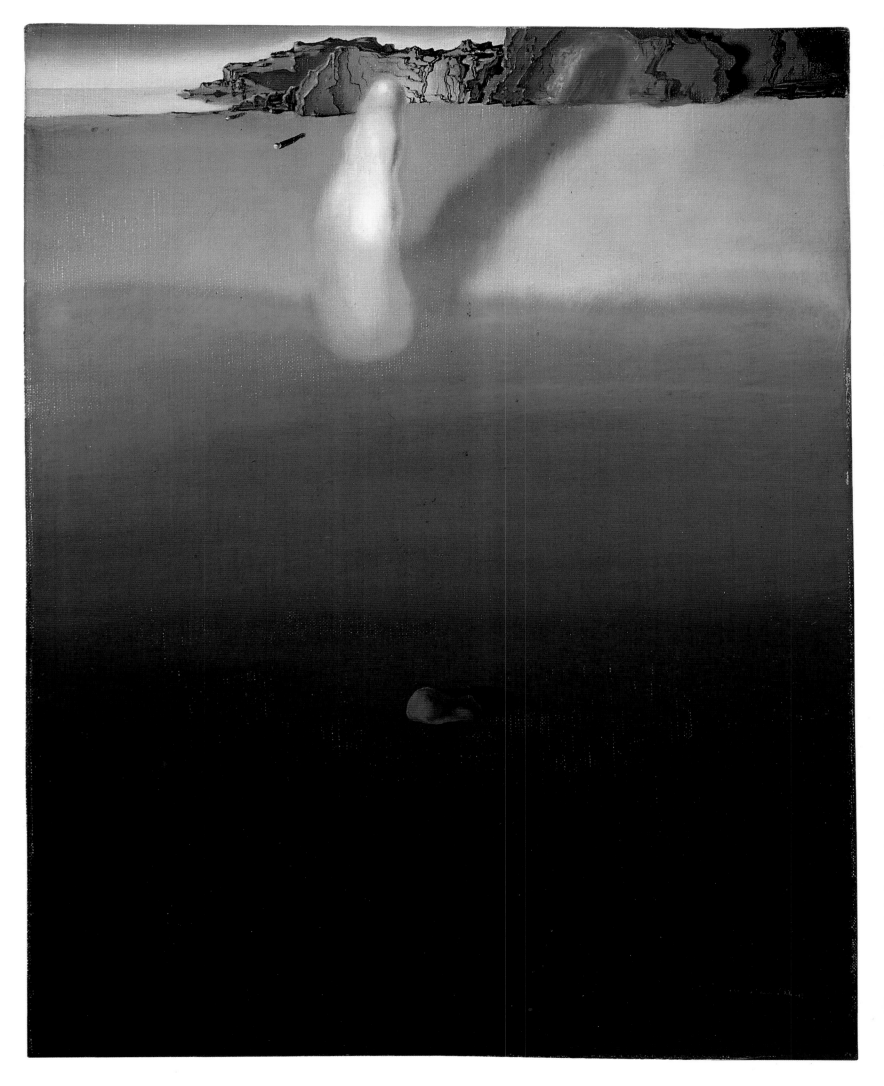

Shades of Night Descending

1931. Oil on canvas, 24 x 19¾" (61 x 50 cm). Signed and dated lower left: "Gala Salvador Dalí / 1931"

The brooding atmosphere that dominates the foreground of this painting is heightened by its contrast to the luminous beach scene in the background. Lengthening shadows announce the approach of the formless night; the silence of the work is disquieting. These evocative attributes are notable in the work of Giorgio de Chirico, so admired by Dalí and all the Surrealists, especially the sense of foreboding, the silent, suspenseful mood, captured by the long, raking shadows in his paintings.

However, what Dalí has done in this painting is not only to emulate the mystery and the melancholy of that important Surrealist precursor, but also to invest them with a more personalized focus. For instance, the large, dark shadow with its Böcklin-like sense of heavy drama, at the lower left, appears to be cast by a grand piano—an image that springs from the young Dalí's heady days at the Pichot home, where the family piano was often carried out onto the beach and played into the dusk. Similarly, the small white stone near the center, about to be enveloped by the approaching mass of shadow, is drawn from childhood memories of the Playa Confitera, a beach known and loved for its candy-shaped pebbles. These memories, along with the nostalgic ambience of the Cape Norfeo area, contrast with the actual situation of Dalí's life at the time, as his future wife, Gala Eluard, became seriously ill and underwent major surgery. The shrouded figure on the right hides domestic objects—a slipper, table, glass, and jug, perhaps emblematic of better times—while an amorphous shape seems to protrude ominously, like a growth, from its lower abdomen. This figure, reminiscent of the work of the Belgian Surrealist René Magritte, but more probably suggested by Gala's hospital experiences, emerges like a mythological shade from the rocks and shadows. Its evocativeness led Dalí to use it subsequently in other paintings and in his photographs with Man Ray for the magazine *Minotaure* in 1933. Within the arrangement of items hidden in its folds, it contains a compositional element that is a legacy from Man Ray's wrapped sculptural work *The Enigma of Isidore Ducasse* of 1920, a mysterious object itself engendered by the oppositional metaphors contained in the Comte de Lautréamont's fervent novel *Les Chants de Maldoror,* written in Paris in 1869. It is not surprising, then, that as a whole, *Shades of Night Descending* is organized by an opposition: the opposition between the idyllic past, in the background of the work, and the anxieties of the present, in the foreground—the pleasures of the far contrasted with the pain of the near.

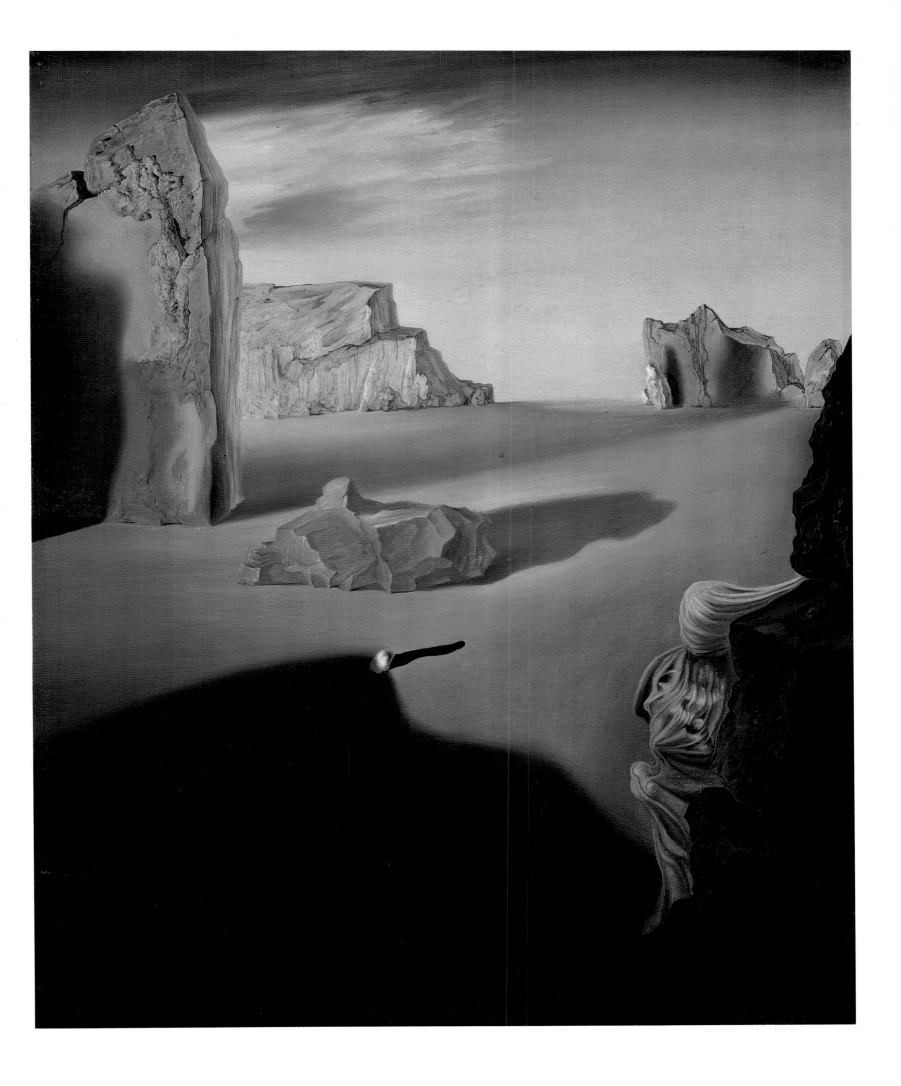

Memory of the Child-Woman

1932. Oil on linen canvas with section of offset lithography, 39 x 47¼" (99 x 120 cm). Signed and dated lower right: "a Gala Eluard Salvador Dalí / 1932"

Contrary to popular belief, the Surrealists were not particularly interested in depicting actual dreams. They were much more interested in how visual memories and poetic associations arise out of the flow of mental processes—images that come to us unformed and of their own accord, when we are only half asleep, or in other unguarded moments. In these states of mind, our thoughts often drift and are generally vague, but with sudden bright patches of clearly remembered sensations or images.

Memory of the Child-Woman reflects these Surrealist ideas about memory and imagination. In the lower center, we see the biomorphic features of Dalí, with a slight nosebleed, in half sleep, suspended in his own cocoon of dreaming blue light. The rest of the painting is made up of the thoughts and associations that emanate from this secluded and seemingly insignificant area. The beach landscape of external reality is all but blocked out by the large, ocher-colored, amorphous mass of eroded rock, suggesting the shape of an artist's palette; but this shape, culled from the paintings of René Magritte, is punctuated by large sections of crystal-clear vision. The locked cupboard in the right foreground, with its collaged section of displayed pocket watches, reminds us of the irrelevance of time to these mental scenes. The other key, at the upper left, also taken from Magritte's paintings, refers to "unlocking" the symbolic Freudian meaning of the painting's semihallucinatory associations; the key's angled position echoes the foreground key, forming a nexus which alludes to the fact that these thoughts are locked in the mind, as time is locked in the cupboard.

These thoughts are generally related to the emotional turmoil resulting from Dalí's desire for his own child-woman—his *femme-enfant*—the idealized woman of Surrealist theory. For example, in the background above the cupboard is a group based on the return of the Prodigal Son; considering the family friction caused by Dalí's liaison with Gala, this scene may indicate Dalí's desire for reconciliation with his father. A centrally placed father figure looms over all; his febrile face forms an anguished opposition to this Oedipal family tension, a stony resolve more clearly seen in the preparatory drawing, bought by Pablo Picasso. This imperious head, later used in Dalí's William Tell series, sits atop a naked female torso surrounded by the red roses that signify the romantic presence of Gala—whose pet name, Olivette, is inscribed three times, for the three years Dalí had known her, in the panel to the right. The small relief panel at the base of the central bust shows a scene of flagellation, which hints at the emotional stress and pain of this period. The memory of his mother is invoked in the plaintive inscriptions on the right, which read "my mother," repeated ten times, for the decade that had elapsed since her death. The background steps on the extreme left lead upward to the distant figure of Gala, beyond the edge of the painting, whose de Chirico-like shadow can be made out in the medallion opening to the left; the location of this scene is specified by the inclusion of a small spring outlet, based upon the fountain of Alsina in Figueres. This cameo view is balanced, on the right, by the clearly recognizable depiction of the nearby Isle of Farnera, which further stresses the precise local placement of the psychological drama. The familiar shadow of Mount Pani falls across the scene, adding a penumbral glow to this important work.

This painting, formerly in the Keller collection, was widely shown internationally, and it was instrumental in later inspiring many artists, among them Henry Moore and Barbara Hepworth in England, to take a deeper interest in psychological themes and the biomorphic potential of their own environs.

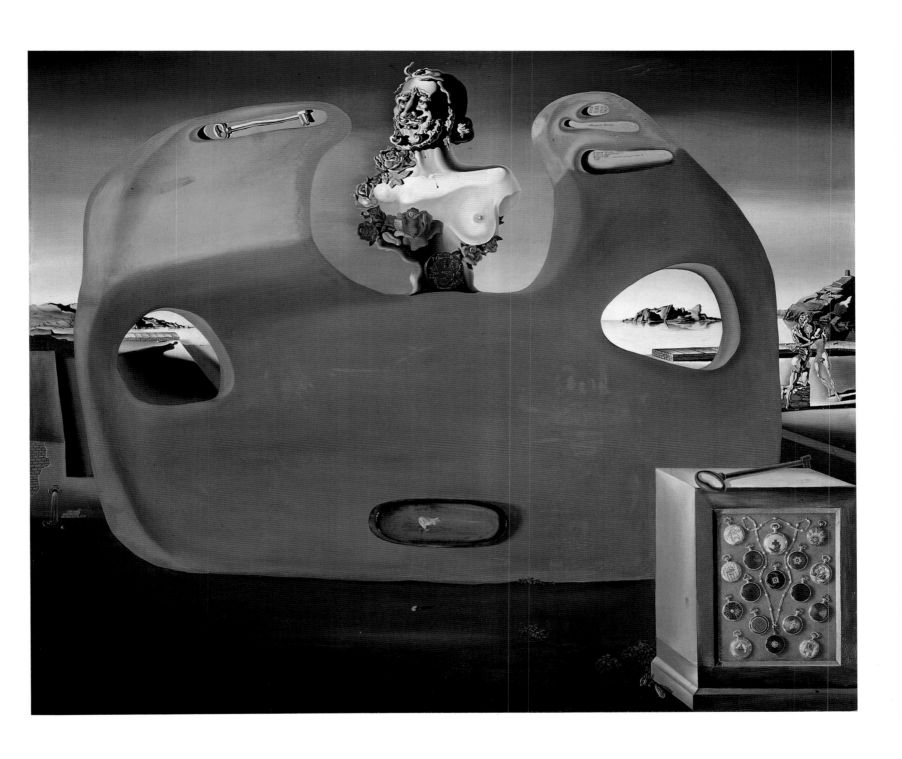

Sugar Sphinx

1933. Oil on canvas, 28⅝ x 23½" (72.5 x 60 cm). Signed lower right, in ink: "Gala Salvador Dalí"

This work, formerly in the O'Donohue collection, is one of Dalí's most meditative paintings. The large expanse of sky creates a quietly contemplative effect that is unique and hints at the solemnity of the theme.

The figure contemplating this scene is Gala Eluard, wearing the favorite striped jacket featured in many later paintings. She and Dalí were not yet married and their relationship held many uncertainties, exacerbated by the open hostility of Dalí's father and sister. Gala sits on an outcropping of rocks, quiet as a sphinx, her attention focused on the two cypress trees that stand in the mid-ground; our attention, too, is drawn to these trees by the way Dalí has them funnel back into the composition.

In Dalí's paintings, the image of the cypress tree makes its appearance shortly before this time, and its use is prompted by the tree's symbolism of mortality. This seemingly strange association is explained by the fact that cypress trees, despite being evergreen, do not regenerate if cut; this sense of finality explains their frequent appearance in cemeteries. Here, the two cypress trees shade two small, barely noticeable figures; a female on the right and a male to the left, in the poses of the couple in Jean-François Millet's famous painting *The Angelus* in the Louvre, a painting whose supposed sexual meaning Dalí later analyzed at length in his text *The Tragic Myth of Millet's "Angelus."* In the present painting, suffused with the somber colors of Millet's work, between Gala and the cypresses stands a wheelbarrow, which, according to Dalí, colloquially denotes a coital position. Perhaps more important is Dalí's related contention that the couple in *The Angelus* are not bent in daily prayer, as is generally thought, but rather that they are mourning the death of a child. The central cypress tree, placed between the figures, marks the spot of the presumed child's grave. Dalí's interpretation of Millet's painting leads to another possible personalization: for Dalí, Gala's recent hysterectomy may have added a poignant note to the theme of the loss of a child.

The overall impression of this powerfully suggestive painting is similar in its sweep to the work of the German artist Caspar David Friedrich, such as *Monk by the Sea,* and to some extent the work of the Belgian artist Fernand Khnopff. In this painting, we can see Dalí at his most reflective, considering the inevitability of death in a way that is indebted to a nineteenth-century Symbolist sensibility. Dalí's meditations center on the fearful associations of the ancient myth of the Sphinx, the female-faced poser of riddles. The large expanse of brooding Goya-like sky that looms over the scene vaguely recalls the bodily shape of the Sphinx of Giza. Gala's identification with the Sphinx is implied, her mystery and her power over Dalí seem acknowledged, but fear is defused—she is the "sugar sphinx" of the title, the one that poses no threat. She is the consultant oracle.

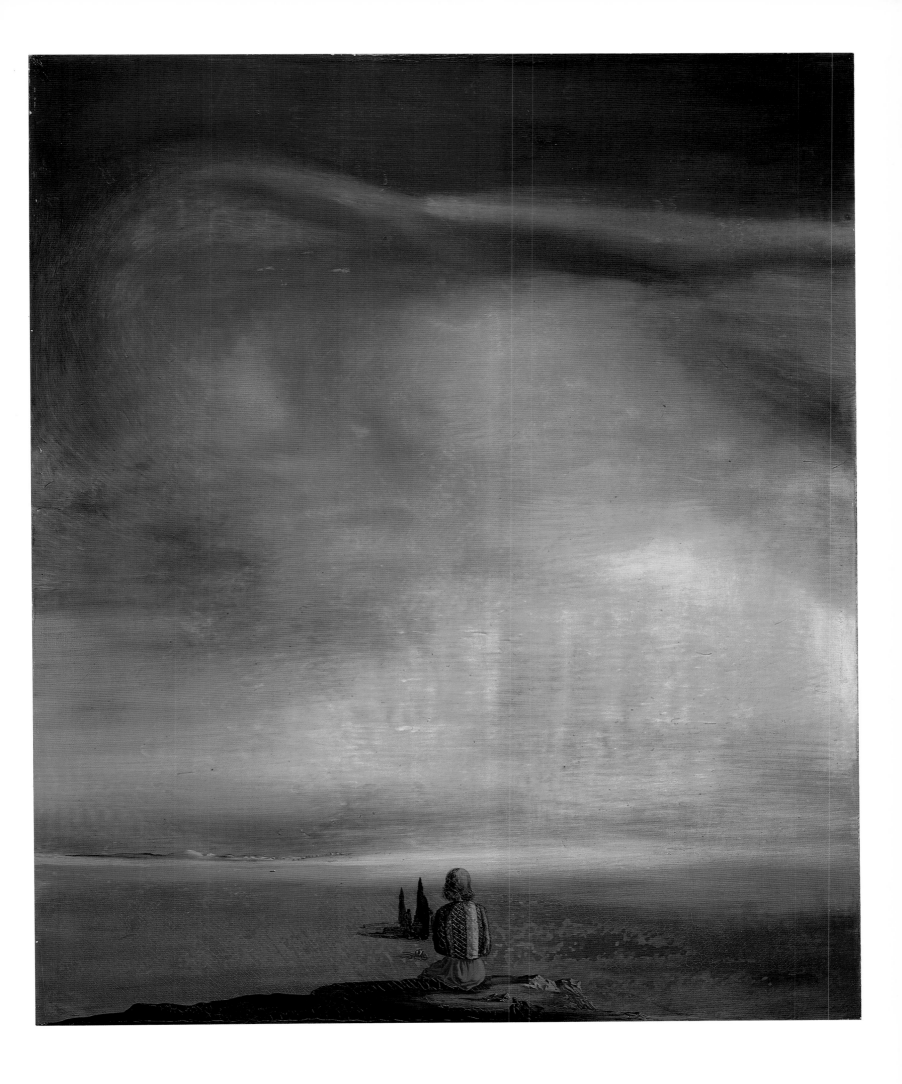

Portrait of Gala

1932–33. Oil on olive wood panel, 3⁷⁄₁₆ x 2⁵⁄₈" (10 x 7.2 cm). Signed lower right: "Dalí"

This small yet detailed work was completed one year before Dalí and Gala were married. The painting derived from a photograph, as did many of Dalí's portraits, and its size was preconditioned by the fact that the olive wood it is painted on is very difficult to obtain in larger sizes. This gave Dalí the opportunity to display his skill as a miniaturist, a technique that often required painting with only one hair in a brush. This portable memento is presented almost as a talismanic icon of Gala, for she stands in front of her namesake olive tree—one of Dalí's pet names for her was Olivette—the same kind of wood on which her image is painted. Indeed, her right foot seems to terminate in the soil, perhaps indicating that she is Dalí's "well-planted woman"—the woman associated with his new, happy life and international success. She is rendered in tones that belong to the narrow light range of black-and-white photographs, tones that give her a tanned appearance and replicate the afterimage effects of bright sunlight. This and the painterly freedom of the background seem to reflect a new optimism.

During this period, Dalí and Gala were settled into the small, simple fisherman's hut that they had purchased at Port Lligat, near Cadaqués. This became the site of their future permanent home, which at the time of this portrait was being developed by their friend the builder Emilio Puignau. In the period of this painting, Dalí gave her a number of pet names: "I call my wife Gala, Galutcka, Gradiva . . . Olive (for the oval of her face and the color of her skin), Olivette, the Catalan diminutive of Olive . . . Lionette (little lion, because she roars like the Metro-Goldwyn-Mayer lion when she is angry); squirrel, tapir, little Negus (because she looks like a pretty little forest animal); bee (because she brings me the essence of everything which, transformed into honey, nourishes the buzzing hive of my brain) . . . and Hazelnut because of the very fine down which covers her cheeks." In these terms of affection, it is difficult to recognize the rapacious, manipulative woman so often depicted by recent Dalí scholarship.

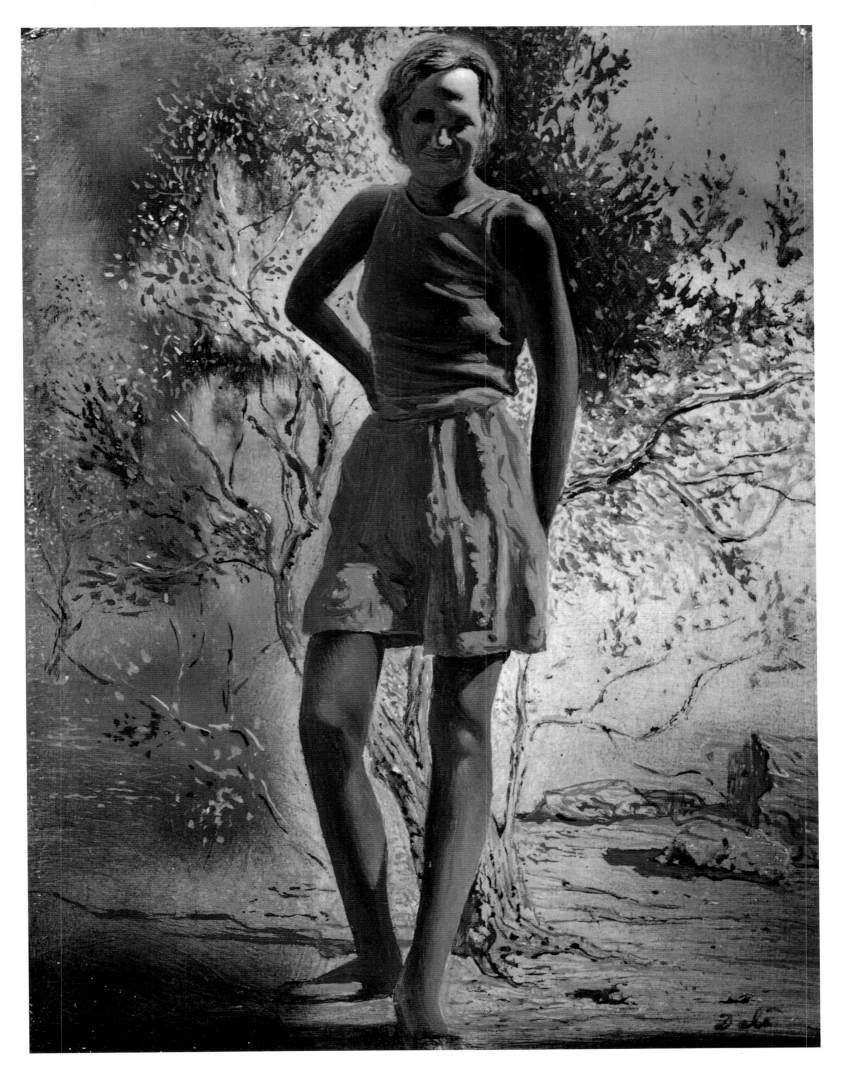

Skull with Its Lyric Appendage Leaning on a Night Table Which Should Have the Exact Temperature of a Cardinal Bird's Nest

1934. Oil on panel, 9½ x 7½" (24 x 19 cm). No visible signature

This small painting was executed during a year of intense artistic activity, the year during which Dalí married Gala. He also traveled to New York, his initial visit to the United States, arranged by Caresse Crosby, his first American patron. The success of the trip encouraged Dalí, and he managed to hold five solo exhibitions during this momentous year: two in Paris, two in New York, and one in London.

This work is most characteristic of that eventful year. In it, we find a background of simple colors and undistracting details; the sky fades toward the horizon. This muted background has the effect of throwing the foreground into harsh prominence. The foreground is made up of finely painted areas of stony earth, and rising from the lower left is a monstrous hybrid combining a distorted human skull and a floating grand piano (compare *Atmospheric Skull Sodomizing a Grand Piano* of the same year, page 75). This strange conjunction of objects is allied to the grand-piano scene in Dalí and Luis Buñuel's film *An Andalusian Dog,* where the piano is draped with two dead donkeys. In the film, this metaphorical juxtaposition is enhanced by the strange affiliation between the prominent teeth of the donkeys and the white keys of the piano. The counterpoint of teeth and piano keys plays a part in the painting as well, as the row of teeth in the skull is simply a continuation of the keyboard. In this way, Dalí suggests not only a visual relationship between them but a causal and philosophical one—the relationship, that is, between art (the piano) and death (the skull), which is so often cause for conjecture in later scholarly texts. In Dalí's mind, however, the link is clear: art results from a desire to fend off the ever-present intimations of mortality. A related 1933 drawing of skulls, reproduced in Dalí's diary of 1942, bears the revealing inscription "all my real memories are sealed with [the words 'inspired by' are scored out] the sense of Death."

Art and death form a dynamic, if morbid, partnership, an insight promulgated by Sigmund Freud and subsequently adopted by the Surrealists. Freud's important study *The Interpretation of Dreams* was translated into Spanish in 1923; Dalí's own annotated copy is still in existence, there is little doubt that at this time he was already well acquainted with the theories of the famous psychologist he was to visit in London four years later. In this painting, Dalí gives his own version of the Freudian principle of sublimation. Here, death transmutes itself into artistic endeavor—by means of the crutch of sexuality that is the intermediary support between it and the emerging piano. The grand piano, the "lyric appendage" of the title and emblem of cultural pursuits, floats upward toward rarefied heights, its scrolled music stand hovering in the ether like the symbolic lyre of Orpheus. Dalí's simple home, to the right, stresses the painting's personal associations, while the night table to the left is a nod to the origins of this sort of image: irrational, fleeting thoughts that come just before sleep—captured in what Dalí called a "dream photograph."

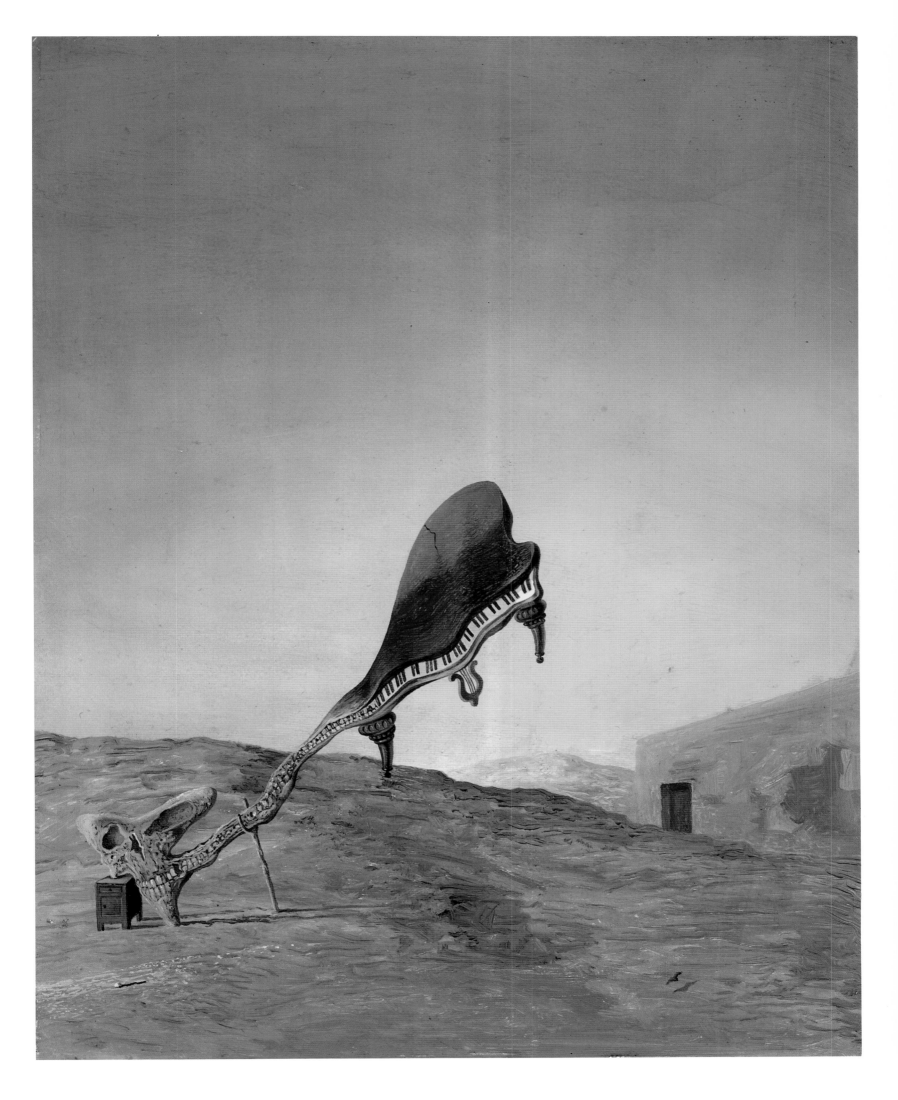

Atmospheric Skull Sodomizing a Grand Piano

1934. Oil on wood panel, 5½ x 7" (14 x 17.8 cm). Signed and dated on verso of panel: "Salvador Dalí / 1934"

This small and bizarrely composed painting, which once belonged to the Surrealist writer Lise Deharme in Paris, betrays an obsessive and gritty psychological sexuality. Its amalgam of the large skull with the grand piano is intended to shock, using the strategy of metaphorically juxtaposing unexpected items that so gripped the attention of the Surrealists.

The sexual undertones of the Comte de Lautréamont's famous clash of images, "the chance encounter between a sewing machine and an umbrella upon a dissecting table," are here made blatant. The central image of the painting grew out of three related associations. First, the grand piano, emblematic of high culture, is seen being attacked by a skull, symbol of death, and violently debased. Second, the painting recalls the famous scene of the grand piano in the film *An Andalusian Dog,* on which Dalí collaborated with his friend Luis Buñuel in 1929. In that scene, the piano is burdened by two dead donkeys, a powerful filmic metaphor for the dead hand of oppressive tradition and bourgeois art. And finally, the "sodomizing" of the piano, mentioned in the title, may have something to do with Federico García Lorca, whose advances Dalí repelled; their eight-year friendship was waning at about the time of this painting. These three associations are conjoined in Dalí's imagination. The piano and the skull meet on a plane, like Lautréamont's dissecting table, in a disturbing encounter. The force of Lautréamont's imaginative clash is redoubled, as the elegant form of the piano is violated by the harshly anthropomorphic skull. As Dalí said, "The lyricism of the piano is brutally possessed by the jaws of a fossil skull."

From this point on, Dalí's use of the symbolism of the piano would fade. He was finished with the piano, finished with civility and nostalgia. The background depicted, together with the careful realism of the boat, seems to stress Dalí's own origins—his personal remoteness from the sexual scene and his essential difference from high culture. The loving richness of the colors in the background highlights this difference. The raking light of the setting sun adds a further sense of drama, with ominous shadows approaching in the foreground.

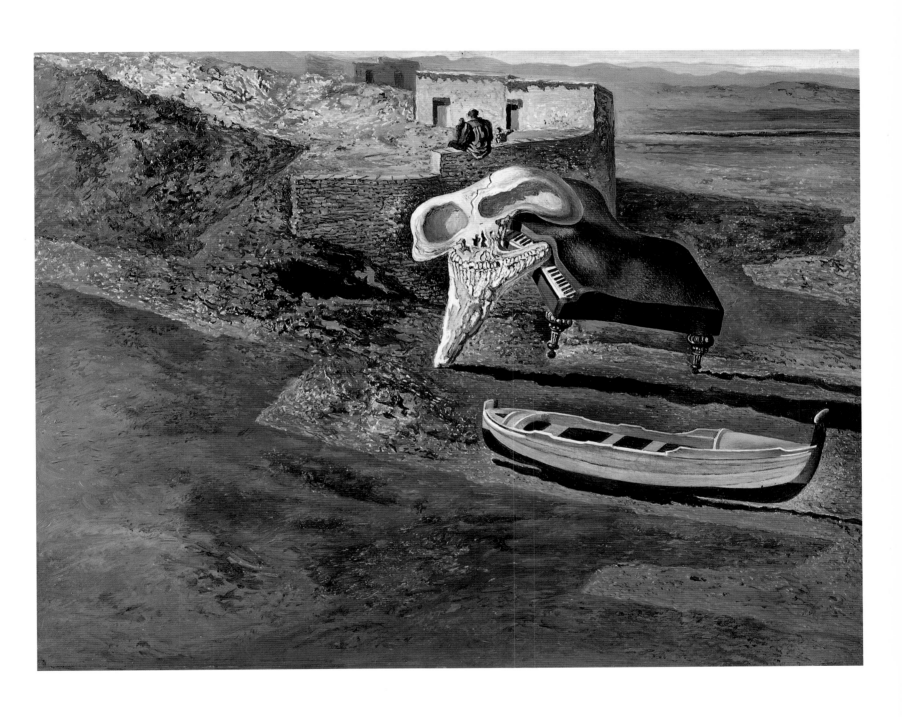

The Weaning of Furniture Nutrition

1934. Oil on redwood panel, 7 x 9½" (17.8 x 24.1 cm). Signed and dated lower left: "Gala Salvador Dalí / 1934"

Dalí's second published journal, his *Diary of a Genius* of 1964, mentions a painting relevant to *The Weaning of Furniture Nutrition*. The painting he cites is of a Nazi nurse wearing a swastika armband, knitting while seated in a puddle of water. That untitled work caused considerable controversy among the Surrealists, and Dalí was forced to paint out the Nazi armband. There is no reference to that work in other documents, and it is possible that it and others—such as a work showing Adolf Hitler as a woman, also mentioned in the diary—were destroyed during the German occupation of France. The portrait of Hitler no doubt grew out of the artist's fantasies and obsessions of the time. These had to do with a fetishistic attention to items of Hitler's clothing—his uniforms and Sam Browne belt—and to the dictator's doughy physique. The date of the two works Dalí mentioned is probably 1933 and the figures, as described, are presumably the forerunners of the sitting woman in the foreground of the present work, *The Weaning of Furniture Nutrition*. The careful emphasis on the back, clothing, and posture of the figure may give some inkling of its controversial and now lost precursors. If that is the case, then the painting is probably the closest surviving example of the sort of works and compositions, if not the content, that so displeased the Surrealists, and occasioned Dalí's expulsion from the group in 1934—the year of this painting. The painting escaped destruction by the Nazis when its then owner, Jocelyn Walker (Mrs. Charles Potter), fled with it under her arm to London, as the German army invaded the Channel Islands, where she lived. Dalí chose the painting as an illustration in his published journal, *The Secret Life of Salvador Dalí* of 1942.

The Weaning of Furniture Nutrition presents the familiar coastal landscape of Dalí's childhood (in this case, terraced for planting), together with the Playa S. Morera (with one of the Dalí family's two boats and five others) at Port Lligat, close to his own home and studio. In the foreground of this beach scene sits a female figure, based on either Lidia Nogueres or, more probably, Lucia Moncanut, Dalí's childhood nurse, shown in an exaggerated scale that emphasizes her importance and prefigures her appearance in many other famous paintings, such as *Apparition of Face and Fruit Dish on a Beach* of 1938. She sits with her back to the viewer, knitting or perhaps mending a fishing net, with a section of her torso cut out in the shape of the night table that stands next to her—a seemingly bizarre image that may have derived from Dalí's recollection of his first trip to Paris, in 1926, and seeing the upper story of the Hôtel des Invalides, which, as Dalí noted, has windows cut out of human figures. The night table itself is cut out, with the shape of a smaller table and a bottle, in a compositional configuration emulating the influential art of Dalí's friend René Magritte. The crutch, emblematic both of sexuality and emotional support, which braces the sitting figure, is associated with the nurse's nurturing of the young Dalí.

The Weaning of Furniture Nutrition was painted during a momentous year for the artist: he became legally married to Gala, he was working at an unprecedented pace, and his fame spread as he had five international solo exhibitions and made his first trips to London and New York. This much-reproduced painting, probably first shown in Dalí's solo exhibition at the Galeria d'Art Catalonia in Barcelona, is one of his most meticulously painted, and most accomplished, works of the time.

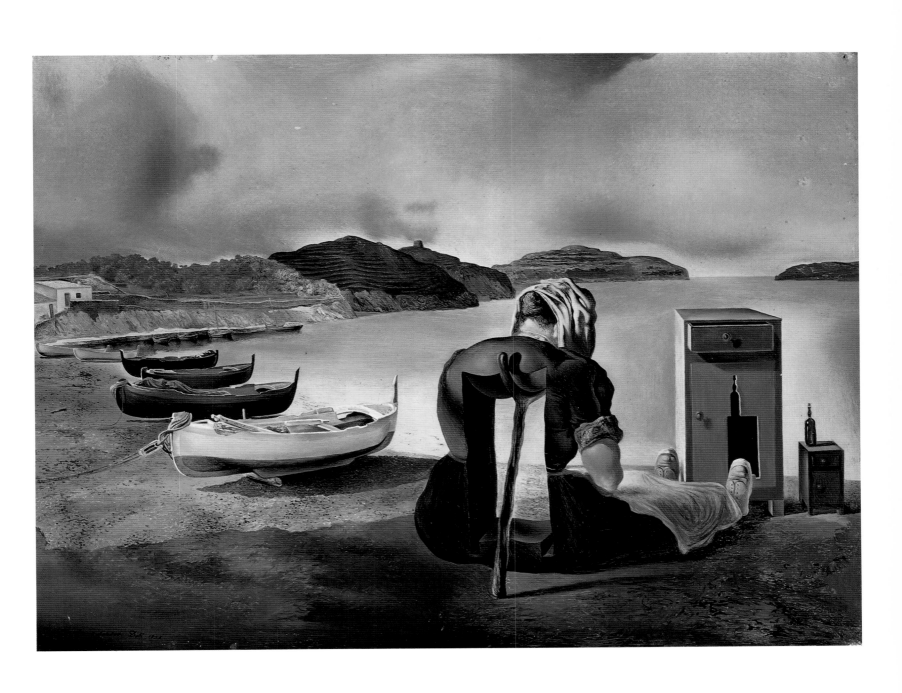

Archaeological Reminiscence of Millet's "Angelus"

1933–35. Oil on panel, 12½ x 15½" (31.5 x 39.2 cm). No visible signature

Formerly in the collection of the American writer Julian Green, this is one of Dalí's most puzzling works of the period. In the 1930s, the Surrealists were much concerned with finding new, contemporary myths that could replace classical mythology as an explanatory model of human behavior, and thereby act as a creative source for the artistic imagination. One of these, and there were many, centered on the bizarre mating ritual of the praying mantis, in which the male mantis, after serving its procreative purpose, is killed and devoured by the female. This remarkable phenomenon, part of the natural, if terrifying, order of things, seemed to reveal something about human lives as well, becoming an entomological metaphor for the eternal battle of the sexes, now seen as fatal to the male. It enhanced the significance of a range of nineteenth-century depictions—of the Sphinx, the Siren, the Vampire, of Judith and Salome—viewing them as manifestations of unconscious male fears within a perennial psychosocial drama.

In typical fashion, Dalí personalized this theme, using it to try to pin down the hidden reasons for his long fascination with the painting *The Angelus* by Jean-François Millet. He idiosyncratically interprets Millet's figures as being posed in the attitudes of praying mantises; for Dalí, the Millet painting became an unconscious parable of female sexual power. The female figure, to the right, poses expectantly, ready to pounce, while the male, head bowed in defeat, vainly tries to protect his genitals with his hat. Dalí's own long-established fears of female sexuality, of impotence and castration, now found a portentous pictorial source, a new "paranoiac-critical" focus. As a consequence, Dalí often turned to this theme as though to expunge his fears.

In *Archaeological Reminiscence of Millet's "Angelus,"* the low horizon line and the almost empty landscape emphasize the monumentality of the strange structure in the foreground. Dalí transforms the Millet figures into monuments not because they are to be seen as dead symbols, but because they represent ever-present, ancient principles, the foundations of human sexuality. Arnold Böcklin's evocative painting *The Isle of the Dead* informs the moonlit gloom of this powerful work, and its cypress trees, symbols of death and finality, stress the atmosphere of fatalism. These supposedly universal principles, in a process of male initiation, are being shown at the bottom center to a small boy—a boy, perhaps Dalí himself, who is also seen to the right, with a seated nurse; these two similar scenes underscore the contrast between the innocence of childhood and the fears of adulthood.

This work's symbolism clearly arose from Dalí's "paranoiac-critical method," a technique that he elaborated at length during the year of this painting in his *Conquest of the Irrational,* published in New York. In this method, when spontaneous, unpremeditated attention is drawn to an object or an event—in this case Millet's *The Angelus* and its associated thoughts of human sexual drama—the object is then searched for a personal psychological significance that can be given symbolic form, as in this painting.

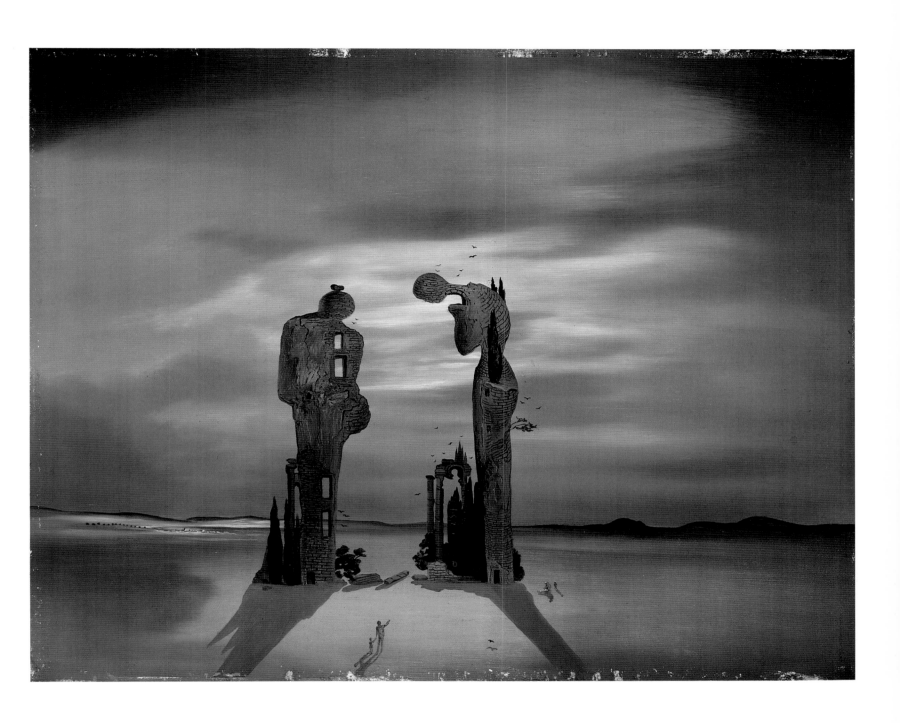

Decalcomania

1936. Gouache on black paper, 12 x 15" (30.5 x 38 cm). No visible signature

This work on paper gives an idea of the range of Dalí's art beyond oil painting and is instructive in its use of the popular Surrealist technique of decalcomania. Decalcomania was invented by Oscar Dominguez in Paris in 1936. Essentially, it is a form of monotype or transfer and was intended to produce suggestive images that invited the artist's visual speculation, creative response, and personalized modification or retouching. The origin of the technique owes much to the diagnostic Rorschach test (named after its inventor, the Swiss psychologist Hermann Rorschach), which asked the subject to interpret "images" that had been produced by folding or pressing paper onto random blobs of ink or paint. The Surrealists used it to produce freely constructed images unobtainable by traditional means and, more important, beyond rational control.

Dalí adopted this new technique promptly, and he used it imaginatively, as shown by this very early example, once in the collection of Georges Hugnet. The technique in this case produced a skeletal image of a woman with a head of flowers, an image related to Dalí's contemporary paintings and to some of his entries in the International Surrealist Exhibition in London in 1936—the year of the production of this work. The skeletal woman is elaborated upon by the painted addition of a conventionally executed strip of winged death's-heads, which ominously circle the central image. The juxtaposition of a woman with symbols of death was a favorite device of the Surrealists, and one that had a cultural legacy derived from the art and literature of the late-nineteenth-century Symbolist movement and was visible in the work of Gustave Moreau, Pierre Puvis de Chavannes, Fernand Khnopff, Félicien Rops, Edvard Munch, and Gustav Klimt. For Dalí, this provocative sort of image became a recurrent theme, cropping up at various times and in various paintings throughout his career and figuring prominently in his writings.

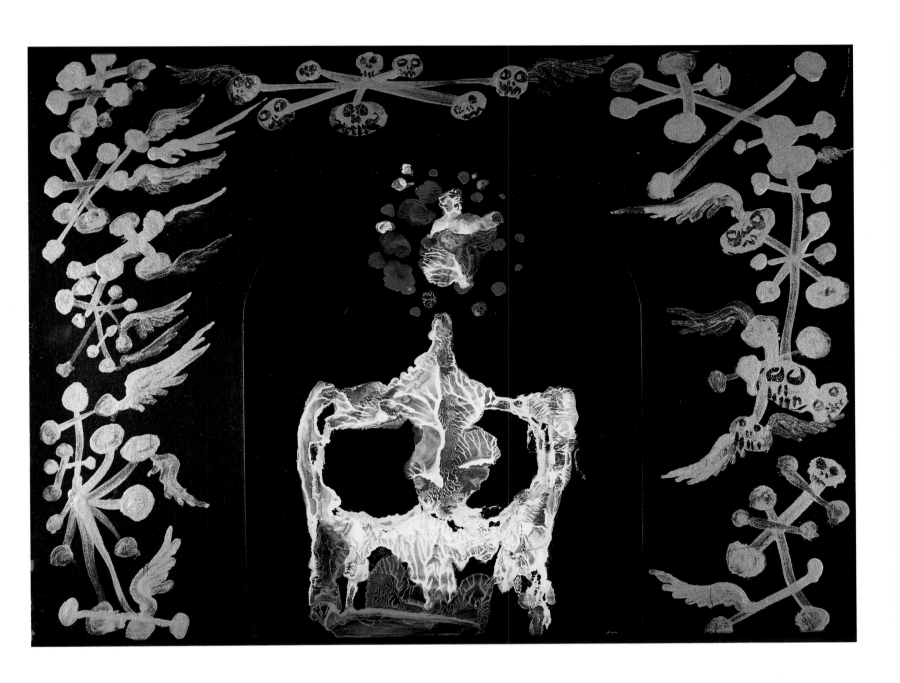

Morphological Echo

1936. Oil on panel, 12 x 13" (31 x 33 cm). Signed and dated lower right: "Gala Salvador Dalí / 1936"

This painting presents us with Dalí's familiar use of the plane of a tabletop, a plane that in his works usually proffers a visual conundrum or a psychological lesson. In this case, the tabletop in the foreground, inspired by the table in Jan Vermeer's painting *Mistress and Maid* in the Frick Collection, New York, contains three simple objects: a glass with a spoon, a piece of bread, and a bunch of black grapes. These three innocuous objects, set on an altarlike plane, lead vertically up to their three corresponding, complementary forms, which in turn lead farther upward to three other forms. Such is the arrangement that it is difficult to ascertain which form was the original source of its related partners. The vertical relationships are dynamic yet fugitive, and the painting acts as an object lesson in Dalí's use of visual cues, which for him were springboards of the imagination.

The whole diagram of formal relationships is suspended in an area faintly suggestive of a beach scene, with no distracting details that might interfere with contemplation of the lesson. The bunch of grapes on the right leads the eye up to a man resting on the beach and in turn to the sloping wall above; the form of the central portion of bread is related to the familiar figure of the sitting nurse and the rock above her; and the glass on the left finds itself mimicked in the shape of the walking figure and in the tower in the upper register. A preparatory drawing, reproduced in Dalí's diary of 1942, shows how carefully he worked out the visual relationships between these disparate objects; he seems to have been pursuing analogies between their shapes. The other Surrealists, too, especially André Breton, were always interested in these sorts of analogical references, whether between words, images, or objects. For them, the word *like* was the most magical of all words: to say that this is like that is to begin to reveal a fascinating network of latent connections between things, enriching our feeble perceptions with poetic associations.

This painting thus forms a sophisticated example of the verbal transposed into the visual, that is, a visual continuation of the verbal practices of the Surrealists; Dalí has placed objects to act as visual links in the same way that words act in similes. Among the Surrealists, Dalí was not alone in developing these analogical links. The paintings of his friend René Magritte are the most popular extensions of this interest, but Magritte's philosophical and semantic interests are absent from this painting by Dalí. What we see instead is a form of visual association, an attempt to give suggestive form to vague optical relationships.

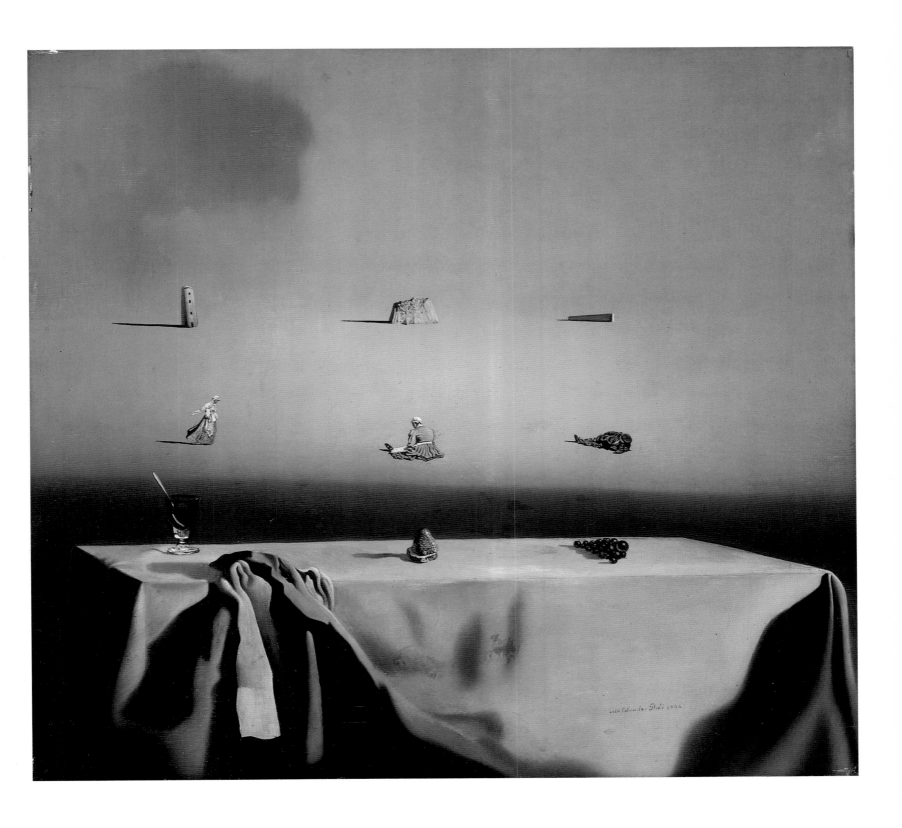

Three Young Surrealist Women Holding in Their Arms the Skins of an Orchestra

1936. Oil on linen canvas, 21¼ x 25⅝" (53.3 x 65 cm). Signed and dated lower right: "Gala Salvador Dalí / 1936"

This painting, formerly in the Fransioli collection, was executed at a propitious time in Dalí's artistic development, as his work was accepted internationally and vied for by collectors. Dalí was enjoying success in the International Surrealist Exhibition in London, where he was accepted into intellectual circles and attracted the patronage of such influential English collectors as Edward James, Cecil Beaton, Peter Watson, Lord Berners, and Sir Roland Penrose.

Three Young Surrealist Women Holding in Their Arms the Skins of an Orchestra reflects, to a certain extent, the invigorating atmosphere of those halcyon days. The painting seems to have been completed before the outbreak of the Spanish Civil War, containing no hint of the turmoil that was to follow. The sunlit beach poses no psychological menace and no looming sky broods over the scene. Earlier, Dalí's painting *The Persistence of Memory* of 1931, with its famous melting watches, symbolizing the irrelevance of time, had stressed the indelible nature of some mental associations and recollections, a concept that owes much to Dalí's reading of Marcel Proust's classic novel, *Remembrance of Things Past.* The present painting deploys some of the same symbolism but to new effect. The grand piano and the cello, recalling the artist's formative days with the Pichot family and its musical evenings, are limp and now irrelevant—indicating a time that had passed. Dalí's interest had moved to another plane, and early memories played a diminishing role in his work. The fact that his own profile can be vaguely made out in the soft form of the grand piano only emphasizes that the part of him once associated with the piano is depleted, the theme exhausted. The influence of René Magritte, alluded to in the very detailed rendition of the tarnished tuba at the left, is also jettisoned on the beach associated with Dalí's youth. The three women, with heads of flowers and shrubs, are no doubt related to Dalí's bleeding rose and Gradiva theme of 1930, a theme occasioned by Wilhelm Jensen's novel *Gradiva: A Pompeian Fantasy* and the associated work of the French artist André Masson. Though this literary and pictorial relationship is important, Dalí adds to it by associating the figures with the Three Graces of Greek mythology; their attributes of the myrtle, the rose, and the apple blossom are displayed as identifying facial features—which were probably suggested to Dalí by contemporary advertisements for shower caps. The central Grace, usually turned away, here faces the viewer and in her posture heralds Dalí's new ambition and confidence: her pose mimics that of the film star Jean Harlow in her seductive Hollywood publicity photographs, and she wears the famous tear-image dress that Dalí designed for the Italian couturier Elsa Schiaparelli. Dalí's aesthetic direction is clear: away from memories of the past and toward images of the present—fashion, the broader world, and America. Little wonder that in the year of this painting, Dalí's face appeared on the cover of *Time* magazine.

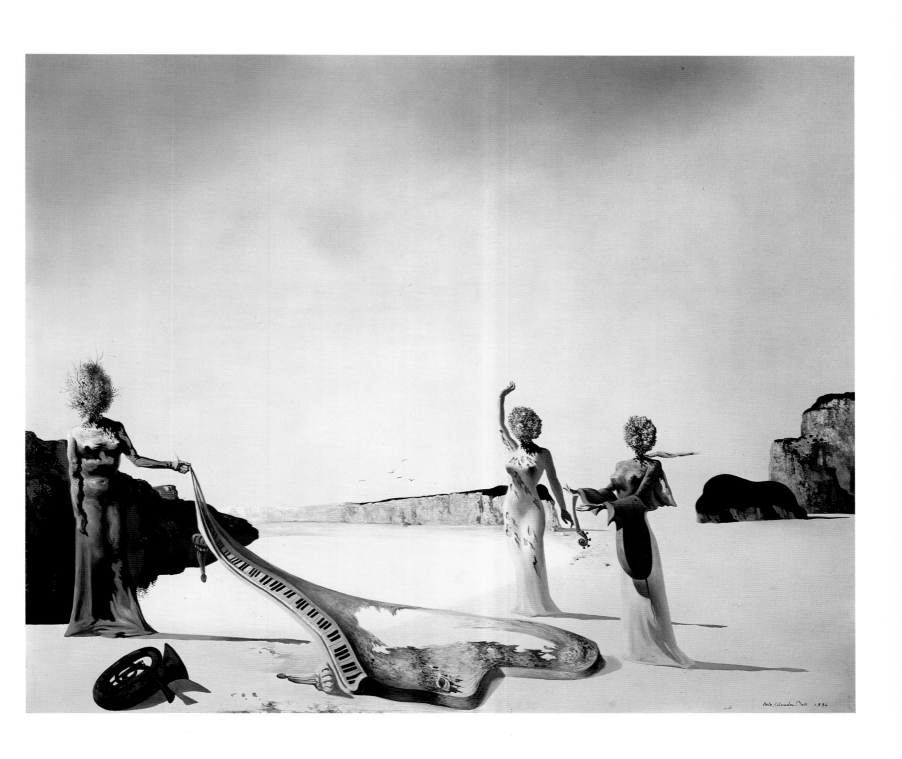

Telephone in a Dish with Three Grilled Sardines at the End of September

1939. Oil on linen canvas, 18 x 21⅝" (45.5 x 54.7 cm). Signed and dated lower right: "Gala Salvador Dalí / 1939"

This important work was painted at Coco Chanel's villa near Monte Carlo, in the year of Sigmund Freud's death. It was first shown in Dalí's solo exhibition at the Julien Levy Gallery, New York, in 1939. Part of a series based on related themes in the late 1930s, the painting is noteworthy because Dalí selected it for illustration in the first edition of *The Secret Life of Salvador Dalí* in 1942, and it was reproduced in the American magazine *Newsweek*.

Reminiscent of the work of Giorgio de Chirico in its solemnity, the painting is also remarkable for its somber tonal range as well as for its bizarre collection of elements. The painting's strange components were suggested by the much-reported telephone conversations in 1938 between Adolf Hitler and the British Prime Minister, Neville Chamberlain, who was attempting to avert the anticipated war. Most of the other paintings in the series by Dalí on this theme were subsequently seized during the Nazi occupation of France and probably destroyed. This surviving work is a notable example of Dalí's technical accomplishment, his skill at realistic representation, and his ability to offer symbolic interpretations of historical events. The traditional Spanish still-life composition is modified by the dark, brooding psychological qualities growing in importance since the outbreak of the Spanish Civil War. With the threat of a larger war, an even greater intensity comes to pervade Dalí's work at this point. In this regard, *Telephone in a Dish with Three Grilled Sardines at the End of September* is linked to such other works of the time as *Beach Scene with Telephone* (Tate Gallery, London), *The Sublime Moment* (Staatsgalerie, Stuttgart), *The Enigma of Hitler* (The Prado Museum, Madrid), and *Imperial Violets* (The Museum of Modern Art, New York). Here, a large dish, which dominates the composition, contains three sardines, a fish associated with Spain, while a disconnected telephone suggests the probable outcome of the conversations between Hitler and Chamberlain.

The background in this composition is familiar and related to Dalí's other Spanish landscape works, placing the painting firmly within a personal, localized context. The background figures to the right seem despondent, while the often-seen figure of the skipping girl—combining the form of his cousin with the shape of the bell tower at Figueres—seems to flee the heavily shadowed drama. The painting's pensive atmosphere reveals not only Dalí's private anxieties, but also his disconsolate thoughts on a penumbral period in European history.

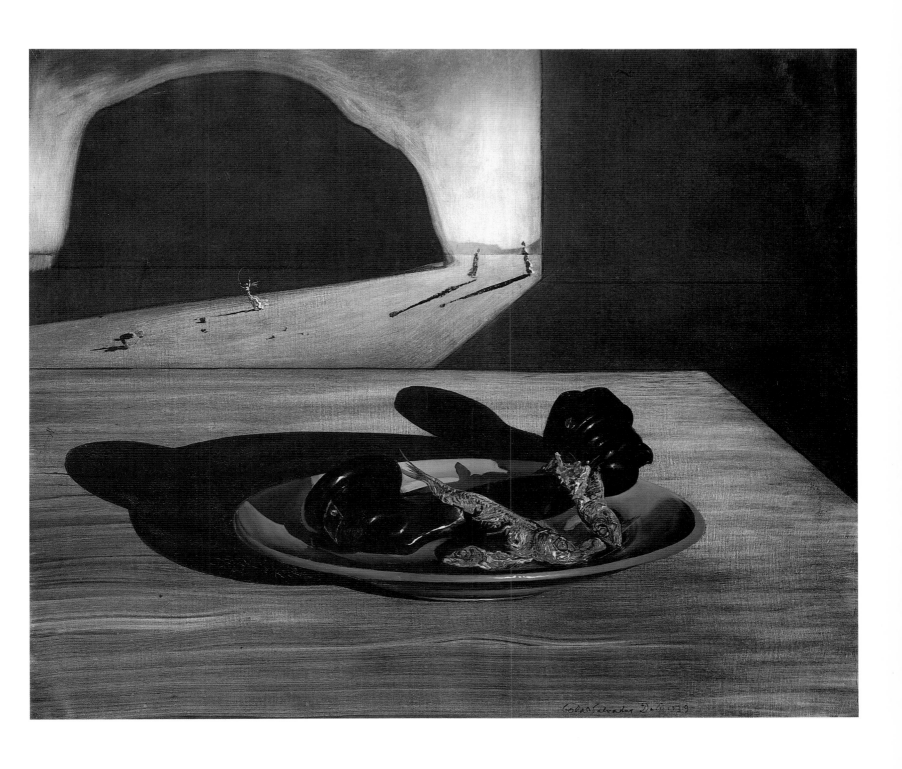

Tristan Fou

1938–39. Oil on wood panel, 18 x 21⅝" (46 x 55.2 cm). Signed and dated lower right: "Gala Salvador Dalí / 1938"

*T*ristan Fou (or *Mad Tristan*) is a study for one of the backdrops to a ballet of the same name that Dalí, admiring the wide-ranging talents of Renaissance artists, used as an opportunity to extend his imaginative repertoire. This rare work disappeared from Dalí's apartment during World War II; it was purchased in Paris by an American soldier, who later took it to the United States.

The ballet, not performed until 1944 because of the war, had been conceived by Dalí, who was responsible not only for the curtain, backdrop, decor, and costumes, but the scenario as well, with choreography by Léonide Massine to music of Dalí's favorite composer, Richard Wagner. The production was, no doubt, spurred by the success of Dalí's two earlier ballets, at the Metropolitan Opera House, New York, in 1939 and 1941, entitled *Bacchanale* and *Labyrinth.* There would follow two other ballets, also performed in 1944: *El Cafe de Chinitas,* in Detroit, and *Sentimental Colloquy,* at the International Theater in New York. The bizarre imagery of *Tristan Fou*—it was subtitled *The First Paranoiac Ballet Based on the Eternal Myth of Love in Death,* and a drawing for the costumes in Dalí's 1942 diary bears his note that the outfits were never made, because they were "too mad"—must, however, have puzzled the New York audience; the production, mounted by Ballet International, drew only indifferent critical notices from the *New York Sun* and the *Morning Telegraph,* on December 16, 1944. Very little was recorded about *Tristan Fou,* its reception perhaps leading to some neglect.

Even without details of the production, we can surmise something of the ballet's content from this painting. Two oval openings seem to beckon the white figure on the right, who, perhaps anguished by the dilemma, holds her hand to her head. The oval on the right denies access with a network of green arms, while the left is open in verdant welcome. The two guardians to the central portal, precedents for the figures in *Disappearing Bust of Voltaire* of two years later (also in the Salvador Dalí Museum), lead the eye into the depths of a Palladian corridor, which is also evident in some other works of the time. The dark eyes of the face on the pediment above seem to indicate that this corridor must be entered blindly—that is, without rationalization. Behind the yellow wall lies the shadow land of Dalí's subconscious, source of the themes of the ballet. There we find the familiar lid of a grand piano, seen in earlier works, recalling Dalí's youth; gigantic figures based upon Millet's *The Angelus,* with their foreboding; and the empty beach scene, the boat, and the rocks that he so often returned to. Here, too, for the first time, we see the shape of a Cadillac automobile, on the far right, protruding from the rocks of Cape Creus and giving a telling indication of ambition; Dalí was to buy his first Cadillac less than a year later, a potent contemporary symbol of success that he presented to Gala as a gift. The painting thus not only suggests some of the content of the ballet production, but also gives us a brief glimpse behind the scenes of Dalí's own drama.

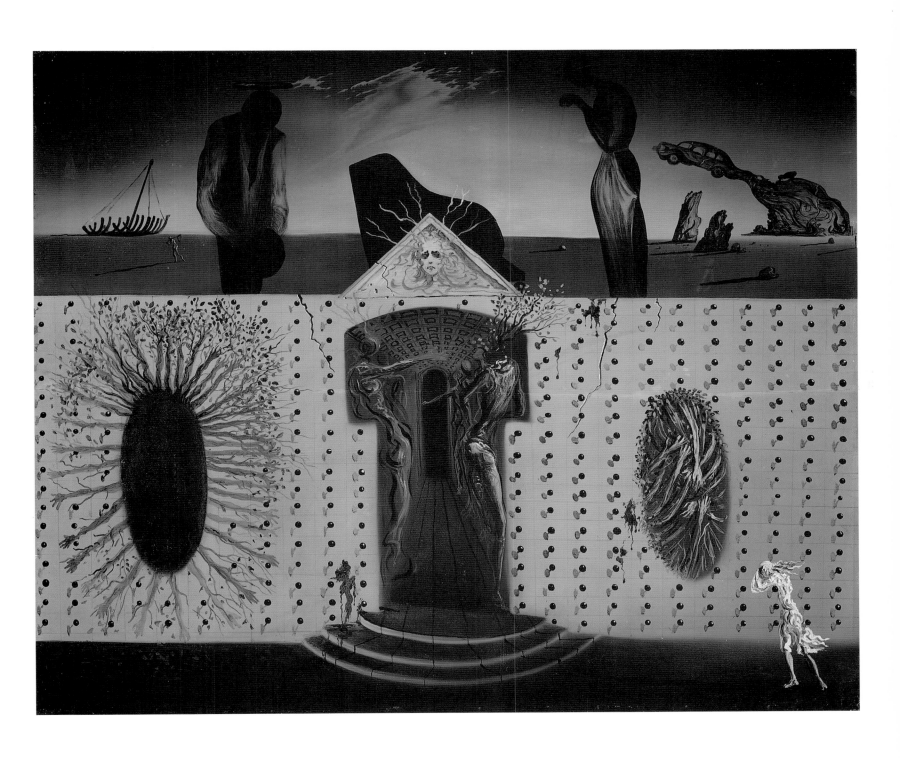

Daddy Longlegs of the Evening—Hope!

1940. Oil on linen textured pulp paper, 16 x 20" (40.5 x 51 cm). Signed and dated lower right: "Gala Salvador Dalí / 1940"

Dalí's familiar landscape is here denuded. The olive tree, emblem of peace, is stripped of its leaves, and the Italianate figures in the background seem to dance a *sardana* of death, their shapes and their ballooning sleeves echoing the languid forms draped across the foreground. Dark shadows, suggestive of evening, cling to the objects and give a sense of loss. This whole melting spectacle is lamented by a winged putto, symbol of love and of artistic pursuits, who sits weeping in the bottom left corner. This putto, recalling the weeping cupid in Félicien Rops's *Pornocrates,* suggests the meaning of this painting, which depicts another sort of pornography—the pornography of war. Set in the devastation of World War II, which Dalí and Gala had recently fled, this work allegorizes the emotional effects of great human upheaval. It is a theater of conflict whose prologue Dalí had already seen in the Spanish Civil War and which he would describe in *The Secret Life of Salvador Dalí:* "Throughout all martyred Spain arose an odor of incense, of the burning flesh of priests, of spiritual quartered flesh, mixed with the powerful smell of the sweat of mobs fornicating among themselves and with Death." Painted in 1940 amid fears of even greater carnage, this work extends the imagery of Dalí's famous *Persistence of Memory* of 1931, now offering us a compendium of cultural enervation—a world grown hostile to artistic effort.

Dalí places himself in the center of this limp world; his features, drawn in the outline of his familiar beach rocks, are joined to the hollow, decaying figure of creativity, draped over the olive tree that once gave it life. Combining attributes of literature (the inkwells) and music (the cello), the wasted body gives shape to Dalí's thoughts. The cannon from Giorgio de Chirico's painting *The Philosopher's Conquest* of 1914 finds itself repeated in the upper left corner of this work, a cannonball assuming the testicular shape appropriate to the cannon's phallic association. Supported by a crutch, the weapon exudes a lifeless seminal mass with a spent spermatozoalike form at its base. Out of this oozing mass rises an ill-defined Nike—a bandaged Victory of Samothrace—being threatened by a decaying horse of the Apocalypse.

The total impression of this disturbing painting, inspired, like Pablo Picasso's *Guernica* of 1937, by the carnage of war, combines lassitude and decay with a sense of remorse. Dalí's inclusive imagination sees these different qualities all playing a part within a cultural tragedy. Yet the tragedy is mitigated to some extent by the centrally placed daddy-longlegs spider of the title, a traditional token of good luck that adds a glimmer of hope.

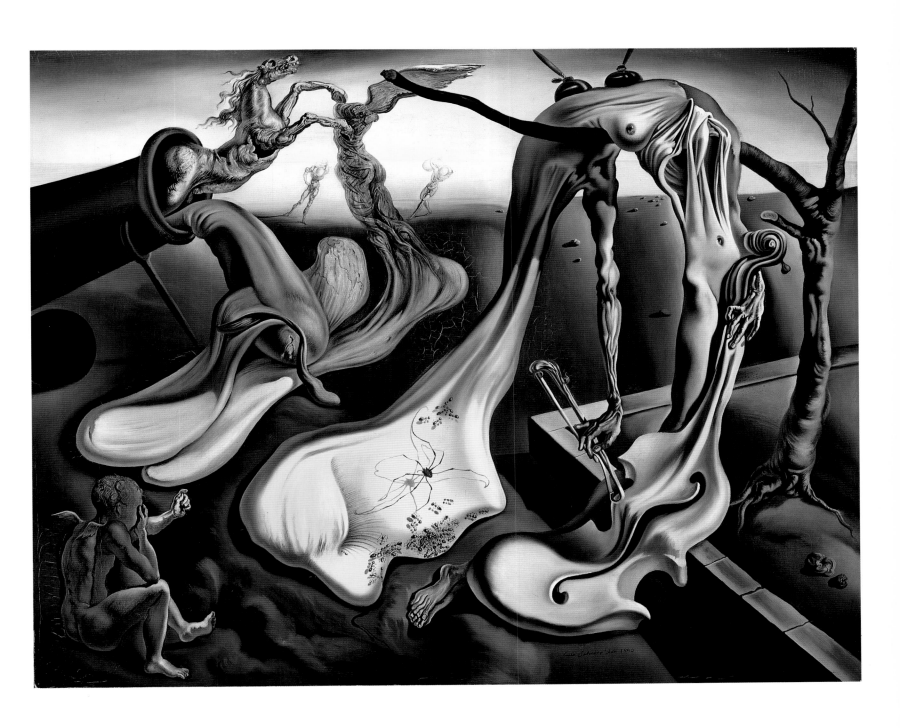

Old Age, Adolescence, Infancy (The Three Ages)

1940. Oil on canvas, 19⅝ x 25⅝" (50.2 x 65 cm). Signed and dated lower center: "Gala Salvador Dalí / 1940"

Formerly in the González collection, this painting was executed the year Dalí traveled to the United States to escape World War II. The devastation of the Spanish Civil War, which he had earlier seen firsthand, on two separate occasions, may have suggested the ruined wall in this work, similar to the one in *Slave Market with the Disappearing Bust of Voltaire* of the same year (page 95). The holes in the brick wall outline the rendition of a *memento mori,* a traditional, cautionary reminder of the presence of death.

In this meditation on time and death, some of the work's meaning is conveyed by the placement of three chestnuts in the immediate foreground: to the far left, an old chestnut with ribbing indicating its advancing age; in the center, a mature, plump chestnut; and to the right, a chestnut husk suggesting immaturity. These three forms lead the eye into the picture, where corresponding images of human features emerge from the mid-ground wall and the beach scene—forming an anthropomorphic metaphor of the relentless progress of time. To the left, an irregular hole reveals a craggy landscape with a cave, three trees, and a waterfall—which visually transform themselves, Arcimboldo-like, into the features of an old man, while also producing a shrouded figure suggestive of mourning. This process of suggestion is repeated in the central portion of the canvas, where the face of a younger man arises, the houses across the water forming his eyes, opposite a bay viewed by a sitting figure whose shape, in back view, suggests the nose, lips, and chin of the imaginary face. Dalí, dressed in his childhood sailor's suit, is at the center of this work, next to the figure of his friend Lidia Nogueres. To the right stands a candlestick, its point leading to a child's face vaguely formed by the background figure of a net mender on the distant beach. Another net mender, in the far background, repeats the motif, and its bent profile suggests Nogueres, who was seen, now aged, by Dalí in the year of this painting. The Italianate figure on the far right refers back to Dalí's stays in Italy in 1937 and 1938, when he was able to study the fantastic visual constructions and double images of Giovanni Battista Bracelli and Giuseppe Arcimboldo, artists whose works inform the convoluted shapes of this painting.

The popularity of this complex work attests to the fascination of the perennial theme of temporality, and of the fundamental questions that it poses.

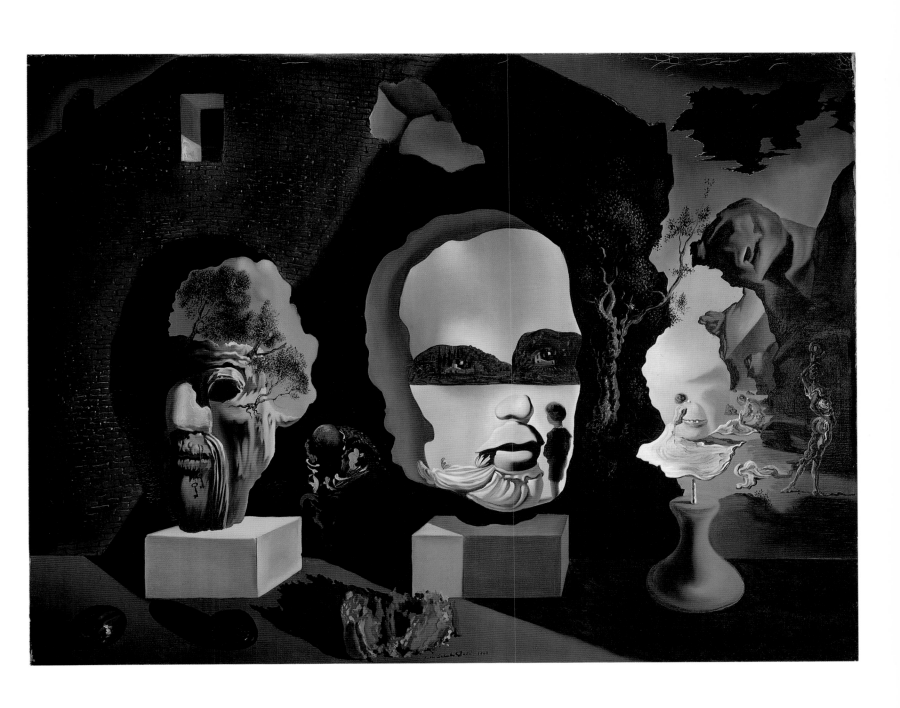

Slave Market with the Disappearing Bust of Voltaire

1940. Oil on canvas, 18¼ x 25¾" (46.2 x 65.2 cm). Signed and dated lower right: "Gala Salvador Dalí / 1940"

This popular and perplexing painting, formerly in the Hambuechen collection, was executed at the Villa Flamberge in Arcachon, north of Bordeaux, where Dalí and Gala had fled to escape the Nazi invasion of France. At the time, Dalí was investigating the nature of double images, an interest related to his study of the imaginative work of the Italian artists Giovanni Battista Bracelli and Giuseppe Arcimboldo, which he had been able to examine closely in Italy in 1937 and 1938. The present painting draws on the visual complexities of those artists while at the same time illustrating Dalí's own concept of visual "confusion" in hallucinatory imagery. That idea, which owed much to Surrealist theories of automatism, was given Dalí's personal form in his "paranoiac-critical method." The idea first took shape in 1930 in Dalí's publication *The Visible Woman,* which he dedicated to Gala, crediting her with enabling him to see the world anew by dispelling, for him, the rationalist skepticism of the French philosopher Voltaire.

In the painting, Gala sits on the left at a table while gazing at a scene that invites us, through Dalí's skillful manipulation, to view a new and changing world. It is a world of perceptual shifts, hidden meanings, and disguised significances. Taken as a whole, the painting reveals a mind that relishes ambiguities—the visual equivalent of pun and wordplay. The eye is led back into the more innocent ways of seeing associated with childhood, when unfettered imagination was allowed free rein. An image based on the bust of Voltaire by the French artist Jean-Antoine Houdon fades and is replaced by a scene of figures and architectural forms that arises out of the same visual elements; even the fruit dish with its two pears, the world of static objects and hard facts, alternately disappears into the fluid contours shared with the background. Dalí's "paranoiac-critical method" was intended to allow us, too, to see the world anew, by challenging our clichéd ways of looking. He described this approach as "a spontaneous method of irrational associations based upon the critical-interpretative association of delirious phenomena." Unpremeditated perceptions were to arise from free association, often based on memories from his childhood or on seemingly mundane objects, like Voltaire's bust or a fruit dish, which acted as imaginative triggers for new visual thoughts. These associations not only display Dalí's imaginative daring and his undeniable skill; they also invite us to experience for ourselves the almost forgotten delights of unrestrained visualization—the pleasures of the eye.

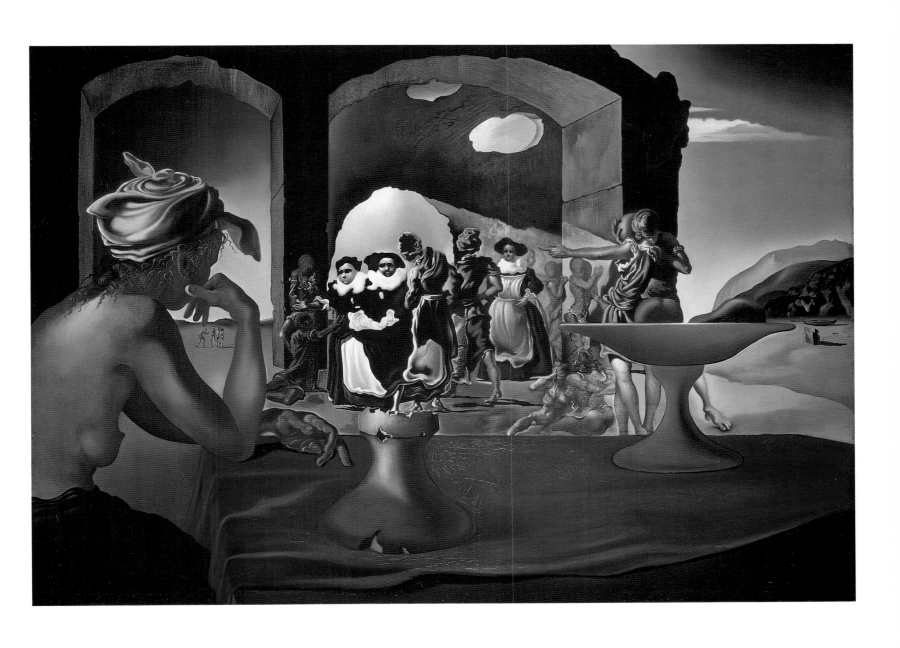

Geopoliticus Child Watching
the Birth of the New Man

1943. Oil on linen canvas, 18 x 20½" (46.1 x 52 cm). Signed and dated bottom center: "Gala Salvador Dalí / 1943"

This painting, first shown at Dalí's solo exhibition at M. Knoedler & Co., New York, in 1943, records Dalí's shifting perception of the war then in progress in Europe. The war's devastation and its psychological impact on Dalí can already be felt in some of his more somber canvases before his period in America. In this painting, however, his style shows a new, more philosophical classicism.

His initial notes for the work read: "parachute, paranaissance, protection, cupola, placenta, Catholicism, egg, earthly distortion, biological ellipse. Geography changes its skin in historic germination." These cryptic words offer some hint of the work's meaning: at the bottom right of the painting, the gaunt body of a classical figure, standing for the Old World and its emaciated civilization, reveals a central scene to a child, who peeks at the male struggling out of a terrestrial globe, distorted into the shape of an egg, which cracks open and releases a globule of placental blood. This strange scene, emblematic of the emergence of a new order after the war, stands in direct opposition to the desperate imagery of Dalí's earlier painting *Daddy Longlegs of the Evening—Hope!* (page 91), countering the more pessimistic sentiments of 1940. The small child, unlike the weeping putto in *Daddy Longlegs of the Evening—Hope!,* does not lament. The central scene of global rebirth is protected by a parachutelike floating cupola that, when seen in conjunction with the cloth at the bottom, forms an oysterlike configuration of fabric—which opens to present the pearly clarity of Dalí's optimistic new vision. The emerging figure, modeled after the central, kicking figure in the Pre-Raphaelite artist John Everett Millais's painting *Isabella* of 1849, bursts out from the North American continent, which Dalí saw as a center of propitious growth—a "historic germination" that seemed evident to him during his time in America. The small background figures that flank the global egg—the left group taken from Raphael's *Marriage of the Virgin* and the right from studies related to John the Baptist—form an allusive framing device.

Not only do these various elements point to a coming new order in the world at large, but there is also some reference to Dalí himself. The pose of the emerging figure is remarkably similar to Dalí's own pose in a photograph later taken by Philippe Halsman, in 1948, and it may be related to many other photographs and film sequences of Dalí coming out of an egg in "rebirth" incidents based on his interpretation of the Castor and Pollux myth and his own fantasies. The central egg form in the painting is surprisingly like the candy-shaped pebbles on the Playa Confitera, his favorite beach in childhood, suggesting a figurative rebirth of Dalí himself—leaving behind the Old World and its attendant nostalgia and anxiety. As is typical of Dalí's imagery, this scene of symbolic parturition thus has both a personal and a social dimension. Dalí's fourteen-year involvement with Surrealism henceforth evolved toward a new classicism, with a greater element of traditional depiction and with the inclusion of historical events that modified any overt references to the self.

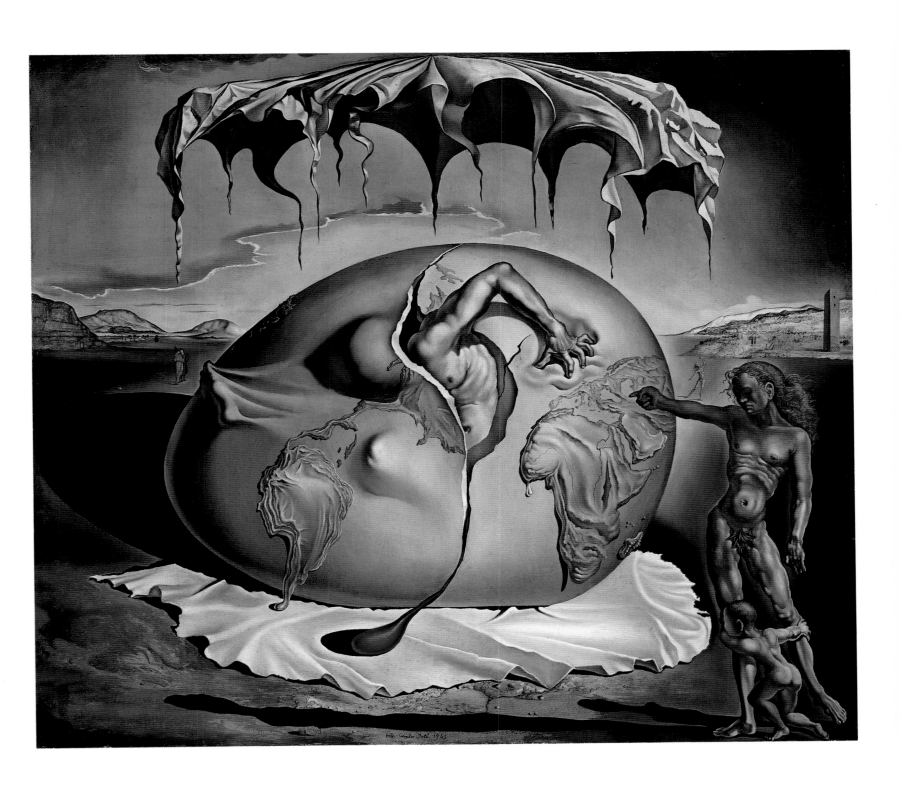

Christ in Perspective

1950. Sanguine and watercolor on Strathmore Wove paper, 30 x 40" (76 x 101.5 cm). Signed bottom center: "G. Dalí"

This highly accomplished drawing is related to Dalí's important commissioned painting *Christ of St. John of the Cross* (until recently in the Glasgow Museum of Art and now in the St. Mungo Museum of Religious Life, Glasgow). It was in fact reserved for the Glasgow Museum of Art, and was acquired for the A. Reynolds and Eleanor R. Morse collection only after the controversial resignation of that museum's director. The sheet is superior in drafting detail to two similar drawings—*Study for "Christ of St. John of the Cross"* (private collection) and *Crucifixion* (Mills College Art Gallery, Oakland, California)—and it is related as well to paintings such as *Assumpta Corpuscularia Lapislazulina* (private collection)—a work that, incidentally, holds the record price for a Dalí painting ($3.7 million). The drawing was inspired by Dalí's reading the poetry of St. John of the Cross and his seeing a dramatic drawing of the crucified Christ by that famous Spanish mystic, an image shown to him in 1950 by a friend, the Spanish Carmelite monk Bruno de Jésus-Maria, at the Monastery of the Incarnation in Avíla.

In this image, the crucified Christ, viewed from above in deep perspective, seems to defy gravity. The dramatic composition, superbly rendered, concentrates attention on the body of Christ, without distracting outside details of the scene, yet achieves a certain impersonal tranquillity by avoiding the face. The composition has a certain affinity to the Baroque in its exploitation of extreme foreshortening and an unexpected viewpoint. The work is also in its impact reminiscent of the paintings of the Spanish artist Francesco de Zurbarán. Dalí's drawing manages not only to contain the highly charged atmosphere of its historical sources but also to convey his own more idiosyncratic convictions. This work was made the year his father died, and one year after the artist's first private audience with the Pope, in Rome. It was a time that also saw the publication of his essay "The Decadence of Modern Art," in Washington, when Dalí's work began to display a more traditional religious iconography. Certainly, the work's intensity evinces a deep personal conviction, but the unusual nature of that conviction may more readily be appreciated when we realize that this powerful work was rigorously designed as a triangle—the points of which are the three nails—encompassing the circle of the head. This configuration, Dalí said, came to him in a "cosmic dream in which . . . an image . . . represented the nucleus of the atom. This nucleus later took on a metaphysical sense that I considered the unity itself of the Universe—the Christ," and, he explained, "I geometrically decided upon a triangle and a circle, which 'aesthetically' summed up all my previous experiments—and put my Christ in that triangle." His comments underscore the arresting iconic power of this simple yet memorable image.

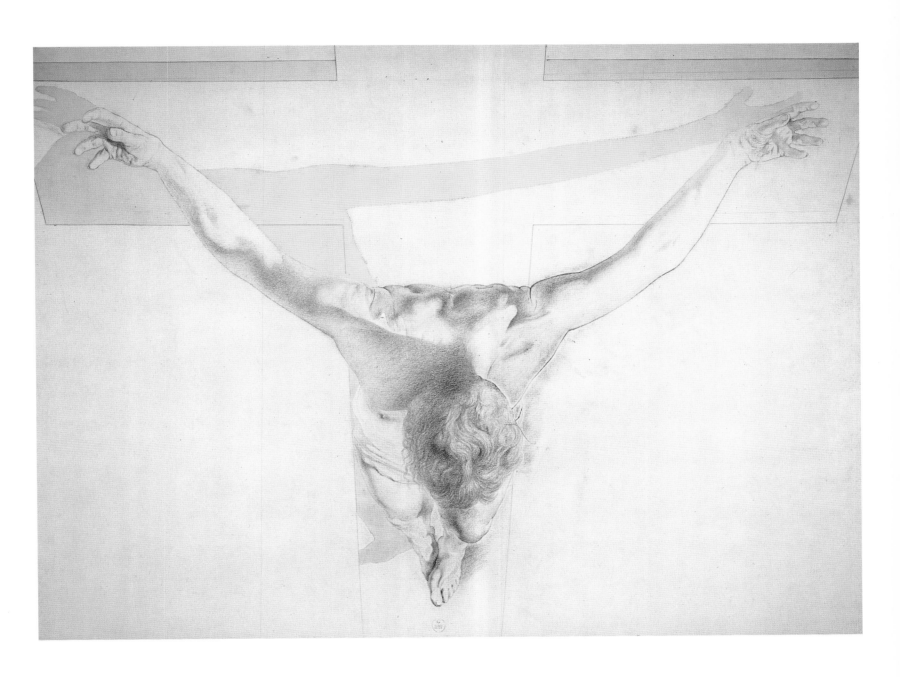

The Disintegration of the Persistence of Memory

1952–54. Oil on linen canvas, 10 x 13" (25.4 x 33.3 cm). Signed bottom center: "DALI"

This work returns to the theme of Dalí's celebrated oil *The Persistence of Memory* of 1931, in the Museum of Modern Art, New York. The renowned melting watch, the image most closely identified with Dalí, had made its first appearance in the earlier work, introducing Dalí's meditation on the inability of time to loosen the tenacious grip of memory on the imagination. Fortuitously suggested by the shape of a melting piece of Camembert cheese, the image conjured up mental associations and recollections in a manner that owed much to the famous incident of the madeleine in Marcel Proust's novel *Remembrance of Things Past*. Now, in *The Disintegration of the Persistence of Memory*, Dalí reconsidered, and modified, the earlier image twenty-one years after its initial appearance.

In this later painting, the bright scene of the objective past, with its nostalgic beach landscape, is lifted up to disclose a new, hidden order—one arising from nuclear physics rather than personal introspection. It is as though Dalí has peeled back the surface of his past work to reveal another layer. His avid reading of scientific journals after the explosion of the first atomic bomb in 1945 reflected an interest in the underlying physical principles of nature and led to his development of what he called "nuclear painting." The inner world of the subjective mind was now subsumed by the inner world of matter itself. This style of painting slowly emerged in a series of fragmented, or "disintegrated," compositions that attempted to suggest the energy at work within the fundamental structural components of matter. Much of the theoretical underpinning of this pictorial style was elaborated in Dalí's contemporary writings, most notably the "Mystical Manifesto" of 1951 and later in the "Anti-Matter Manifesto" of 1958. The present painting recalls many scientific illustrations—of physics experiments, cyclotrons, and particle accelerators—while the lower register, with its eerie tones, seems to be of radioactive origin. The painting, initially prompted by an illustration of the chromosome for the opalescent eye of a fish, presents, in addition to the fish, a distorted self-portrait, together with fragmenting limp watches, in a meticulously painted pictorial analogy to the analytical world of contemporary scientific thought. The small pearl that accompanies Dalí into this submarine world hints at the wisdom to be found in these depths, an apt allusion for an artist who was always proud of having been born on a street named after the inventor of the submarine.

The phenomenon of imperious time, represented by four watches, which become increasingly fragmented as they glide into the depths, is more irrelevant than ever in this new order of space and time. The inclusion of the watches stresses thematic continuity with earlier work, as does the appearance, on the left, of two olive trees; in previous works the olive tree, emblem of peace and harmony, had been shown denuded, in reference to the Spanish Civil War. In this painting, by contrast, the olive tree is segmented as it mimics the disintegration of the soft watches, as though it too were now subject to molecular dematerialization. Dalí's "Mystical Manifesto" supports these various associations: "The explosion of the Atom Bomb . . . sent a seismic shock through me. Since then, the atom has been central to my thinking. Many of the scenes I have painted in this period express the immense fear that took hold of me when I heard of the explosion of the bomb. I used my paranoiac-critical method to analyze the world. I want to perceive and understand the hidden powers and laws of things, in order to have them in my power." The external world of surface appearance and the interior world of psychological processes are now joined by a new desire to comprehend recent advances in scientific thought: the resultant conceptual amalgam propelled Dalí into a period of what he called "nuclear mysticism."

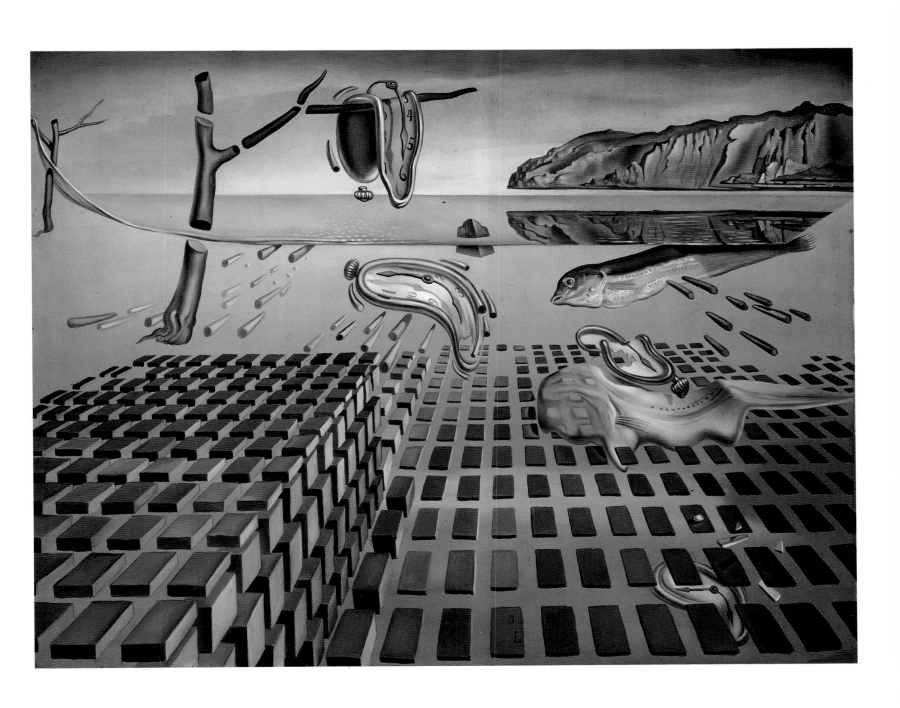

Nature Morte Vivante (Still Life—Fast Moving)

1956. Oil on canvas, 49¼ x 63" (125 x 160 cm). Signed and dated lower right: "Dalí / 1956"

Dalí was always interested in mysticism, particularly that related to alchemy, the ancient art of transforming matter. He was therefore understandably fascinated by the development of nuclear physics, which actually did seek to alter matter, in nuclear reactions, and thereby release the astonishing power seen in the atomic bomb. In these years, Dalí's favorite reading consisted of scientific journals, especially *Scientific American. Nature Morte Vivante (Still Life—Fast Moving)* explores some of these new scientific mysteries, but within what is an almost liturgical atmosphere. The nature of these mysteries is suggested by the inclusion of water and wine, as well as a swallow, faintly reminiscent of the Holy Ghost; such elements give this painting a sacramental quality linked to some of Dalí's recent religious works. This association is strengthened by the red tablecloth with its cross forms, which originate from the star of the church of Santiago de Compostela and the tomb of St. James, the patron saint of Spain.

Although this work does not illustrate any particular scientific theory, in it we can see the impact of scientific thought. In contrast to traditional still-life antecedents, such as Floris van Schooten's *Table with Food* of 1617, it shows a tabletop that, though decked out like an altar, presents an array of objects that whirl about, like atoms, and float without touching; the tranquillity of traditional still-life painting is charged, challenged, and displaced. The forms are suspended by the same mysterious forces that propel atoms and hold the key to matter itself. This painting is thus informed not by science proper but by scientism; that is, by *faith* in science. For Dalí, the mysterious order of the physical universe could be explored only by critical, scientific thought, and, of course, by implication, his own "paranoiac-critical method."

Some of these thoughts are reflected in this complex painting. The whole composition is supported by an intricate underlying structure of squares, triangles, parallelograms, and rectangles balanced in grids of Luca Pacioli's Golden Section, which seems to represent the hidden order of all matter—a fixity of natural law that freezes the suspended objects. The cauliflower on the right, painted in monochrome, like a scientific diagram, shows a logarithmic spiral in its patterns of growth, which hints at the inherent beauty and order of all living matter. This is balanced by the inclusion to the left of a hand holding a rhinoceros horn, which also, according to Dalí, displays logarithmic spirals in its conical shape; its links to nature lie both in its animal origin and its resemblance to rock forms at Cape Creus, near Dalí's home. The fruit dish, the subject of many earlier works, is shown in two stages as it undergoes a process of disintegration, as though to indicate the whirling activity that in fact, at an atomic level, underlies its stable state. Its connections with earlier works are shown in preparatory drawings, where it arises from the Madonna's face and forms a spiral, seen also in the painting, that is vaguely based on the DNA spiral, discovered in 1953.

Set in a time of great scientific advance, the painting, too, challenges the static Newtonian view of nature; here, everything is invested with energy, undergoing processes of dynamic change that can be likened to transubstantiation. The forms of nature—animal, mineral, and vegetable—are locked in the new alchemy of nuclear mysticism. As Dalí commented at the time, what he sought to portray was "the vision of matter constantly in the process of dematerialization, of disintegration, thus showing the spirituality of all substance."

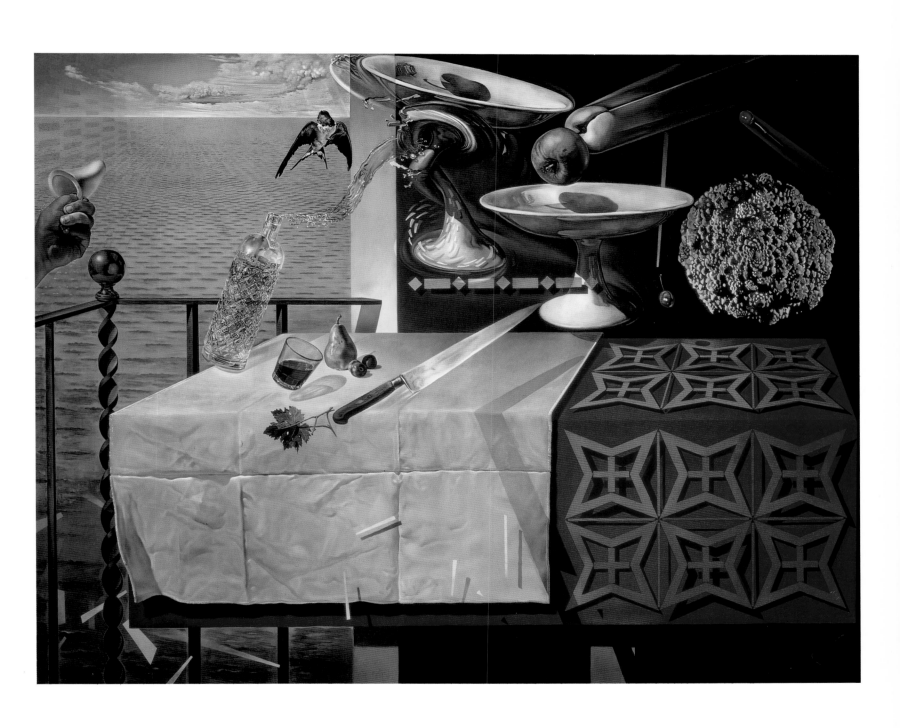

The Discovery of America by Christopher Columbus

1958–59. Oil on canvas, 13' 5½" x 10' 2⅛" (410.2 x 310.1 cm). Signed and dated lower left: "Gala Salvador Dalí / 1958"

Dalí's epic painting *The Discovery of America by Christopher Columbus* (also called *The Dream of Columbus*) was completed in 1959 after two years of effort. The work was commissioned by the American collector Huntington Hartford, shown once privately, then stored until the opening of his Gallery of Modern Art, which was located at Columbus Circle in New York City, in 1962.

In this painting, Gala floats majestically on a banner in a Murillo-like posture of Assumption that acknowledges her role, to Dalí, of muse, protectress, and guide. In the lower center of the work, Dalí, dressed in the habit of a Carmelite monk, kneels in humility holding the crucifix of St. John of the Cross, like Constantine before battle; his pose indicates his subservient, secondary role in his own "discovery" of America during his first trip there in 1934. Gala as St. Helena, the finder of the True Cross, sanctified by her blue and gold halo, is held aloft as the inspirational symbol of victory and another kind of "discovery." Her magnificently painted raiment trails downward, enfolding a young, idealized Christopher Columbus, and the cloth continues on to Dalí; in this way, Gala becomes an agent of transmission, a "thread" that connects creative endeavor, Spanish and European culture, and Dalí himself. The work also thereby links historical events with personal meaning, as happens so often with Dalí.

In addition, the painting's large size and historical subject evince considerable patriotic pride. Dalí has in fact depicted Columbus as a Spaniard, and has included, on the right, the banners of the provinces of Spain, reflecting his often-expressed belief in the theories of Luis Ulloa, a history scholar in Figueres, who held that Columbus was, in reality, Christofal Colom, a Catalan, rather than a native Italian, and that his quest, financed by a Spaniard, was prompted by his interpretation of the writings of the thirteenth-century Catalan alchemist Raymond Llull. (It is known that Dalí was reading Llull in the years just prior to starting this painting.) Columbus, his right foot aglow with light, is poised to step onto a New World that will itself later explore the darker realms of outer space, a region symbolized by the dead, lunarlike landscape of the large sea-urchin form at the bottom center, with its circumnavigating orbital bands. With his left hand, holding a staff, Columbus points back to his origins and motivations—to his ship, the *Santa Maria,* with its Spanish cross insignia and its Holy Grail and Host double images; and, above that, to what will be his future reception by King Ferdinand and Queen Isabella; and, still higher up, to the Church.

The connection with Spain is bolstered by Dalí's inclusion, at the bottom left, of St. Narciso, the patron saint of Catalonia and Bishop of Gerona, in the fourth century, at the Cathedral of St. Felix, who, as national legend has it, miraculously released a protective swarm of stinging gadflies from his tomb in the cathedral whenever the area was threatened by invaders. St. Narciso's vertical crosier is echoed, in the right side of the painting, by the three crosses of Calvary, the forms of which are repeated in the lances, halberds, and banners that retreat into the background and are held by seminude males, possibly derived from Theodor de Bry's engravings of 1590. This configuration of perpendicular lines leads us to an additional important source: the painting by Diego Velázquez entitled *The Surrender of Breda,* also called *The Lances*—a work brought to Dalí's mind at this time by Spain's preparations for the three-hundredth anniversary of Velázquez's death.

In sum, with this Baroque-inspired monumental painting, Dalí, once noted for his meticulously executed small works, instead displayed his undeniable virtuoso ability for grand, almost operatic visions. The painting is an aesthetic tour de force of historical themes patterned primarily after his own life and his own artistic ambitions.

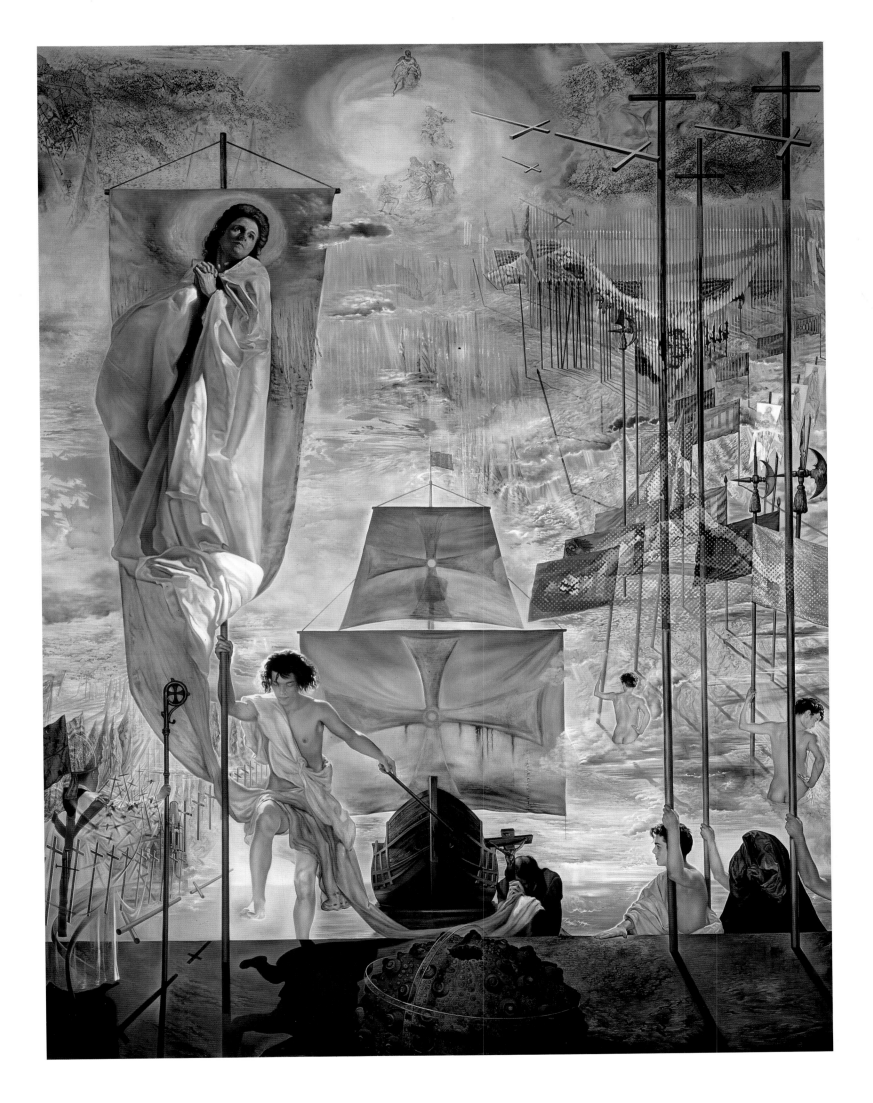

The Ecumenical Council

1960. Oil on linen canvas, 9' 10" x 8' 4" (299.7 x 254 cm). No visible signature

This large painting commemorates the election in 1958 of Angelo Giuseppe Cardinal Roncalli as Pope John XXIII, the 261st Pontiff of the Catholic Church, and pays homage to the abiding spirit of his ecumenicism. The painting's title was prompted by Pope John's 1960 meeting with Geoffrey F. Fisher, the Archbishop of Canterbury and Primate of the Church of England, the first such meeting in 426 years. The spiritual household of all Christian faiths that opens up in the sky seems to unite with the earth through the figure of Christ and his representatives on earth, who crowd around the small figure of the new Pope. The composition is built around this analogical conjunction of heaven and earth, land and sky. A self-portrait of the fifty-six-year-old Dalí stands, Velázquez-like, in the lower region of the work, gazing out at viewers as though to challenge our ability to understand the vision he paints. The mountains of the rocky coast recall the original founding of the Church upon the "rock" of St. Peter, and the eye is led back from them to previous ecumenical meetings, then upward to the right, to a progression of historical popes, bishops, and archbishops, all vicars of Christ, entrusted with the transmission of Christian faith.

The faith is mediated by the floating image of Gala as St. Helena, discoverer of the True Cross and the patron saint of Port Lligat, where this work was painted. The cross that she holds reflects the one in the hand of Christ, above her, who points upward to its spiritual significance, and to its historical occurrence with the two thieves and their own crosses. The cross held by Christ locates the lateral center point of the painting, the crux of the mystery of the Holy Trinity that surrounds it—with the figures of God the Son on the left; God the Holy Ghost on the right, with the symbolic attribute of the dove; and a dominant central figure within a basilica (based on the Christ in Michelangelo's *Last Judgment)* having the unrepresentable, hence obscured, face of God the Father. The heavens swirling about these iconic images are painted in a way appropriate to their ethereal origins, while the lower region, representing the earth and the known, is painted with the sharp optical clarity of the familiar. The eye moves upward, from the known to the unknown, toward time-honored mysteries, the significance of which would be pursued in the Second Vatican Council, which was being planned for 1962.

It is a depiction that also gives Dalí's idiosyncratic interpretation of such contemporary spiritual beliefs as those of Pierre Teilhard de Chardin—the controversial French theologian whose "process" theology stressed knowledge as a form of universal evolution toward a final "omega point" of redemption. In this painting, the earth itself is made to dream such cosmic thoughts, as theological concepts swell upward with the almost nuclear effulgence of this highly personalized, visionary work.

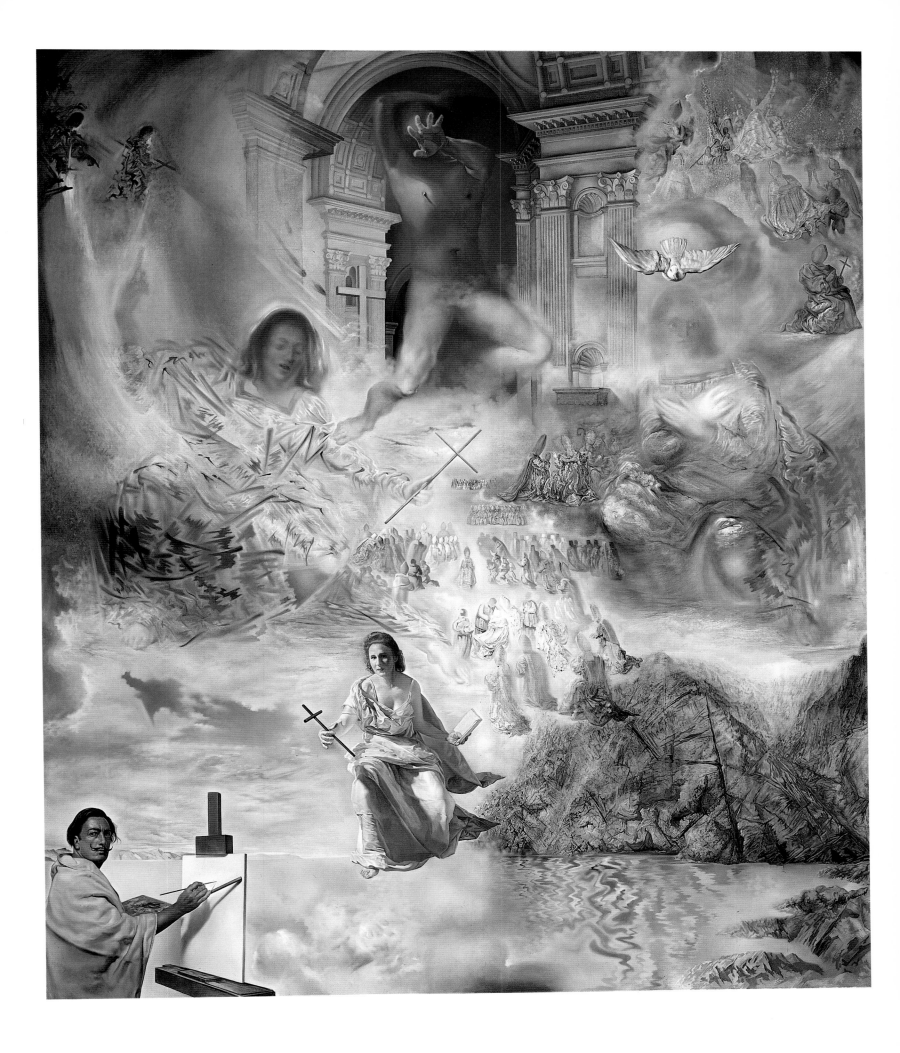

107

Galacidalacidesoxiribunucleicacid [*sic*]
(Homage to Crick and Watson)

1962–63. Oil on canvas, 10' x 13' 7½" (305 x 410 cm). Signed and dated lower left: "Dalí / 1963"

This large, rarely seen painting, once in the collection of the New England Merchants National Bank of Boston, is an ambitious work inspired by disparate events and phenomena. Essentially, it is a painting about the transmission of life force and the mysteries of creation. Set in an atmosphere reminiscent of the Romantic visions of the nineteenth-century British artist John Martin, the painting offers a pictorial reflection on contemporary events that impressed themselves on Dalí's mind. One of these was the flash flooding of the Rio Llobregat in Barcelona in 1962, a tragedy that killed 450 people, shocked Dalí, and moved him to donate a painting for a relief-work auction. In this painting, we see depicted the distant town, the central river, and the flooded plains, together with the predominantly silty colors that stain Dalí's beloved landscape. This natural disaster brought to mind such human-made disasters as the civil uprisings and wars in Arab countries at the time. To the right of the plain stand cubic molecular structures made of turbaned figures, each pointing a rifle at the other's head, suggesting a chain reaction started by a single shot.

On the left side, visionary elements raise countervailing hopes. To the left of the center of the painting, the ethereal figure of the dead Christ floats upward. His ascent is assisted by the right hand of God the Father, who looms out of the upper region of the cloudy sky in divine intervention. God's form, suggested by the reclining, headless torso sculpture by Phidias that Dalí kept in his studio, has been given a head comprising a double image of revelation or annunciation, which is accompanied by a central angel, and his obscured face turns downward to look at the scenes of devastation. His gaze is met by an upward-striving figure, made of the left arm of Christ, in the center of the painting, and who strains toward divine life over the vague form of the cross at his feet. This group, modeled after Michelangelo's last sculpture, the *Rondanini Pietà,* is adjacent to a topographical scene, upon which Dalí has placed a molecular group of spherical forms approximating the supposed shapes of DNA clusters, which had been discovered by the Nobel laureates Francis Crick and James Watson in 1953. This side of the painting, with its conjunction of divine force and newly revealed biological secrets, seems to offer a mystical rejoinder to the sobering secular realities depicted in the right side; the cypress tree, the symbol of death once so prominent in Dalí's work, is distant and now without menace.

God's face, in reality the imagined head of Phidias's classical torso, is reflected in the flooded plain in the exact center of the canvas. The upper left shows a figure, adapted from Michelangelo's depiction of Jonah in the Sistine Chapel ceiling, pointing to the scene while holding a scroll with part of the title of this painting. This scene is visually balanced by the appearance of two shadowy *sfumato* figures in kneeling adoration before the mysteries that unfold in the vortex of the lowering sky. The figure of Gala in the foreground, dressed in an ecclesiastical robe, adds further theological associations to this complex work; the often-noted resemblance of her hair to a loaf of bread, with its eucharistic associations, sounds a liturgical note in this celebration of divine mystery.

This compositionally divided painting adds up to a dualistic representation of the forces of life and death, caught in an analogical form that was prompted by various biological, theological, and natural phenomena, and informed by the metaphysical theories of Teilhard de Chardin. In it, Dalí produced an evocative, modern *memento mori* of considerable contemplative gravity.

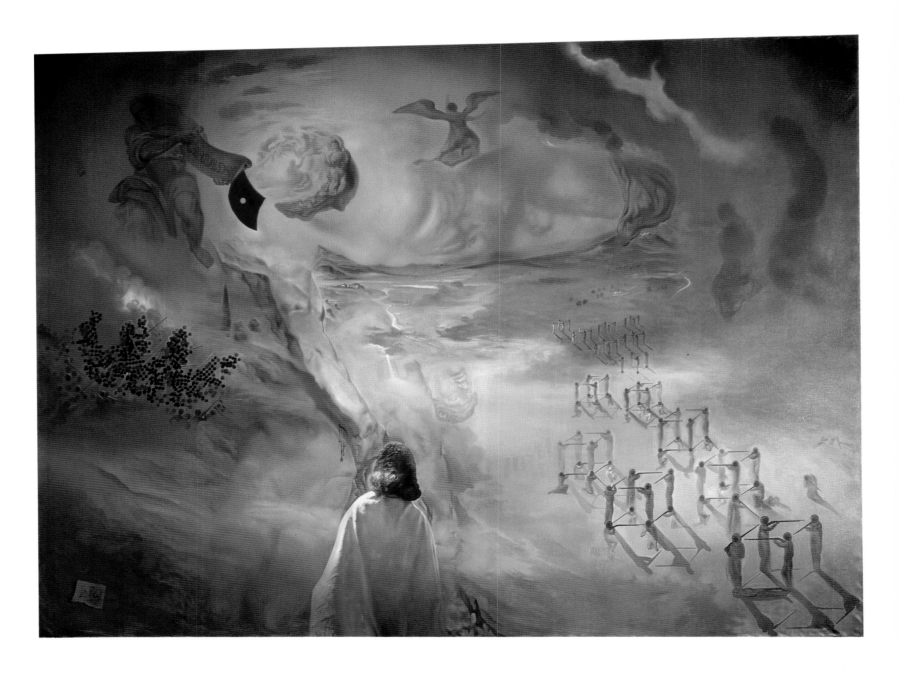

The Hallucinogenic Toreador

1969–70. Oil on canvas, 13' 1" x 9' 10" (398.7 x 299.7 cm). Signed and dated lower left: "Gala Salvador Dalí / 1970"

This imposing painting, which took two years to complete, was obtained directly from the artist. The painting is a complex compendium of Dalí's work and an instructive example of his method of pictorial generation. The Venus de Milo on the right was engendered by seeing a fortuitous double image derived from the logo illustration on a common box of Venus de Milo–brand coloring pencils. Dalí's scrutiny of the negative spaces in that well-known image produced the complementary, alternate image of a bullfighter, to the left of the main Venus de Milo. This supplementary image invites the eye to wander in a way that relives Dalí's visualization and introduces us to the almost hypnotic array of forms that populates the vista of this vast canvas.

The whole scene is contained in a bullfight arena; afternoon shadows sweep to the left and engulf a panorama of memories and visual associations: the gadflies of St. Narciso, patron saint of Catalonia, swarm over the arena and form the cap, hairnet, and cape of the bullfighter, and the tear in his eye, together with the shape of a dying bull in the lower left; a pool of the bull's blood and saliva transforms itself into a sheltered bay with a sunbather on an inflatable mattress; the flotsam and jetsam in the lower section of the beach takes on the shape of a Dalmatian dog, its head facing the pool of water; the green tie of the toreador makes a visual twin of the shadows of Venus's garment; the form of the slain bull rises to become the sheltering mountain landscape of the Cape Creus area around Port Lligat, where this work was painted; a mountain which, in turn, is mimicked on the right by the inclusion of a craggy peak with a rose near its summit, recalling the precipitous mountains around the town of Rosas, near Dalí's studio.

The unfolding, shifting spectacle of all this is watched, at bottom right, by the very young Dalí, dressed in a sailor's suit. His innocent vision seems propelled by the flies of St. Narciso, while he stands distracted, holding a child's toy hoop. On the opposite side, an artist's easel or chair, with a Cubistic rendition of the Venus de Milo, harks back to Dalí's art-school experiences of drawing from plaster casts, one of which stands immediately behind the easel. The space between the student days and the childhood days is peppered with items from Dalí's mature works: his beach landscapes are suggested in the landscape at lower left; the double image of the dog recalls his interest in optics; the molecular diagram in the bull's head reminds us of his fascination with atomic science, together with his love of the architectural decorations of Antoní Gaudí; the shadows of the small, floating plaster Venus statues suggest both the silhouettes of his *Angelus* series and repetitive art-school practice; the bust of Voltaire goes back to his famous double-image work; and the floating rose brings to mind his Gradiva and bleeding-rose works. Read this way, the space bridges Dalí's artistic history. This creative chronicle is dedicated to Gala, who is seen in a cameolike apparition at the upper left; she looks disapprovingly at the bullfight scene while returning the young Dalí's gaze. Their gazes meet exactly midpoint in the canvas, fixed upon the central and obsessively painted button of the shirt collar of the toreador.

In broad view, this ambitious painting is a kind of visual autobiography, prompted by the chance viewing of the Venus de Milo, the cold stone of which, in a reversal of the myth of Pygmalion, is transformed back into an artistic vision. The beloved landscape of his birthplace, the innocence of childhood, the bullfights of youth, the legends of his adolescence, the unfolding interests of his maturity, and the faith in his wife—all are placed beneath our gaze, suffused with the red and yellow tones of the Spanish national flag. In this monumental canvas, multifarious images and memories crowd before us in a cinematic flurry of self-revelation.

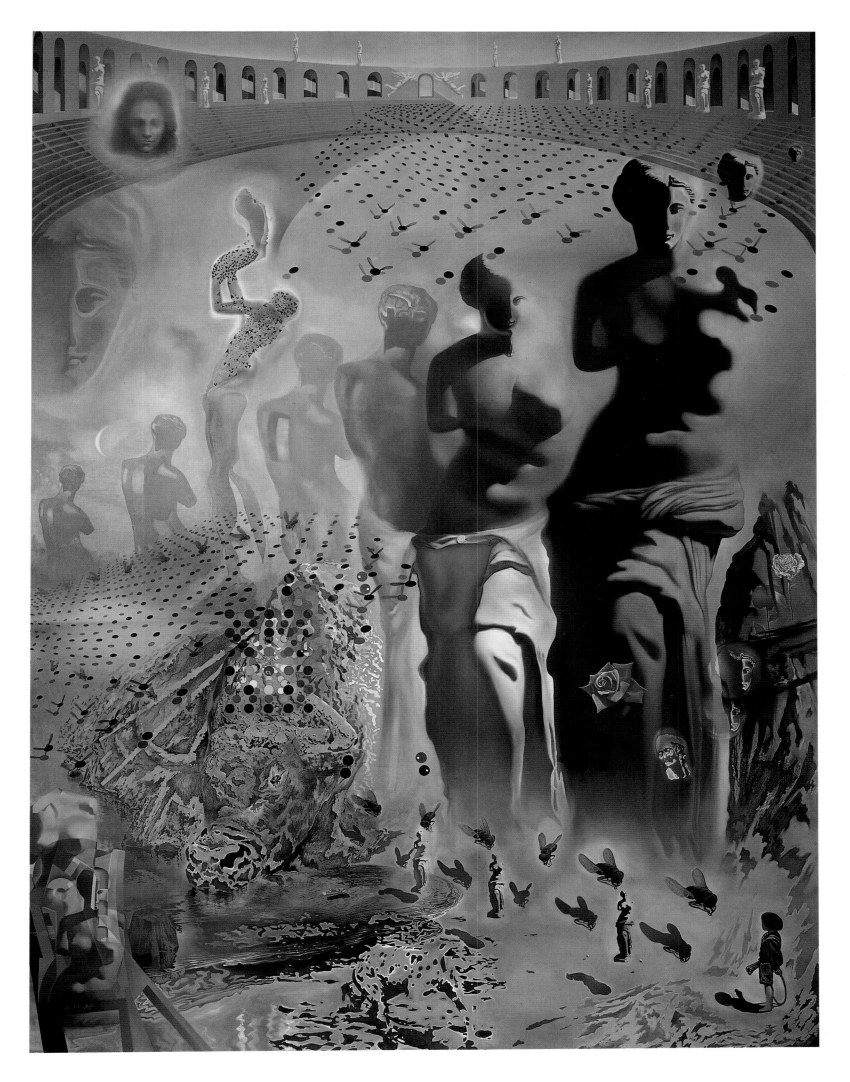

Biographical Chronology

1904

Salvador Dalí (Salvador Felipe Jacinto Dalí i Domènech) is born to Salvador Dalí Cusí (1872–1950), aged thirty-one, and Felipa Domènech Ferrés (1874–1921), aged thirty, at 8:45 A.M., May 11, in the family home at 20 Monturiol Street, Figueres, in the principality of Catalonia, Spain. (His father, a local notary, and mother, the daughter of a Barcelona haberdasher, had married on December 29, 1900. An elder son, named Salvador Galo Anselmo Dalí Domènech, had been born to them October 12, 1901, but had died at the age of twenty-two months, on August 1, 1903.) Is given the names Salvador after his father and great-grandfather, Felipe as the masculine form of his mother's name, and Jacinto after his uncle.

1908

Sister, Ana María Dalí, is born.

Parents employ Lucia Moncanut as nurse for the two children; she will later appear in many of Dalí's paintings.

Dalí attends the municipal kindergarten.

1910

Attends the Immaculate Conception primary school, run by the Christian Brothers. Is taught by Señor Esteban Trayter for four years; is an indifferent student. Instruction at the school being entirely in French, learns that language, while continuing to speak Catalan at home.

1914

Becomes familiar with the fifty-two volumes of the Gowan's series of art books kept in the family home. The German artist Siegfrid Burmann, staying at Cadaqués, near Figueres, gives the ten-year-old Dalí his first set of oil paints and a palette.

Dalí's birthplace at 20 (later renumbered 10) Monturiol Street, Figueres, Spain

1916

Dalí attends secondary school, through 1921, the six-year state baccalaureate course at the Figueres Institute and the Academy of the Marist Order in Figueres.

Through his father's connections, begins to spend summer holidays with the family of Ramón Pichot (1871–1925).

1917

Attends classes, studies drawing, and is introduced to printmaking, under the well-known artist and engraver Juan Nuñez (1877–1963), at the Municipal School of Drawing, in Figueres. Begins to display exceptional talent. Is awarded a prize certificate by the Municipal School of Drawing; subsequently, his drawings are publicly exhibited by his father at the family home in Figueres.

Writes and illustrates stories for his sister while she is convalescing. Also begins to write stories, journal entries, and notes probably in response to the

inspiration of Gabriel Alomar, one of his teachers at the Figueres Institute.

Paints *View of Cadaqués with Shadow of Mount Pani* (page 33).

1918

Shows two oil paintings in a local art exhibition at Figueres.

Submits a drawing for publication in the Catalan magazine *Patufet*. Begins to read philosophical texts, notably Voltaire, Nietzsche, Kant, Spinoza, and Descartes.

Pays increasing attention to the work of the Cubists. Becomes interested in the works of the nineteenth-century artist Mariano Fortuny.

1919

Participates in a group exhibition of the Sociedad de Conciertos in Figueres. Sells two paintings, his first recorded sale of works, to family friend Joaquim Cusí. Is praised in his first review, in the local newspaper *Empordià Federal:* "Dalí Domènech, a man who can feel the light . . . is already one of those artists who will cause a great sensation . . . one of those who will produce great pictures. . . . We welcome this new artist and express our belief that at some point in the future our humble words will prove to be prophetic."

Collaborates on the student magazine *Studium;* there publishes his own writings for the first time, including a poem, a prose piece, and a number of articles on artists (Goya, El Greco, Dürer, Leonardo, Michelangelo, Velázquez).

Begins to keep a diary, entitled *Impressions and Private Memories,* where he writes, "I'll be a genius, and the world will admire me."

Paints *Port of Cadaqués (Night)* (page 35).

1920

Begins a novel, *Summer Evenings* (never published).

Is encouraged by his father to take up a teaching course at the Academy of Fine Arts in Madrid. Is

allowed to use a room at the Pichots' home as a studio, to continue his painting during vacations.

Probably travels to Barcelona to see an exhibition of eighty-seven modernist paintings at the Dalmau Gallery that includes works by Picasso, Braque, Léger, Miró, and Matisse.

1921

Is accepted as a student at the Academy of San Fernando (also known as the Special School of Painting, Sculpture, and Engraving), Madrid, where he remains until 1923. Lives at the Residentia de Estudiantes, next to what is now the National History Museum, and meets fellow students Federico García Lorca, Luis Buñuel, Pedro Garfias, Eugenio Montes, Rafael Barradas, Maruja Mallo, Moreno Villa, and José Bello. Through lectures at the Residentia de Estudiantes, probably first becomes acquainted with the theories of Sigmund Freud and with some of the writings of the Surrealists, in Catalan translation—especially Louis Aragon, Jacques Baron, André Breton, Paul Eluard, Robert Desnos, Benjamin Péret, and Philippe Soupault, all of whom were translated in magazines. Becomes familiar with the collection of the Prado Museum in Madrid.

Through reading and study, learns more about the Cubist works of Picasso, Braque, and Juan Gris, and the Metaphysical School paintings of the Italian artists Carlo Carrà, Gino Severini, Giorgio Morandi, and Giorgio de Chirico.

His mother, Felipa Domènech Ferrés, dies of cancer on February 6. His father subsequently marries Catalina Domènech Ferrés, his late wife's sister. Paints *Self-Portrait (Figueres)* (page 37).

1922

Shows eight works in the Catalan Students' Association group exhibition at the Dalmau Gallery in Barcelona; is favorably reviewed. Breton gives a lecture on Surrealism in Barcelona.

Dalí becomes disenchanted with the curriculum of the Academy of San Fernando.

Paints *Still Life: Pulpo y Scorpa* (page 39).

1923

Is suspended by the Academy of San Fernando for his part in a student group protest.

Attends drawing classes given by Julio Moisés at the Free Academy in Madrid.

Returns to Figueres, sees his former teacher Juan

Nuñez, and begins making prints, many of them on celluloid. His father buys him his first printing press. Probably at this time reads Freud's *Interpretation of Dreams* (1900), which is now translated into Spanish; makes annotations in his personal copy (private collection, Cadaqués).

1924

Is jailed for thirty-five days in Figueres for supposed "subversive activities," in retaliation for his father's political opinions. Begins to take a developed interest in the works of de Chirico and Carrà.

Illustrates C. Fages de Climent's *Les Bruixes de Llers,* published in Barcelona.

Paints *Still Life: Sandia* (page 41).

1925

Has his first solo exhibition, at the Dalmau Gallery, Barcelona, with fifteen paintings. The poet Josep Vicens Foix writes an article about the exhibition; Picasso visits it and praises the work.

Returns to the Academy of San Fernando in Madrid.

His father begins to compile a scrapbook of the young artist's growing successes and critical reviews; in it admits, "We were already convinced of the futility of turning him to any other profession than that of a painter."

Ramón Pichot, his early supporter, dies.

Spends a holiday at Cadaqués with Lorca; a strong friendship between the two develops. His sister Ana María seems taken with Lorca and a correspondence develops between them.

Shows ten paintings in a group exhibition at the Salón de la Sociedad de Artistas Ibéricos in Madrid. Begins to be more widely shown in group exhibitions; participates in eight of these (one of them international) over the next four years.

Probably attends the lecture on Surrealism given by Aragon at the Residentia de Estudiantes in Madrid.

1926

Is permanently expelled from the Academy of San Fernando for refusing to be examined in Fine Art Theory. Returns to Figueres and continues painting.

Lorca publishes his "Ode to Salvador Dalí" in *La Revista de Occident;* a passage reads: "O Salvador Dalí of the olive-colored voice / I do not praise your halting adolescent brush / or your pigments that flirt with the pigment of your times / but I laud your longing for eternity with limits."

Dalí is personally encouraged by Joan Anton Maragall y Noble, the influential Director of the Sala Parés, in Barcelona; exhibits two paintings in the Autumn Salon at the Establiments Maragall in Barcelona and in the exhibition "Modern Catalan Art" in Madrid. One of his paintings is bought by Daniel Vázquez Díaz, the subject of the protest that had led to his suspension from the Academy of San Fernando in 1923.

Death of the architect Antoní Gaudí, to whom Dalí will devote some of his later writings.

Shows three paintings in the "Exhibition of Catalan Pictorial Modernism Compared with a Selection of Works by Foreign Avant-Garde Artists" at the Dalmau Gallery, Barcelona.

The magazine *L'Amic de les Arts* is published in Sitges, featuring many articles on Surrealism.

Traveling with his stepmother and sister, Dalí visits Brussels and Paris for the first time. In Paris, calls on Picasso to show him two of his paintings; is introduced by Manuel Angeles Ortiz. Visits Miró and Buñuel. Buñuel accompanies him on visits to the Café de la Rotonde, Jean-François Millet's studio, the Grévin Museum in Versailles, and the Louvre, as well as a trip to the Royal Museum in Brussels.

Returns to Figueres to work.

Illustrates J. Puig Pujades's *L'Oncle Vicents,* published in Barcelona. Dalí paints *The Basket of Bread* (page 43) and *Femme Couchée* (page 45).

1927

Has his second solo exhibition at the Dalmau Gallery, Barcelona, with twenty-one paintings.

Completes twelve months of compulsory military service in the Castle of San Fernando in Figueres.

Designs costumes and decor for a play in Barcelona by his friend Lorca. Publishes his article "St. Sebastian," dedicated to Lorca, in the magazine *L'Amic de les Arts.* Lorca and the Spanish guitarist Regino Sáinz de la Maza visit him for two months in Cadaqués. Dalí works on decor and costumes for Lorca's play *Mariana Pineda* in Barcelona.

Publishes his essays "Art Films and Anti-Artistic Films," "Christmas in Brussels (An Ancient Story)," "My Girlfriend and the Beach," "My Pictures at the Autumn Salon," "St. Sebastian," and "Photography, Pure Creation of the Mind."

Is visited in Figueres by Miró and the Parisian art dealer Pierre Loeb, organizer of the first Surrealist exhibition in Paris.

Shows two paintings in the second Autumn Salon group exhibition at the Sala Parés in Barcelona. Paints *Apparatus and Hand* (page 47).

1928

Encouraged by Miró, is eager to exhibit in Paris. Returns to Paris and signs his first contract with the dealer Camille Goemans.

Publishes his essays "Yellow Manifesto: Catalan Anti-Artistic Manifesto," written in collaboration with Lluís Montanyà and Sebastià Gasch, "Poem of the Little Things," "Poetry of Standardized Utility," "Reality and Surreality," and "Joan Miró."

Friendship with Lorca begins to wane.

Dalí's fame has grown to the point where his work is acknowledged in an interview by Filippo Tommaso Marinetti, the Futurist movement's leader.

Shows three paintings in the 27th Carnegie International exhibition in Pittsburgh. Shows three works at the "Manifestation of Vanguard Art" exhibition at the Dalmau Gallery in Barcelona, nine works at the Casino Menestral in Figueres, and two works in the third Autumn Salon at the Sala Parés in Barcelona. One work is rejected from this last exhibition because of its purportedly obscene subject matter.

Paints *The Bather* (page 49), *Beigneuse* (page 51), *Dit Gros, Platja, Luna, i Ocell Podrit (Big Thumb, Beach, Moon, and Decaying Bird)* (page 53), and *Ocell . . . Peix* (page 55).

1929

Has his first solo exhibition in Paris, with eleven paintings, at the Goemans gallery. Breton writes a glowing introduction for the exhibition catalogue. With the success of this exhibition, Dalí begins a long period of highly productive activity: will have twenty major international solo exhibitions in the next sixteen years.

Shows four paintings at an exhibition in Madrid entitled "An Exhibition of Painting and Sculpture by Spanish Artists Resident in Paris." Shows two paintings in the exhibition "Abstract and Surrealist Painting and Sculpture" at the Kunsthaus, Zurich.

Publishes his essays "Review of Anti-Artistic Tendencies," "The Liberation of the Fingers," and "The Photographic Donnée."

Works with Buñuel in Figueres on a film script initially **called** *Dangereux de Se Pencher en Dedans (Dangerous to Lean Inside)*, then changed to *El Marista de la Ballesta (The Marist of the Crossbow)*;

Dalí's family home at Playa d'es Llaners, Cadaqués, Spain

finally entitled *Un Chien Andalou (An Andalusian Dog)*, it is first screened at the Ursulines Film Studio, then privately shown at the home of the Vicomte and Vicomtesse de Noailles in Paris and again in the Swiss town of La Sarraz. Its first public screening takes place on October 1 at Studio 28 in Paris. It is publicly praised by the filmmakers Sergei Eisenstein and Jean Vigo and accepted with great acclaim by the Surrealists.

Dalí is subsequently introduced to Tristan Tzara, Aragon, René Magritte, Hans Arp, and Eluard in Paris by Miró, and is formally invited to join the Surrealist group. Begins to attend its meetings regularly and becomes more fully acquainted with its individual members and their work.

Notices Gala Eluard at a social function; shortly after, first formally meets her when she visits Cadaqués with her husband, Paul Eluard, together with their daughter Cécile Grindel and René Magritte, Georgette Magritte, Buñuel, Goemans, and Yvonne Bernard. Dalí tells Buñuel, "There has just arrived an extraordinary woman." Gala chooses to stay with Dalí while the rest of the visiting group (except for Cécile Grindel) returns to Paris, and their relationship commences at this point.

Paints *The First Days of Spring* (page 57) and *The Profanation of the Host* (page 59).

1930

Begins to contribute writings, illustrations, drawings, and photographs to the journal *Le Surréalisme au*

Service de la Révolution (Surrealism in the Service of the Revolution), which now publishes the first of its six issues (through 1933) in Paris.

Collaborates with Buñuel on the film *L'Age d'Or (The Golden Age)*, which is financially supported by the Vicomte de Noailles.

Gives a lecture, "The Moral Position of Surrealism," in Barcelona.

His father and sister strongly disapprove of his developing relationship with Gala. Difficulties with his family are exacerbated by misunderstandings regarding his inscription on a reproduction of a religious image. After a serious disagreement with his father, returns to Paris; the two are not reconciled until 1948. Dalí will later confide in his diary of 1942 that at the time of their falling-out, his father's house at a distance looked to him like "a piece of sugar—a piece of sugar soaked in gall!"

Dalí and Gala go on holiday, spending considerable time at the Hôtel du Château in Carry-le-Rouet, on the Côte d'Azur in the south of France; they return to Spain and buy a small fisherman's hut at Port Lligat, near Cadaqués, with funds mostly supplied by the Vicomte de Noailles. (The hut had belonged to Lidia Nogueres, a local personality and a childhood friend of Dalí's who appears in some of his paintings and was also the subject of Eugenio d'Ors novel *The Well-Planted Woman*.) This will become the site of their permanent home, as the hut is later extended and developed

by their friend Emilio Puignau, a builder. While their home is being renovated, Dalí and Gala stay with the poet José María Hinojosa at his home in Torremolinos.

Dalí writes and illustrates *La Femme Visible (The Visible Woman)*, dedicated to Gala, which first outlines his later celebrated "paranoiac-critical method."

Meets Alfred H. Barr, Jr., Director of New York's Museum of Modern Art, and is encouraged to visit the United States. In Paris, meets such future friends and supporters as Coco Chanel, Elsa Schiaparelli, Misia Sert, Princesse Marie-Blanche de Polignac, Comte Etienne de Beaumont, Arturo López-Wilshaw, Prince Mdivani, the Maharajah of Kapurthala, Vicomte de Noailles, and Prince Jean-Louis Faucigny-Lucinge.

Begins to take an interest in double imagery and admires the work of the Italian Renaissance artists Giovanni Battista Bracelli and Giuseppe Arcimboldo.

Illustrates *The Immaculate Conception* by Breton and Eluard. Illustrates Breton's *Second Manifesto of Surrealism*, published in Paris. Illustrates René Char's book *Artine*.

L'Age d'Or is first screened, at the Panthéon cinema in Paris on October 22, for an invited audience that includes Picasso, Gertrude Stein, Jacques Lipchitz, Constantin Brancusi, André Malraux, Misia Sert, Tzara, Marcel Duchamp, Man Ray, Breton, Eluard, Yves Tanguy, Fernand Léger, Michel Leiris, Le Corbusier, Princesse Marie-Blanche de Polignac, Dalí, and Gala. The film is screened again on November 28 at Studio 28 in Paris. Condemned by intellectuals and the Church alike, the film survives attempts to destroy it, although it is officially banned for fifty years by the State Censorship Board.

Dalí paints *The Average Bureaucrat* (page 61).

1931

Has a solo exhibition, with eleven works, in Paris at the Pierre Collé Gallery. Through Eluard, he and Gala obtain an apartment at 7 Rue Becquerel.

Is introduced to the American collector and patron Caresse Crosby by René Crevel.

Begins to sign his paintings with his name intertwined or combined with that of Gala.

Takes a deeper interest in Freudian themes and content.

Gala becomes seriously ill with a lung tumor and undergoes surgery; tests reveal complications that necessitate a hysterectomy.

The Surrealists hold their fourth group exhibition, at the Wadsworth Atheneum in Hartford, Connecticut, the first public exhibition of their works in America; organized by Julien Levy and curated by A. Everett Austin, it is an immediate success. Dalí is represented by eight paintings and two drawings.

Begins to produce Surrealist objects and sculpture. Paints *Au Bord de la Mer* (page 63) and *Shades of Night Descending* (page 65).

1932

Has a solo exhibition, with twenty-seven works, in Paris at the Pierre Collé Gallery. Eluard writes a poem, "Salvador Dalí," for the exhibition catalogue and sends the original manuscript (now lost) to Gala and Dalí. The two obtain an apartment at 7 Rue de Gauguet.

Dalí shows four paintings at an exhibition in Madrid. Praises the work of Charlie Chaplin and the Marx Brothers while working on the script for a film, *Babaouo*, which is never produced.

Begins to refine his "paranoiac-critical method."

Publishes a poem, "Binding Cradled—Cradle Bound"; a seminal essay, "The Stinking Ass" (both translated by Jacob Bronowski); and an important paper on the development of Surrealist sculpture, "The Object as Revealed in Surrealist Experiment" (translated by Richard Thoma), in Paris in the English-language journal *This Quarter*, with Breton acting as guest editor for this special Surrealist number of the journal and Samuel Beckett as translator. *This Quarter* is published by the American writer Edward Titus, husband of Princess Artchil Gourielli (Helena Rubinstein), who later becomes a patron and supporter of Dalí.

The Surrealists hold a group exhibition at the Julien Levy Gallery, New York.

Dalí and Gala are visited at Port Lligat by Breton and Valentine Hugo.

Picasso introduces Dalí to the photographer Brassaï; they cooperate on work for the new magazine *Minotaure*.

Dalí completes illustrations for Breton's book *The White Haired Revolver*, published in Paris.

Paul Eluard and Gala Eluard are legally divorced.

Dalí paints *Memory of the Child-Woman* (page 67).

1933

Has a solo exhibition at the Pierre Collé Gallery, Paris, with twenty-two paintings and ten drawings.

Contributes to the Surrealist journal *Minotaure*, which now publishes the first of its twelve issues (through 1939) in Paris. Meets and exchanges ideas with the psychiatrist Jacques Lacan, who publishes "The Problem of Style and the Psychiatric Conception of Paranoiac Forms of Experience" in the first issue of *Minotaure*.

Breton publishes *Surrealism: Yesterday, Today, and Tomorrow* in Paris. Dalí publishes his essays "Art Nouveau Architecture's Terrifying and Edible Beauty," "A Reverie: Port Lligat, 17 October 1931, Three in the Afternoon," and "The Vision of Gaudí" in Paris.

Has a solo exhibition, his first in America, at the Julien Levy Gallery, New York, with twenty-five paintings, and publishes an explanatory article, "This Exhibition of My Paintings." Exhibits eight "symbolically functioning objects" in the "Exhibition of Surrealist Objects," Pierre Collé Gallery, Paris.

Is reacquainted with Duchamp in Cadaqués; they become firm friends. Man Ray visits Dalí in Cadaqués to take photographs for *Minotaure*.

Dalí has a solo exhibition at the Galeria d'Art Catalonia, Barcelona, with twenty-seven prints, three drawings, two paintings, one Surrealist object, and six photographs.

The Zodiac group of patrons is formed to help Dalí out of constant financial difficulties; the group's arrangements continue until the outbreak of World War II.

Dalí paints *Sugar Sphinx* (page 69) and *Portrait of Gala* (page 71).

1934

Dalí and Gala are married in a civil ceremony in Paris, January 30. They obtain an apartment at 88 Rue de l'Université in Paris. Eluard marries Maria Benz; invents a diminutive for her, as he had for Gala, and thereafter his second wife is known as Nusch (sometimes spelled Nush).

Dalí visits America for the first time; travels to New York, at the instigation of Crosby, his earliest American patron, Picasso donating part of the travel expenses. While there, writes the article "New York Salutes Me."

Has five solo exhibitions during this year: at the

Julien Levy Gallery, New York, with drawings and etchings for Lautréamont's novel of 1868–70, *Les Chants de Maldoror;* the Galerie Quatre Chemins, Paris, with forty-two etchings and thirty drawings for *Les Chants de Maldoror;* the Galerie Jacques Bonjean, Paris, with thirty-two paintings, two sculptures, and four Surrealist objects; the Zwemmer Gallery, London, his first exhibition in England, with sixteen paintings and twenty drawings; and again at the Julien Levy Gallery, New York, with twenty-two paintings.

Is featured in the Hall of Fame section of the American magazine *Vanity Fair.*

The Surrealists hold a group exhibition, at the Palais des Beaux-Arts, Brussels. Dalí is formally expelled from the Surrealist group in Paris, mainly for political reasons arising from the unsympathetic interpretation of some of his paintings.

Sir Herbert Read publishes his article "Bosch and Dalí" in London. Dalí and Gala visit the English collector Edward James at his country home in West Dean, Sussex.

Dalí's friendship with Lorca continues to decline through lack of contact.

Begins to form a psychological interpretation of the work of Jean-François Millet.

Tries his hand at a type of automatic printmaking, for which he coins the term *spasmographism.*

Has a serious falling-out with Buñuel over their film collaborations.

Illustrates Lautréamont's *Les Chants de Maldoror* and Georges Hugnet's *Onan,* both published in Paris.

Paints *Skull with Its Lyric Appendage Leaning on a Night Table Which Should Have the Exact Termperature of a Cardinal Bird's Nest* (page 73), *Atmospheric Skull Sodomizing a Grand Piano* (page 75), and *The Weaning of Furniture Nutrition* (page 77).

1935

Publishes *The Conquest of the Irrational* in New York. Gives a lecture, "Surrealist Paintings, Paranoiac Images," at the Museum of Modern Art, New York, translated by Julien Levy. Begins to make more frequent use of the term *paranoiac-critical method.* Dalí and Gala are embroiled in a scandal when the American media take offense at Gala's outfit for a costume ball—incorporating a celluloid baby and a set of black wings—because the Lindbergh baby had just been kidnapped. Breton takes Dalí to task over this damaging controversy.

The Surrealists hold a group exhibition, at Den Frie Udstilling Bygning, Copenhagen—known as the first International Surrealist Exhibition—and another at Santa Cruz de Tenerife in the Canary Islands, where Breton gives a lecture.

Dalí sees Lorca, his friend of fourteen years, for the last time, in Barcelona. René Crevel, a friend and early supporter, commits suicide in Paris.

Dalí illustrates Tzara's *Grains et Issues,* and Paul Eluard's *Nuits Partagées,* both published in Paris.

Wins the patronage of Edward James. Subsequently enters into an important contractual arrangement with James, for the purchase of paintings and other work, which continues until World War II.

Paints *Archaeological Reminiscence of Millet's "Angelus"* (page 79).

1936

Is included in the International Surrealist Exhibition in London. Visits London; meets the exhibition organizer, the collector Sir Roland Penrose, and is introduced to English Surrealists and to the critic Sir Herbert Read. Gives his famous "diving-suit lecture"—"Paranoia, the Pre-Raphaelites, Harpo Marx, and Phantoms"—at the opening of the exhibition. Stays at the homes of his patron Edward James and the photographer Cecil Beaton. Has a solo exhibition, his second in London, at the Alex, Reid, and Lefevre Gallery, with twenty-nine paintings and eighteen drawings.

Upon returning to Spain, Dalí and Gala must hurriedly leave for Paris due to the outbreak of the Spanish Civil War. During the war, the family home in Cadaqués is damaged, Dalí's own home at Port Lligat is destroyed, his friend Lorca is executed, and his sister Ana María is imprisoned and tortured. A new and lugubrious intensity enters his work at this time.

Julien Levy, an early supporter, publishes *Surrealism,* the first Surrealist anthology to appear in the United States. Dalí publishes his article "Cradled Pamphlet" in New York.

Begins to experiment with the new technique of decalcomania.

Is introduced to the English collector and patron Lord Berners by Edward James, and to the English collector Peter Watson. Is introduced to Harpo Marx.

Surrealist group exhibitions, at La Louvière, Belgium; the Charles Ratton Gallery, Paris; and the New Burlington Galleries, London—the second International Surrealist Exhibition. Alfred H. Barr,

Jr., organizes the exhibition "Fantastic Art, Dada, Surrealism" at the Museum of Modern Art, New York.

Breton writes his essay "The Dalí Case" in Paris.

Dalí has a solo exhibition, his fourth in America, at the Julien Levy Gallery, New York, with twenty-one paintings and twelve drawings.

A Man Ray photograph of Dalí, taken in 1933, appears on the cover of *Time* magazine.

Dalí completes *Decalcomania* (page 81). Paints two versions of *Morphological Echo* (see page 83), and *Three Young Surrealist Women Holding in Their Arms the Skins of an Orchestra* (page 85).

1937

Dalí and Gala visit Italy for an extended period, because of the Spanish Civil War. They stay at the homes of Edward James, Lord Berners, and Chanel at various locations in Italy. Dalí seems to be suffering from nervous exhaustion; travels with Gala to rest at the Tre Croci in Cortina.

Designs fashion items for Schiaparelli. Takes an interest in the art of the Italian Renaissance and the Baroque and the architecture of Andrea Palladio and Donato Bramante.

Meets Bettina Bergery, the Paris editor of American *Vogue.* Begins to produce designs, illustrations, and advertisements for *Vogue, Harper's Bazaar, Town and Country,* and *Flair.* Dalí and Gala are photographed by Cecil Beaton.

Surrealist group exhibitions are held at the Ginza Galleries, Tokyo, and the London Gallery, London.

Dalí publishes *Metamorphosis of Narcissus* and his articles "I Defy Aragon" and "Surrealism in Hollywood."

Works in Hollywood with the Marx Brothers on a scenario for the film *Giraffes on Horseback Salad,* which is never produced.

1938

Accompanied by Gala, Stefan Zweig, and Edward James, Dalí meets Sigmund Freud on July 19 at his home in the London suburb of Hampstead. Although Dalí is elated by the meeting, Freud remains relatively indifferent to his art and theories. Dalí makes a portrait sketch of Freud, later elaborated in a number of further drawings, one of which is in the Freud Museum, London.

Breton and Eluard publish their *Abridged Dictionary of Surrealism,* where Dalí is described as "the colossally rich principal intellect of Catalonia" and Gala

as "a violent and sterile woman."

Dalí and Gala travel to Florence for a holiday, visit the convalescing Chanel in Venice, and later stay with her at her villa near Monte Carlo.

The Surrealist journal *London Bulletin* publishes the first of its twenty issues (through 1940).

Dalí visits the Wadsworth Atheneum in Hartford, Connecticut.

Eluard begins to distance himself from Breton and the Surrealists. A Surrealist group exhibition is held at the Galerie des Beaux-Arts, Paris—the third International Surrealist Exhibition—and another at the Galerie Robert, Amsterdam.

Dalí's stepdaughter Cécile Grindel marries the poet Luc Decaunes.

1939

Has a solo exhibition in his private apartment in Paris, on Rue de la Tombe-Issoire; when the exhibition opens, Picasso is the first to arrive, buys a drawing, and is the last to leave.

Dalí visits New York to work on a project for the New York World's Fair; controversy ensues over his contract. Designs a window display for the Bonwit Teller store on Fifth Avenue; when the display is altered without his consent, he breaks the window glass and is arrested. Releases his publications "Declaration of the Independence of the Imagination and the Rights of Man to His Own Madness," "Geological Foundations of Venusberg," and "Prophesy on Jewels" in New York. *The New Yorker* magazine features a profile of him by Margaret Case Harriman entitled "A Dream Walking." With Chanel and Léonide Massine, he works on the decor and costumes of the ballet *Bacchanale* at the Metropolitan Opera House. Has a solo exhibition at the Julien Levy Gallery, New York, with twenty-one paintings and five drawings.

Dalí and Gala return to France. When World War II breaks out, they flee Paris and stay at the Grand Hôtel in Font Romeu and the Villa Flamberge at Arcachon, north of Bordeaux; other refugees staying in the area include Duchamp, Leonor Fini, and Chanel. Dalí is visited by the designer Jean-Michel Frank and collaborates with him on furniture designs, many not executed until much later. Dalí and Gala are soon forced to leave the area because of the Nazi invasion of France. Dalí writes a final letter to Breton.

Eluard is mobilized in Paris.

Freud dies of cancer in London.

Dalí paints *Telephone in a Dish with Three Grilled Sardines at the End of September* (page 87) and *Tristan Fou* (page 89).

1940

Dalí and Gala emigrate to the United States via Madrid and Lisbon. Will remain in America for eight years. Travel to California and Virginia.

The Surrealist journal *VVV* publishes the first of its thirty-four issues in New York (through 1944). Dalí meets the writers Henry Miller, Anaïs Nin, and John Dudley at Hampton Manor, Caresse Crosby's country home at Bowling Green, Virginia. Buys his first Cadillac and presents it to Gala as a gift.

Surrealist group exhibition is held at the Galerie de Arte Mexicano, Mexico City—the fourth International Surrealist Exhibition.

Dalí paints *Daddy Longlegs of the Evening—Hope!* (page 91), *Old Age, Adolescence, Infancy (The Three Ages)* (page 93), and *Slave Market with the Disappearing Bust of Voltaire* (page 95).

1941

Has a solo exhibition at the Julien Levy Gallery, New York, with twenty-one paintings, six items of jewelry, and one crystal cup; the exhibition travels to the Arts Club of Chicago and the Dalzell Hatfield Galleries, Los Angeles. Also has a solo exhibition at the Julien Levy Gallery in Hollywood. Is given his first museum retrospective, at the Museum of Modern Art, New York, with fifty paintings, seventeen drawings, and six items of jewelry; the exhibition travels to eight cities in the United States.

Dalí begins to take a greater interest in traditional painting and academic technique. Works on the decor and costumes for the ballet *Labyrinth* at the Metropolitan Opera House, New York.

Collaborates with the French director Jean Gabin on his film *Moontide.*

Designs his first jewelry collection.

Finishes writing *The Secret Life of Salvador Dalí,* at Crosby's home in Bowling Green, Virginia.

Is featured in *Life* magazine.

Breton arrives in America. Dalí's self-promotion seems to irk the Surrealists, and Breton criticizes him in his *Artistic Genesis and Perspective of Surrealism.* Breton devises an anagram for Salvador Dalí: Avida Dollars ("Eager for Dollars").

Nicolas Calas publishes the critical article "Anti-Surrealist Dalí" in New York.

1942

The English collector and patron Lord Berners publishes his "Surrealist Landscape: A Poem Dedicated to Salvador Dalí" in London.

Eluard joins the French Underground in Paris. Breton gives his lecture "The Situation of Surrealism Between the Wars" at Yale University, New Haven, Connecticut.

Dalí publishes *The Secret Life of Salvador Dalí* and his articles "Dalí to the Reader" and "Total Camouflage for Total War" in New York.

The Surrealist journal *View* publishes the first of its three issues (through 1944) in New York.

A Surrealist group exhibition is held at the Coordinating Council of French Relief Societies, New York—the fifth International Surrealist Exhibition.

James Thrall Soby of the Museum of Modern Art, New York, publishes "Salvador Dalí," his first article on the artist, as well as his pioneering monograph *Salvador Dalí: Paintings, Drawings, Prints* in New York.

1943

Has a solo exhibition at M. Knoedler & Co., New York, with twenty paintings and thirteen drawings.

Dalí and Gala meet A. Reynolds Morse and Eleanor R. Morse in New York, the beginning of a long friendship.

While living in the Dalís' apartment in wartime Paris, Cécile Decaunes is forced to sell some of Dalí's paintings, cause of later friction between mother and daughter.

Paints *Geopoliticus Child Watch the Birth of the New Man* (page 97).

1944

Meets the Spanish collector the Marqués Georges de Cuevas in New York. Completes his only novel, *Hidden Faces,* at the home of the Marqués de Cuevas in New Hampshire; the novel is published in New York.

In California, becomes interested in the theories of proportion of the fifteenth-century monk Luca Pacioli, the work of the Renaissance writer Cennino Cennini, and the contemporary research of the Romanian mathematician Matila Ghyka, Professor of Aesthetics at the University of Southern California.

A Surrealist group exhibition is held at the Arcade Gallery, London.

George Orwell publishes his critical essay "The Benefit of Clergy: Some Notes on Salvador Dalí" in London; Edmund Wilson publishes "Salvador Dalí as a Novelist" in New York; Cyril Connolly writes on Dalí and film in *The Unquiet Grave,* published in London.

Dalí illustrates Maurice Sandoz's *Fantastic Memories,* published in New York. Works on the decor and costumes for the ballet *El Cafe de Chinitas* in Detroit and on the decor and costumes for the ballets *Tristan Fou* and *Sentimental Colloquy* in New York.

1945

Has a solo exhibition at the Bignou Gallery, New York, with eleven paintings and related drawings and watercolors. Publishes the article "Gelatinous Space Time" and his *Dalí News* in New York.

Cécile Decaunes marries the artist Gérard Vulliamy.

Dalí becomes interested in nuclear science after the explosion of the atomic bomb.

A. Reynolds Morse publishes his article "The Dream World of Salvador Dalí" in New York.

1946

Collaborates on film projects in Hollywood, notably Alfred Hitchcock's *Spellbound.*

Nusch Eluard dies of a cerebral hemorrhage. Breton returns to Paris.

Dalí illustrates editions of Benvenuto Cellini's *Autobiography* and Miguel de Cervantes's *Don Quixote,* published in New York.

Publishes his article "Painting after the Tempest" in New York. James Thrall Soby publishes his monograph *Salvador Dalí* in New York. Peggy Guggenheim, an early supporter of Dalí, publishes her autobiography, *Out of This Century,* in New York.

1947

Works with Walt Disney on a film project, *Destino,* which is never produced.

A Surrealist group exhibition is held at the Galerie Maeght, Paris, and another in Prague—the seventh International Exhibition of Surrealism.

Dalí publishes the second number of *Dalí News* in New York.

Dalí and Gala return to Paris. They stay with the López-Wilshaws and later at the Comte de Beaumont's home at Neuilly, where they meet the English director Peter Brook.

1948

Dalí and Gala return to Spain and their home at Port Lligat. A reconciliation is effected with Dalí's father and with his sister Ana María.

A Surrealist group exhibition is held at the Galeria Dédalo, Santiago, Chile.

Dalí publishes his *Fifty Secrets of Magic Craftsmanship* in New York.

Works in Rome on a production of Shakespeare's *As You Like It* with the Italian director Luchino Visconti.

1949

Works in Madrid on decor and costumes for the play *Don Juan Tenorio* by José Zorilla.

Seeks an audience with Pope Pius XII in Rome.

Works with Peter Brook on a production of Richard Strauss's opera *Salome* at the Royal Opera House, Covent Garden, London.

Ana María Dalí publishes her reminiscences, *Salvador Dalí as Seen by His Sister,* in Barcelona.

Dalí's work begins to make greater use of religious iconography.

1950

Dalí's father, Salvador Dalí Cusí, dies on September 21.

Dalí works in Hollywood with the American director Vincente Minnelli on the decor for certain scenes in the film *Father of the Bride.*

Publishes his article "The Decadence of Modern Art" in Washington.

Makes the drawing *Christ in Perspective* (page 99).

1951

Dalí and Gala, who is wearing a design by Christian Dior, attend the famous costume ball given by Count Carlos de Bestegui at the Palazzo Labia, Venice. Dalí's painting *Christ of St. John of the Cross* is purchased by the Glasgow Museum of Art. Dalí meets Robert Descharnes, his future biographer and manager.

1952

Goes on an extensive college lecture tour in the United States, accompanied by A. Reynolds Morse and Eleanor R. Morse.

Publishes his articles "Credo" in New York and "One of the First Objections" in Glasgow.

Becomes interested in the writings and theories of the thirteenth-century Catalan mystic Raymond

Dalí and Gala in 1958 in their official wedding portrait, taken after they remarried on August 8, in a religious ceremony at La Capella de la Mare de Deu dels Angels, near Gerona, Spain

Llull and of the contemporary Francesc Pujols.

Paul Eluard, Gala's first husband, dies in Charenton, France.

1953

Travels to Paris and New York. Publishes his article "Salvador Dalí's Mimicry in Nature" in New York.

Caresse Crosby, an early supporter of Dalí, publishes her autobiography, *The Passionate Years,* in New York.

Dalí plans a film entitled *The Flesh Wheelbarrow,* but it is never made.

Meets Nanita Kalachnikoff, who remains a close friend for the next thirty years.

1954

Dalí traveling retrospective exhibition is shown in Rome, Venice, and Milan.

Dalí publishes *Dalí's Moustache* with Philippe Halsman in New York.

Publishes his article "Report on My Italian Campaign" in New York.

Is interested in the work of Vermeer.

Completes the painting *The Disintegration of the Persistence of Memory* (page 101).

1955

Collaborates with Descharnes on the film *The Prodigious Story of the Lacemaker and the Rhinoceros* (never completed).

Publishes his article "Comments on the Making of *Un Chien Andalou* and *L'Age d'Or*" in New York.

Gives a lecture entitled "Phenomenological Aspects of the Paranoiac-Critical Method" at the Sorbonne, Paris.

Seeks an audience with Pope Pius XII in Rome.

Dalí at work on The Discovery of America by Christopher Columbus *of 1958–59 (page 105)*

The French artist Yves Tanguy, an early influence on Dalí, dies in Woodbury, Connecticut.

1956

Dalí traveling retrospective exhibition is shown in Belgium.

Dalí begins to make prints employing what he calls "bulletism"—an automatic technique involving ammunition and explosives; some of the works are produced with the help of the French *tachiste* artist Georges Mathieu.

James Thrall Soby publishes his article "Freud and Modern Art" in New York. Dalí paints *Nature Morte Vivante (Still Life—Fast Moving)* (page 103).

1957

Publishes his article "The Face of Courage" and *Dalí on Modern Art: The Cuckolds of Antiquated Modern Art* in New York.

Illustrates an edition of Cervantes's *Don Quichote* published in Paris.

Is visited at Cadaqués by Walt Disney; they plan a film of *Don Quixote* (never produced).

1958

Dalí and Gala are remarried on August 8, in a reli-gious ceremony at La Capella de la Mare de Deu dels Angels, near Gerona, Spain.

Dalí is presented with the Gold Medal of the City of Paris and the French Medal of Distinction.

1959

Publishes his article "The King and Queen Traversed by Swift Nudes" in New York.

Illustrates Pedro A. de Alarcón's *Le Tricorne,* published in Monaco.

A Surrealist group exhibition is held at the Galerie Daniel Cordier, Paris—the eighth International Surrealist Exhibition.

Fleur Cowles publishes her monograph *The Case of Salvador Dalí* in Boston.

Dalí paints *The Discovery of America by Christopher Columbus* (page 105).

1960

Camille Goemans, who gave Dalí his first exhibition in Paris, in 1929, dies in Paris.

A Surrealist group exhibition is held at the D'Arcy Galleries, New York—the ninth International Surrealist Exhibition.

Dalí publishes his articles "Cartier-Bresson Moralities" in New York and his "Picasso, Dalí" in London.

Dalí paints *The Ecumenical Council* (page 107).

1961

A Surrealist group exhibition is held at the Galerie Schwarz, Milan—the tenth International Surrealist Exhibition.

Dalí publishes his articles "Ecumenical 'chafarrinada' of Velázquez" and "The Secret Number of Velázquez Revealed" in New York.

Writes and designs the *Ballet de Gala,* which pre-mieres in Venice.

Is awarded the Silver Fig Leaf, the highest honor of Figueres, his birthplace. The idea of a local muse-um devoted to Dalí is first suggested.

1962

Publishes his *Tragic Myth of Millet's "Angelus": Paranoiac-Critical Interpretation* in Paris, his

Dalí, Gala, and A. Reynolds Morse at the Dalí home in Port Lligat, Spain, 1960

Impressions and Private Memoirs of Salvador Dalí, January 1920 in Cleveland, and his articles "Tàpies, Tàpies, Classic, Classic!" and "The Price Is Right" in New York.

Matthew Josephson publishes *Life Among the Surrealists* in New York.

Dalí meets Francis Crick, James Watson, the Comtesse Isabelle de Bavière (Ultra Violet), Andy Warhol, Paul Morissey, and Mia Farrow in New York.

Returns to his early interest in the work of Mariano Fortuny.

Enters into a ten-year contractual arrangement with the publisher Pierre Argillet to produce illustrations for various texts: completes illustrations for works by Rimbaud, Ronsard, Apollinaire, Sacher-Masoch, Mao Zedong, and Goethe.

Meets Peter Moore, his future manager and secretary.

1963

Dalí retrospective exhibition is shown at M. Knoedler & Co. in New York.

Dalí publishes his articles "A Manifesto," "Dalí's Notes on the Battle of Tetuan," and "Why They Attack the Mona Lisa" in New York.

Illustrates an edition of Dante's *Divine Comedy,* published in Paris.

Gala meets William Rotlein, her close companion for a time.

Dalí completes *Galacidalacidesoxiribunucleicacid [sic] (Homage to Crick and Watson)* (page 109).

1964

Dalí retrospective exhibition is shown in Tokyo.

Dalí is interviewed in *Playboy* magazine and publishes *The Drawings of Salvador Dalí* in Los Angeles.

Helena Rubinstein, an early Dalí patron, publishes her autobiography, *My Life for Beauty,* in New York.

Stephen Longstreet publishes his monograph *The Drawings of Dalí* in Los Angeles.

Dalí is awarded the Grand Cross of Isabella the Catholic, one of Spain's highest honors.

1965

Publishes his *Diary of a Genius* in New York.

Meets Amanda Lear in Barcelona.

A Surrealist group exhibition is held at the Galerie L'Oeil, Paris—the eleventh International Surrealist Exhibition, and the last formal Surrealist group exhibition is held at the Galerie Le Ranelagh, Paris.

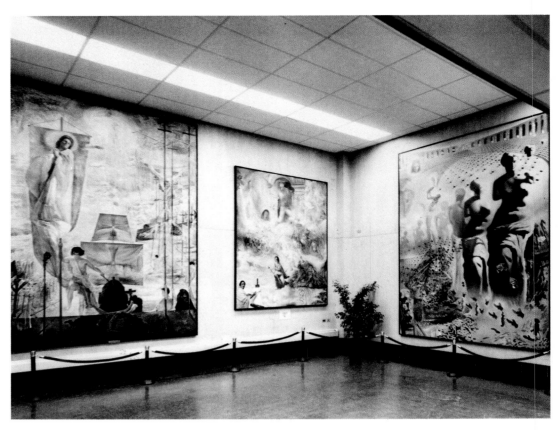

A gallery in the original Salvador Dalí Museum, Beachwood, Ohio, in 1971; from left to right: The Discovery of America by Christopher Columbus *of 1958–59 (page 105),* The Ecumenical Council *of 1960 (page 107), and* The Hallucinogenic Toreador *of 1970 (page 111)*

1966

A Dalí retrospective exhibition is shown at the Gallery of Modern Art, New York, and includes the entire A. Reynolds Morse and Eleanor R. Morse collection of works by the artist.

The German artist Hans Arp, an early influence on Dalí, dies in Locarno, Switzerland. The Italian artist Alberto Giacometti, another early influence on Dalí, dies in Paris. André Breton dies in St. Cirq-la-Popie, France.

1967

Dalí publishes his articles "How an Elvis Presley Becomes a Roy Lichtenstein" and "The Incendiary Fireman" and his *Open Letter to Salvador Dalí* in New York.

Begins illustrations for an edition of the Bible to be published in Milan. Dalí illustrates Mao Zedong's *Poèmes,* published in Paris.

The Belgian artist René Magritte, a friend and early influence on Dalí, dies in Brussels.

Dalí purchases Pubol Castle, near the city of Gerona, and begins interior renovations.

1968

Gives a celebrated series of interviews with Louis Pauwels, published as *The Passions According to Dalí* in Paris. Has a private meeting with General Franco, the Spanish head of state, in Madrid.

The French artist Marcel Duchamp, a friend and supporter, dies in Paris.

Dalí publishes the article "Who Is Surrealism?" and his *Dalí* in New York.

1969

Gala moves into Pubol Castle, a gift from Dalí, in nearby Gerona to live on her own; her relationship with Dalí becomes strained.

Dalí publishes his article "De Kooning's 300,000,000th Birthday" in New York.

Alain Bosquet publishes a series of interviews, *Conversations with Dalí,* in New York.

1970

Dalí retrospective exhibition is shown in Rotterdam.

Dalí publishes *Dalí by Dalí* and his articles "I Have Used," "Statement," and "The Cylindrical Monarchy of Guimard" in New York.

Founding of the Teatro-Museo Dalí, Figueres, is formally announced. The theater is to be located in Plaza del Ayuntamiento and was originally built in 1849 by Josep Roca Bros and decorated by Felix Cagé.

Dalí becomes interested in the work of the seventeenth-century Dutch artist Gerard Dou.

Makes a print series to commemorate the 500th anniversary of the birth of the German artist Albrecht Dürer.

Dawn Ades interviews Dalí at his home in Port Lligat. Dalí paints *The Hallucinogenic Toreador* (page 111).

1971

The Salvador Dalí Museum opens at its original location in Cleveland, with the artist in attendance at the inaugural ceremonies.

Giorgio de Chirico's *Memoirs,* published in London, contains a sharp attack on Dalí.

Dalí retrospective exhibition is shown at the Museum Boymans-van Beuningen in Rotterdam.

Dalí begins work on mural paintings for the Teatro-Museo Dalí, Figueres.

Becomes interested in holography; arranges a meeting with Dennis Gabor, the Nobel laureate and inventor of the hologram.

1972

Dalí publishes his ideas on holography in the article "Holos! Holos! Velázquez! Gabor!" in New York.

1973

Dalí retrospective exhibition is shown at the Louisiana Museum, Humlebaek, and the Moderna Museet, Stockholm.

Dalí illustrates André Malraux's *Roi, je t'attends à Babylone,* published in Geneva.

Begins to withdraw from managerial arrangements with Peter Moore and to rely instead on Enrico Sabater for business decisions.

Pablo Picasso, a friend and early supporter of Dalí, dies in Mougins, France.

Dalí makes a hologram of the rock musician Alice Cooper. Is asked by John Lennon, formerly of the Beatles, to produce a birthday present for Ringo Starr.

1974

Dalí retrospective exhibition is shown at the Städtische Galerie und Städelsches Kunst-Institut, Frankfurt.

Construction begins on the Teatro-Museo Dalí, designed by Emilio Pérez Pinero, in Figueres; the museum opens later the same year. Dalí is presented with the Gold Medal of Figueres.

Publishes his *Dalí . . . Dalí . . . Dalí* in New York and *Salvador Dalí* in London.

Makes the film *Voyage in Upper Mongolia* for West German television.

Works on a series of prints based on Freud's *Moses and Monotheism*. Dalí's health wanes as he begins to suffer from skin cancer, a hernia, and prostate problems.

1975

Publishes his essay "The Six Days of Dalí" and his *Eroticism in Clothing* and *My Cultural Revolution* in Cleveland and his *Explosion of the Swan* in Los Angeles.

Works on a series of prints entitled *Homage to Leonardo da Vinci.*

Flies to the United States. Michael Stout, the New York attorney, becomes his lawyer.

Dalí shows increasing signs of mental turmoil, especially after a controversy regarding General Franco's execution of Basque nationalists. (Franco dies in Madrid on November 20; the investiture of Prince Juan Carlos I as King of Spain takes place November 22.)

Dalí begins to show signs of Parkinson's disease.

1976

Publishes *Salvador Dalí* in New York.

Man Ray, the American Surrealist, dies in Paris. The German artist Max Ernst, an early influence on Dalí, dies in Paris.

1977

Dalí's health continues to decline.

Julien Levy publishes his *Memoirs of an Art Gallery* in New York.

1978

Dalí undergoes prostate surgery at the clinic of Dr. Antonio Puigvert in Barcelona.

Becomes interested in the mathematical and theoretical writing of René Thom.

Publishes *The Wines of Gala* in New York.

The Italian artist Giorgio de Chirico, an important early influence on Dalí, dies in Rome.

Dalí is elected a Foreign Associate Member of the Académie Française des Beaux-Arts, Paris.

Mizue magazine in Tokyo publishes a special issue on Dalí.

Dawn Ades organizes the influential exhibition "Dada and Surrealism Reviewed" at the Hayward Gallery, London, with 1,245 items, including twelve paintings, five works on paper, seven Surrealist objects, and four books by Dalí.

1979

Dalí retrospective exhibition is shown at the Georges Pompidou Center, Paris.

Dalí is formally installed as a Foreign Associate Member of the Académie Française des Beaux-Arts in Paris; his acceptance address is entitled "Gala, Velázquez, and the Golden Fleece."

Dalí becomes ill shortly after his return to Spain from a trip to New York. A. Reynolds Morse and Michael Stout fly to Spain to assist him. Dalí is placed in the care of Dr. Antonio Puigvert, Dr. Joan Obiols, and Dr. Manuel Subirana.

1980

Enjoys some respite from illness and begins to paint again.

Dalí retrospective exhibition is shown at the Tate Gallery, London.

Plans are advanced for the Salvador Dalí Museum in St. Petersburg, Florida.

Jean-Claude du Barry begins to act as business manager for Dalí, but the arrangement is ended when contractual problems arise. Robert Descharnes becomes Dalí's new business manager.

1981

Dalí retrospective exhibition is shown at the Heidelberg Castle in Germany.

André Parinaud publishes the series of interviews *The Unspeakable Confessions of Salvador Dalí* in New York.

Dalí is visited in Port Lligat by His Majesty King Juan Carlos and Her Majesty Queen Sofía of Spain.

Is treated for Parkinson's disease in Paris. Issues a press statement expressing disappointment at the misuse and forgery of his work since his illness.

Is awarded the Gold Medal of the Generalitat of Catalonia.

1982

Gala dies suddenly on June 10 in Port Lligat at the age of eighty-eight. Is buried at Pubol Castle. Devastated by the loss of his partner, guide, mentor, preceptor, Dalí moves into Pubol Castle, which he had given her thirteen years earlier. Begins to shun friends and visitors.

King Juan Carlos awards Dalí the Grand Cross of Charles III and bestows upon him the title of Marquis of Pubol.

Dalí redrafts his last will and testament.

Edward James, an early patron and supporter of Dalí,

publishes his autobiography, *Swans Reflecting Elephants: My Early Years,* in London. Dawn Ades publishes her influential scholarly study and monograph *Dalí* in London.

The relocated Salvador Dalí Museum opens in St. Petersburg, Florida, on March 7.

Dalí traveling retrospective exhibition is shown at the Isetan Museum of Art, Tokyo, and in Osaka, Kitaskyushu, and Hiroshima.

1983

Dalí retrospective exhibition is shown in Madrid and Barcelona.

Dalí issues a legal writ in a French court listing thirty-six works of doubtful authenticity. Five Spaniards are arrested for faking Dalí works after an investigation in Barcelona conducted by the magistrate Manuel Saez Parga.

The Catalan artist Joan Miró, a friend, supporter, and an early influence on Dalí, dies in Majorca.

Illness and fatigue prevent Dalí from painting.

1984

Suffers serious burns in an electrical fire at Pubol; is hospitalized and undergoes a number of skin grafts in Barcelona. Friends organize inquiries into the circumstances of the fire. Dalí's health deteriorates further and King Juan Carlos and Felipe González, the Spanish Prime Minister, send personal messages to him in the hospital.

The Gala-Salvador Dalí Foundation is formally established in Figueres.

Dalí retrospective exhibition is shown at the Galleria Civica d'Arte Moderna, Ferrara, Italy.

Peter Moore publishes his *Guide to the Genuine and Original Signatures of Salvador Dalí* in Vienna.

1985

Dalí appears on television to announce his donation of a substantial body of his works to the Teatro-Museo Dalí in Figueres.

Eighteen Dalí paintings stolen from a Newport Beach, California, gallery are recovered.

Amanda Lear publishes *My Life with Dalí* in London.

Dalí's interviews with Louis Pauwels from 1968 are published as *The Passions According to Dalí* in St. Petersburg, Florida.

1986

Dalí is fitted with a pacemaker to correct cardiac problems. The photographer Helmut Newton takes portrait pictures of the convalescent Dalí for the magazine *Vanity Fair;* he is shown wearing the Grand Cross of Isabella the Catholic.

The Salvador Dalí Museum shows the Isidro Clot collection of forty-eight bronze sculptures by Dalí, never before publicly exhibited.

A New York grand jury indicts forgers of Dalí's artworks.

1987

Dalí's painting *Lincoln in Dalívision* sells to a Tokyo museum for $2.3 million; his *Battle of Tetuan* sells for $2.4 million to Japanese investors.

Lieutenant Thomas Moscardini of the New York Police Department fraud squad conducts investigations into forgeries of Dalí's works. Mark Rogerson publishes his study of Dalí forgeries as *The Dalí Scandal* in London.

The French artist André Masson, one of the original members of the Surrealist group, dies in Paris.

1988

Dalí moves into a private room at the Torre Galatea next to the Teatro-Museo Dalí in Figueres. In December, goes to Barcelona for treatment of pneumonia and related problems. King Juan Carlos visits him in the hospital.

Dalí donates his *Birth of a Goddess* to Jordi Pujol i Soley, President of the Catalonian Government.

The first Dalí exhibition ever held in Moscow opens at the Pushkin State Museum of Fine Arts.

1989

Dalí's health deteriorates, and he returns from Barcelona to his room at the Torre Galatea. Dies of respiratory complications and heart failure on January 23 at the age of eighty-four. Lies in state for one week at the Teatro-Museo Dalí. The town of Figueres observes three days of mourning. Dalí is interred at the Teatro-Museo Dalí.

In an obituary, the art critic and scholar John Russell writes in the *New York Times*: "Dalí will have a permanent place in the history of art. When still in his 20's, and in competition with some of the most gifted artists of the day, he made an inventive and enduring contribution to European Surrealism. . . . It was Salvador Dalí, with his meticulous and persuasive visions of a world turned inside out, who brought home to the public at large the full potential of Surrealism. . . . In his prime Dalí was not only an artist of intermittent substance but also a man whose wit, style, panache and readiness to take on all comers in conversation added to the gaiety of more than one capital city." John Russell Taylor of the *Times* of London writes: "When he began to be noticed in the Twenties Surrealism was a dangerous new movement, anarchic in its politics, courting charges of blasphemy and obscenity, and generally hard for the layman to approach. Within twenty years it had become the dominant influence in smart decoration, and magazine design, and many other areas which constantly impinged on everyday life. . . . For this transformation in public attitudes Dalí and his personal fame were almost entirely responsible."

Ana María, Dalí's sister, dies in Cadaqués on May 17.

The first sale of a work by Dalí after his death is made by Sotheby's in Madrid; sold at £74,000, it fetches three times the catalogue estimate.

The Salvador Dalí Museum, St. Petersburg, Florida

The Salvador Dalí Museum Board of Trustees

\intelected \mathbb{B}ibliography

By the Artist

The Conquest of the Irrational. New York: Julien Levy, 1935.

Metamorphosis of Narcissus. Translated by Francis Scarpe. New York: Julien Levy, 1937.

The Secret Life of Salvador Dalí. New York: Dial, 1942.

Hidden Faces. Translated by Haakon Chevalier. New York: Dial, 1944.

Fifty Secrets of Magic Craftsmanship. Translated by Haakon Chevalier. New York: Dial, 1948.

Dalí on Modern Art: The Cuckolds of Antiquated Modern Art. New York: Dial, 1957.

Impressions and Private Memoirs of Salvador Dalí, January 1920. Cleveland: Reynolds Morse Foundation, 1962.

The Diary of a Genius. London: Hutchinson, 1964.

Open Letter to Salvador Dalí. New York: Heineman, 1967.

Dalí by Dalí. Translated by Eleanor R. Morse. New York: Abrams, 1970.

Eroticism in Clothing. Cleveland: Salvador Dalí Museum and Teatro-Museo Dalí, 1975.

Explosion of the Swan. Los Angeles: Black Sparrow, 1975.

My Cultural Revolution. Cleveland: Reynolds Morse Foundation, 1975.

The Tragic Myth of Millet's "Angelus": Paranoiac-Critical Interpretation and the Myth of William Tell. Translated by Eleanor R. Morse. St. Petersburg, Fla.: Salvador Dalí Museum, 1986.

Critical Books and Articles

Ades, Dawn. *Dada and Surrealism Reviewed.* London: Hayward Gallery, Arts Council of Great Britain, 1978.

———. *Dalí.* London: Thames & Hudson, 1982.

———. "Surrealism: Fetishism's Job." In Antony Shelton, ed., *Fetishism: Visualizing Power and Desire.* London: Lund Humphries, 1995.

Ades, Dawn, and Michael Sweeney. *Surrealism in the Tate Gallery Collection.* Liverpool: Tate Gallery Liverpool, 1988.

Alexandrian, Sarane. *Dalí.* New York: Tudor, 1969.

Arco, Manuel del. *Dalí in the Nude.* Translated by Antonio Cruz and Jon Ber. St. Petersburg, Fla.: Salvador Dalí Museum, 1984.

Barr, Alfred H., Jr., ed. *Fantastic Art, Dada, Surrealism.* New York: The Museum of Modern Art, 1936.

Bosquet, Alain. *Conversations with Dalí.* New York: Dutton, 1969.

Breton, André. *Surrealism and Painting.* London: Macdonald, 1972.

Capua, Marco di. *Dalí.* New York: Crescent, 1994.

Catterall, Lee. *The Great Dalí Art Fraud and Other Deceptions.* Fort Lee, N.J.: Barricade Books, 1992.

Cevasco, G. A. *Salvador Dalí, Master of Surrealism and Modern Art.* New York: Story House, 1972.

Chadwick, Whitney. *Myth in Surrealist Painting, 1929–1939.* Ann Arbor: UMI Research Press, 1980.

Cowles, Fleur. *The Case of Salvador Dalí.* Boston: Little, Brown, 1959.

Descharnes, Robert. *Salvador Dalí.* Translated by Eleanor R. Morse. New York: Abrams, 1976.

———. *The World of Salvador Dalí.* Translated by Albert Field and Haakon Chevalier. London: Macmillan, 1979.

———. *Salvador Dalí. The Work, the Man.* Translated by Eleanor R. Morse. New York: Abrams, 1984.

Dopagne, Jacques. *Dalí.* New York: Amiel, n.d.

Ethrington-Smith, Meredith. *The Persistence of Memory: A Biography of Dalí.* New York: Random House, 1992.

Field, Albert. *Salvador Dalí: A Retrospective of Master Prints.* Los Angeles: Art Source International, 1992.

Finkelstein, Haim. *Surrealism and the Crisis of the Object.* Ann Arbor: UMI Research Press, 1979.

Fornes, Eduard. *Dalí and His Books.* Barcelona: Generalitat de Catalunya (Autonomous Government of Catalonia) and Editorial Mediterrania, 1987.

Gerard, Max, ed. *Dalí.* New York: Abrams, 1968.

———. *Dalí . . . Dalí . . . Dalí.* New York: Abrams, 1974.

Giralt-Miracle, Daniel, A. Reynolds Morse, Albert Field, and Franco Passoni, eds. *Dalí.* Stratton, England: Stratton Foundation for the Cultural Arts, 1991.

Hammacher, Abraham M. *Phantoms of the Imagination: Fantasy in Art and Literature from Blake to Dalí.* Translated by Tont Langham and Plym Peters. New York: Abrams, 1981.

Harris, Nathaniel. *The Life and Works of Dalí.* New York: Shooting Star, 1994.

Hodge, Jessica. *Salvador Dalí.* London: Park Lane, 1994.

Hubert, René. *Surrealism and the Book.* Berkeley: University of California Press, 1988.

Hughes, Robert. "Dalí in 3-D." *Time,* May 15, 1972, p. 46.

———. "Baby Dalí." *Time,* July 4, 1994, pp. 54–56.

Ilie, Paul. *The Surrealist Mode in Spanish Literature: An Interpretation of Basic Trends from Post-Romanticism to the Spanish Vanguard.* Ann Arbor: University of Michigan Press, 1968.

Krauss, Rosalind. *The Optical Unconscious.* Boston: MIT Press, 1993.

Kropf, Joan R., and A. Reynolds Morse. *Salvador Dalí: The Secret Life Drawings.* St. Petersburg, Fla.: Salvador Dalí Foundation, 1982.

———. *Dalí's Animal Crackers.* St. Petersburg, Fla.: Salvador Dalí Museum, 1993.

Kropf, Joan R., and Peter Tush, eds. *The Young Dalí: Works from 1914–1930.* St. Petersburg, Fla.: Salvador Dalí Museum, 1995.

Lake, Carlton. *In Quest of Dalí.* New York: Paragon, 1990.

Larkin, David, ed. *Dalí.* London: Pan, 1974.

Lasarte, Joan Ainaud de. *Catalan Painting from the Nineteenth to the Surprising Twentieth Century.* Geneva: Skira, 1992.

Lear, Amanda. *My Life with Dalí.* London: Virgin Books, 1985.

Liano, Ignacio Gomez de. *Dalí.* New York: Abrams, 1984.

Livingston, Lida. *Dalí: A Study of His Art in Jewels—The Collection of the Owen Cheatham Foundation at the Virginia Museum of Fine Arts, Richmond, Virginia.* New York: Owen Cheatham Foundation, 1977.

Longstreet, Stephen. *The Drawings of Dalí.* Los Angeles: Borden, 1964.

Lopsinger, Lutz, and Rolf Michler. *Salvador Dalí: Catalogue Raisonné of Etchings and Mixed Media*

Prints, 1924–1980. Munich: Prestel, 1994.

Lubar, Robert S. *Dalí: The Salvador Dalí Museum Collection.* New York: Little, Brown, 1991.

Maddox, Conroy. *Dalí.* New York: Crown, 1979.

———. *Salvador Dalí: Eccentric and Genius.* Cologne: Taschen, 1990.

Matthews, John Herbert. *Eight Painters: The Surrealist Context.* Syracuse, N.Y.: Syracuse University Press, 1982.

McGirk, Tim. *Wicked Lady: Salvador Dalí's Muse.* London: Hutchinson, 1989.

McIlany, Sterling. "Playboy Interview: Salvador Dalí." In G. Barry Golson, ed., *The Playboy Interviews,* vol. 2. New York: Putnam, 1964.

Moore, John Peter. *Guide to the Genuine and Original Signatures of Salvador Dalí.* Vienna: Collectors Club, 1984.

Moorhouse, Paul. *Dalí.* London: Bison, 1990.

Neret, Gilles, and Robert Descharnes. *Salvador Dalí, 1904–1989: Complete Paintings.* 2 vols. Cologne: Taschen, 1994.

Orwell, George. "Benefit of Clergy: Some Notes on Salvador Dalí." In *Dickens, Dalí, and Others: Studies in Popular Culture.* New York: Harcourt Brace, 1973.

Parinaud, André, ed. *The Unspeakable Confessions of Salvador Dalí.* New York: Quill, 1981.

Pauwels, Louis. *The Passions According to Dalí.* Translated by Eleanor R. Morse. St. Petersburg, Fla.: Salvador Dalí Museum, 1985.

Raeburn, Michael, ed. *Salvador Dalí: The Early Years.* London: South Bank Centre, 1994.

Rogerson, Mark. *The Dalí Scandal.* London: Gollancz, 1987.

Rojas, Carlos. *Salvador Dalí, or The Art of Spitting on Your Mother's Portrait.* Translated by Alma Amell. University Park: Pennsylvania State University Press, 1993.

Romero, Luis. *Dalí.* Secaucus, N.J.: Chartwell, 1975.

Rubin, William. *Dada and Surrealist Art.* New York: Abrams, 1969.

Secrest, Meryl. *Salvador Dalí, Surrealist Jester.* London: Weidenfeld & Nicolson, 1986.

Serna, Gomez de La. *Dalí.* New York: William Morrow, 1979.

Shanes, Eric. *Dalí: The Masterworks.* London: Studio Editions, 1994.

Soby, James Thrall. *Salvador Dalí: Paintings, Drawings, Prints.* New York: The Museum of Modern Art, 1942.

———. *Salvador Dalí.* New York: Simon & Schuster, 1946.

Tashjian, Dickran. *A Boatload of Madmen: Surrealism and the American Avant-Garde, 1920–1950.* London: Thames & Hudson, 1995.

Theberge, Pierre, ed. *Salvador Dalí.* Montreal: Montreal Museum of Fine Arts, 1990.

Tush, Peter. *Dalí: Les Chants de Maldoror.* St. Petersburg, Fla.: Salvador Dalí Foundation, 1991.

Volboudt, Pierre. *Homage to Salvador Dalí.* New York: Leon Amiel, 1980.

Wach, Kenneth. "The Pearl Divers of the Unconscious: Freud, Surrealism, and Psychology." In Christopher Chapman, Ted Gott, and Michael Lloyd, eds., *Surrealism: Revolution by Night.* Canberra: National Gallery of Australia, 1993.

Walton, Paul. *Dalí, Miró.* New York: Tudor, 1967.

Wilson, Simon. *Salvador Dalí.* London: Tate Gallery, 1980.

Index

Page numbers in *italics* refer to illustrations.
All works are by Dalí unless otherwise noted.
Separate listings are included for alternate titles.